# THE ART OF
# BIRD ILLUSTRATION

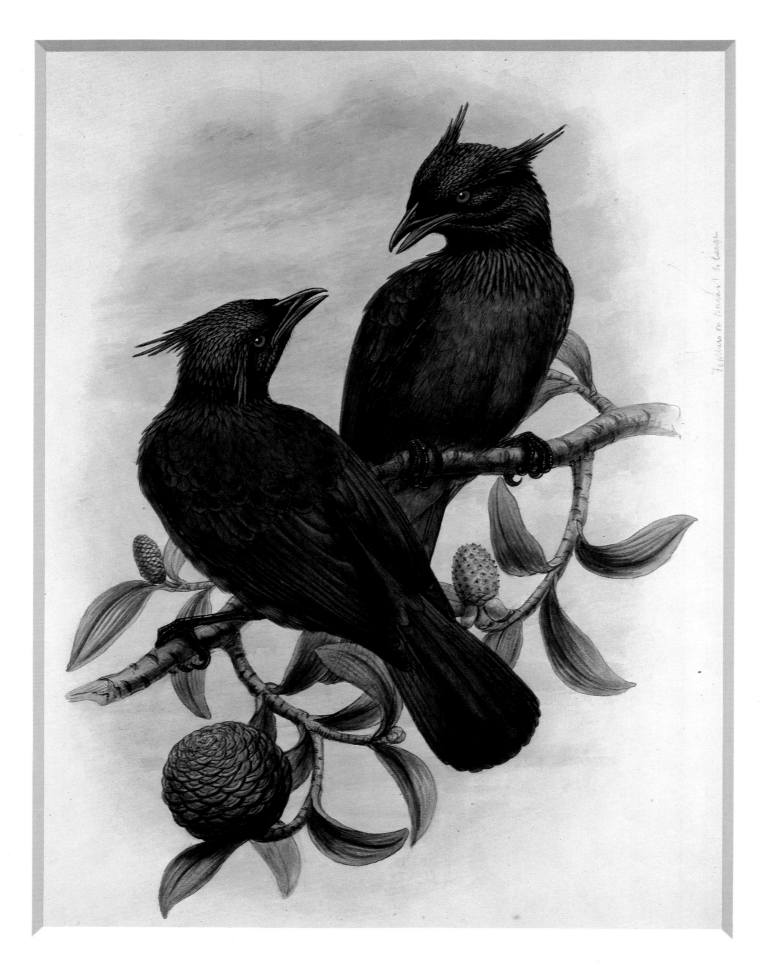

THE PURPLE AND VIOLET MANCODE
......................................................
Painting by William Hart for John Gould's *The Birds of
New Guinea*.

# THE ART OF
# BIRD ILLUSTRATION

## MAUREEN LAMBOURNE

THE WELLFLEET PRESS

A QUARTO BOOK

Published by Wellfleet Press
110 Enterprise Avenue
Secaucus, New Jersey 07094

ISBN 1-55521-585-8

This book was designed and produced by
Quarto Publishing plc
The Old Brewery, 6 Blundell Street
London N7 9BH

Creative Director: Peter Bridgewater
Art Director: Ian Hunt
Designer: Anna Brook
Editorial Director: Jeremy Harwood
Senior Editor: Hazel Harrison
Artwork: Jean Foley
Picture Manager: Joanna Wiese
Picture Researcher: Arlene Bridgewater

Typeset by
Central Southern Typesetters, Eastbourne
Manufactured in Hong Kong by
Regent Publishing Services Ltd
Printed in Hong Kong

# Contents

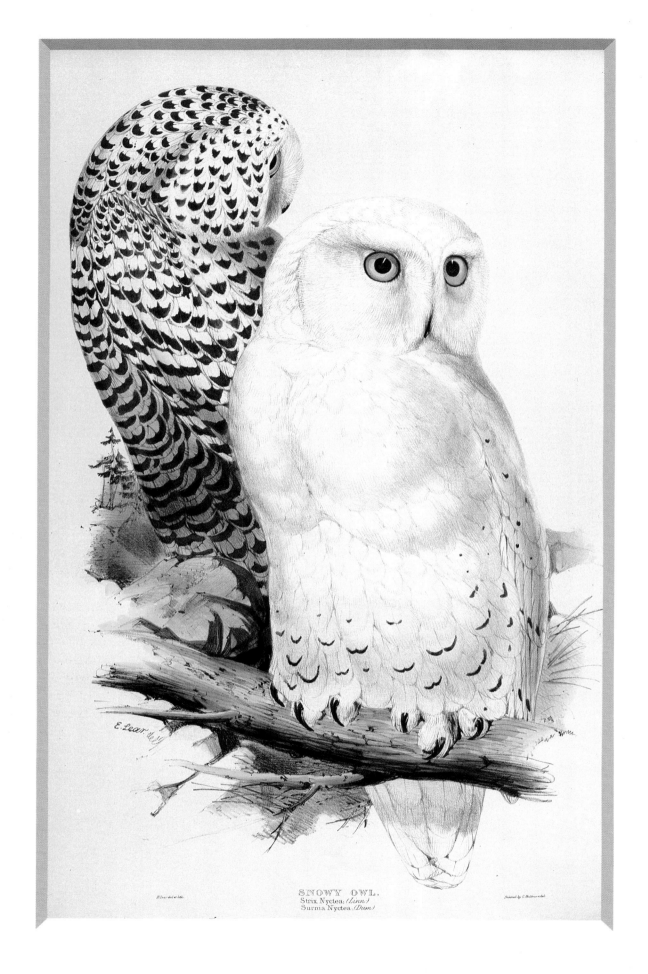

SNOWY OWL.
Strix Nyctea (Linn.)
Surnia Nyctea (Dum.)

SNOWY OWL
........................................
Lithograph by Edward Lear for John Gould's *Birds of
Europe*.

# Introduction

*'Art and Nature, like two Sisters, should always walk hand in hand, so that they may reciprocally aid and assist other'.*
*George Edwards,* circa *1743.*

THIS BOOK IS A PICTORIAL INTRODUCTION rather than a comprehensive survey of bird illustration through the centuries. My commentary to the pictures has taken the form of an imaginary bird-watcher's stroll through the ages including visits to the Nile valley, Pompeii, medieval Europe, the aviaries of the Baroque era, early colonial settlements in America and Australia, the English garden, and a bird conservation area in the twentieth century. At all these places and periods of history I have stopped to admire the diversity of colours, shapes and movements of birds as portrayed by many artists. The journey has been a leisurely one, and I have made no attempt to provide a complete record of names – either of artists or species – to be ticked from a list in the manner of the obsessive bird-spotter, the contemporary 'twitcher'.

My personal selection has been limited to two-dimensional representations, thus excluding the arts of sculpture and ceramics, and I have laid an emphasis on depictions of birds portrayed as living creatures. For this reason many virtuoso still-life paintings of dead game by Dutch, Flemish and French artists will not be found here, and neither will sporting pictures, with the one exception of an illustration of a hooded falcon by Joseph Wolf. Inevitably there are large gaps: for instance limitations of space have precluded the lovely prints and paintings of Eastern cultures as well as many fine illustrations from Western masters, but it is hoped that the book will give a flavour of the immense variety of approach in the depiction of birds.

The life histories and personalities of the illustrators and authors of bird books were remarkably diverse; some were important public figures, while other lived in obscurity. They came from varied walks of life, and included scholars, explorers, an art teacher, a librarian, a clergyman, a weaver and poet, a storekeeper, a gardener and taxidermist. Their financial fortunes ranged equally widely, from the wealth of the French aristocrat, the Comte de Buffon, the landowning squires Sir William Jardine and P.J. Selby, or the successful businessman John Gould, to the poverty of William Hayes and the bankrupt J.J. Audubon. Many suffered great hardships and overcame enormous difficulties to produce work of lasting beauty.

What were the motivations held in common by this diverse group of naturalists? All were united by an enthusiasm for bird life and the ambition to record pictorially the latest exciting scientific information concerning both birds of their own countryside and previously unknown foreign species.

Because of the fragility of paper and pigments, many bird pictures have to be kept in libraries and art galleries under carefully controlled conditions, away from the deteriorating effects of strong light and varying temperatures. Many of the nineteenth-century illustrations are in heavy, unwieldy books, and the prints of Audubon, Selby, Levaillant, Lear and Wolf are difficult to see except on a spacious library table. To visualize the huge size of an Audubon print it is helpful to imagine the double-spread of an opened-out quality newspaper – the prints are half as large again. At the end of the last century Lord Lilford, writing about Gould's work, said that the books were so big that 'you will require a boy to help you carry them from the house'.

A few artists and writers, among them Bewick, Jardine and Wilson, fulfilled the wish expressed by the ornithologist William Swainson for smaller volumes to be printed, more 'accessible to naturalists and thereby diffuse science, instead of restricting it only to the wealthy'. Swainson's wish has largely come true today; the convenient format of a book like this one enables us to share the pleasures of looking at these superb bird pictures chosen from rare books housed in specialized libraries. By turning its pages the reader can enjoy vicariously the visual thrill of seeing the plates in their pristine original colours. I trust that this personal choice may introduce to many newcomers some of the hidden treasures of the art of bird illustration.

MAUREEN LAMBOURNE

---

AUTHOR'S NOTE
Modern classification sometimes results in changes to the names of birds. In the captions to the illustrations throughout the book the present-day English and Latin names have been given. In some cases these differ from those used in the past, which appear in several of the illustrated plates.

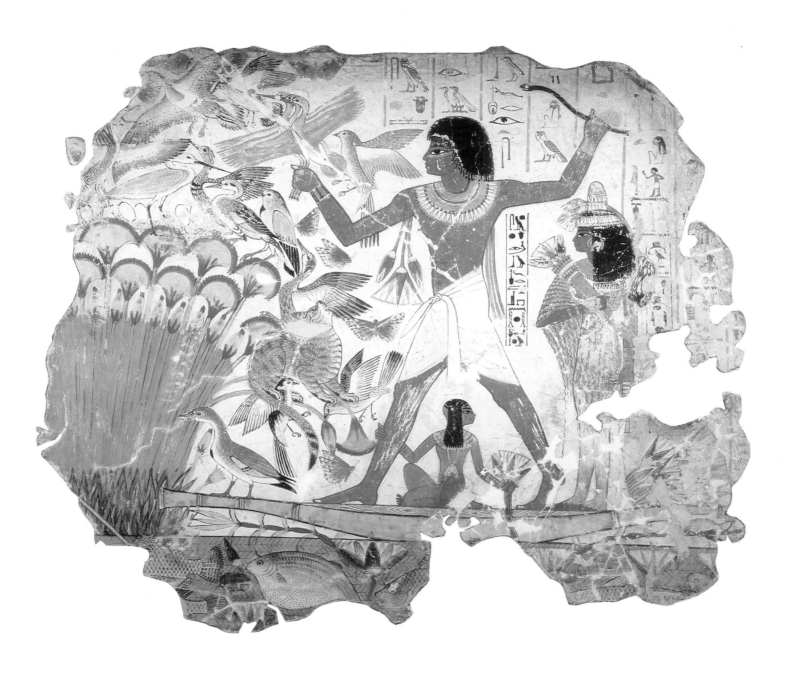

HUNTING BIRDS IN THE MARSHES

Painting of about 1400 BC from the tomb of Nebamun. The
fowler holds three decoy herons and aims his throw-stick
at rising ducks, geese and heron, while a retriever cat
leaps at a bird.

# Early Beginnings:
# from Cave Art to the Romans

AMONGST THE VIGOROUS REPRESENTATIONS of animals on the walls of the Lascaux underground caves in France, drawn in Paleolithic times is one of the earliest known pictures of a bird. In a cave called 'the Well', set apart from the main diorama of animals, is an enigmatic scene of a rhinoceros, a disembowelled bison, a falling man and a long-legged bird on a pole, powerfully painted in black outline. It is difficult to interpret this strange scene, but prehistorians believe that cave paintings had magical or religious significance; they were not merely dramatic descriptions of the events of a hunt. Perhaps this was part of a ceremony, with the falling man in the throes of an ecstatic trance and the bison a sacrificial beast. In this context, the bird on a stick could have been a symbolic carved post like a totem pole, or might even have represented the external soul of the falling man. But whatever the meaning, these marvellous paintings are fascinating and compelling pictorial descriptions, as well as providing a record of the creatures which men of the Paleolithic Age hunted for food.

## EGYPTIAN PAINTING

The Egyptians, thousands of years later, were also keen huntsmen, although this was far from being their only means of sustenance – they were also sophisticated farmers and agriculturalists. In the swamps of the Nile hunting for fowl was a favourite pursuit practised by Egyptian nobles from the earliest times. The art of fowling was depicted on the walls of their tombs, as a desirable occupation for the afterlife, and this remained a popular theme for over 2000 years. Magical spells gave assurances that the deceased would catch an abundance of fowl, symbolic of food and plenty.

In the British Museum there is a superb painting from a Theban tomb showing a high official, accompanied by his wife and daughter, on his boat in the marshes catching birds. He is thought to have been called Nebamun, and lived during the Eighteenth Dynasty, *c.* 1400 BC, about a hundred years before Tutankhamun. In one hand he clutches three decoy herons, and in the other a boomerang or throw-stick shaped like a serpent, which he aims at the water birds rising from the swamp. Three falling birds are caught by his agile retriever cat, especially trained for this

purpose. The painting teems with agitated bird life – some flying in a flurry, others disturbed from their roosting places in the reeds – while a pet goose stands in the prow of the boat oblivious of the surrounding panic.

This magnificent painting shows the skills of the Egyptian artist at their best. The overall pictorial effect is of a superb patterning of overlapping shapes and subtle blends of colour. The flowing outlines of the birds are drawn in browns and blacks, and the colouring is a limited palette of soft blues, iron red, copper green, carbon black and yellow ochre.

A more tranquil scene, also in the British Museum, depicts the ornamental pond in Nebamun's private garden. Here ducks and geese swim in the pale blue rippling water among fishes and lotus plants. In the same delightful way that children draw from memory, the Egyptian artist, unaware of the rules of perspective, has painted the date palms growing sideways, the birds and fishes in profile, and the pool as though looking down from above.

One of Nebamun's official duties as an overseer was to supervise a census of fowl, and another glimpse of his life shows a gaggle of geese, each with different markings, crowded and overlapping as they wait to be herded into baskets. One can almost hear the noise of the lively creatures and see their agitated movements. In contrast to this realistic scene, a scroll called the *Satirical Papyrus* (*c.* 1500–1200 BC) gives an ironic version of Egyptian daily life, showing a large striped cat acting as a herdsman and driving the domesticated geese to market with a stick.

Due to their limited range of pigments, the Egyptian bird paintings were not always naturalistic in terms of colour, but some species are recognizable. The earliest-known identifiable birds are the striking red-breasted geese strolling along a meadow, portrayed in a frieze known as the 'Maidum Geese', from the tomb of Nefermaat and Itet. Despite its early date (*c.* 2600 BC), the observation of the birds' red-brown markings is so accurate that one could believe they were alive today. From the same tomb is a fragment of a scene of trapping birds in a clap-net. A surviving detail of a decoy duck shows its outstretched wing feathers painted with four bands of white, red, green and white.

With the wealth of bird life around them, the Egyptians were never short of ornithological inspiration. A much

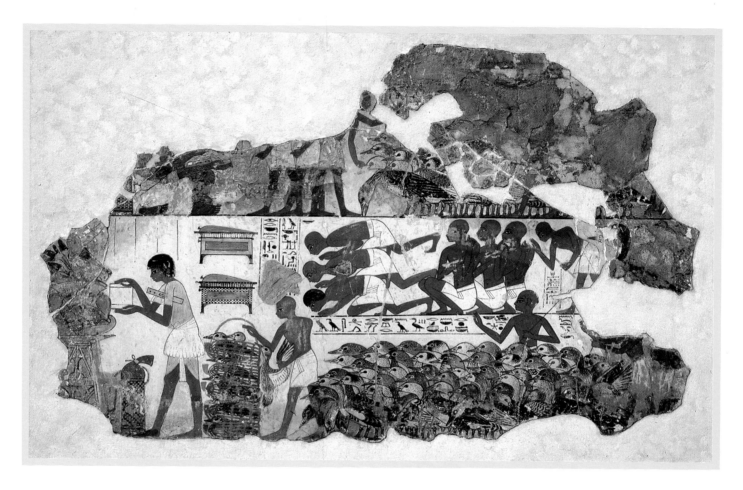

Here geese are herded for a count, while a scribe on the
left presents his record on an open papyrus roll. Painting
from Nebamun's tomb.

more recent account of the Nile bird life by Edward Lear,
who painted landscape in Egypt after a career as a bird
artist in England, lists 'geese, pelicans, plovers, eagles,
hawks, cranes, herons, hoopoes, doves, pigeons [and]
kingfishers'. In his diary entry for 9 January 1867, he wrote:
'On a long sand spit are 4 black storks – one legged: apart.
– 8 Pelicans – careless foolish. 17 small ducks, cohesive.
23 Herons – watchful variously posed: & 2 or 3 flocks of
lovely ivory ibis – (or Paddybirds –) flying all about.'

The Egyptians had no inhibitions in painting flying birds,
and portrayed their movements with a skill that European
artists were not to equal for many centuries. The artist of a
painted pavement from a royal building at El-Amarna (*c.*
1370 BC) captured the essence of birds flying out of a
thicket with a few deft strokes, and a kingfisher swooping
to fish in the water is given more detailed treatment in
another painting from the same site.

Another facet of Egyptian bird painting was religious, as
animals were associated with the gods in a complex theo-
logy. Re-Horus, the sun-god, one of the most ancient of
Egyptian deities, was identified with the all-powerful falcon,
'the Lofty One', which could fly high in the sky towards the
sun and descend from the heights of heaven while hunt-
ing. Horus wore a falcon's head, or was symbolized by a

perched falcon, sometimes wearing the sun-disc as a
headdress.

At a later period, great prominence was given to Thoth,
symbolized by the ibis. He was the scribe of the gods,
representing wisdom and intelligence, the Lord of laws,
chronology and sacred writings. Both falcon Horus and
tall ibis-headed Thoth appear frequently on funerary
papyri. Another symbolic bird was the heron, represent-
ing abundance and plenty, and thus was the subject of
devotions to ensure a good harvest. Unlike the secular
paintings, the representations of these bird-gods were
carefully regulated, and there were 'model' drawings
showing the correct way to draw their profiles within a
grid of ruled lines.

## ROMAN PAINTING

Whereas the Egyptian paintings were intended to benefit
the happy existence of the dead, and their wall paintings
remained immured in temples and tombs unseen by liv-
ing eyes, Roman paintings were for present enjoyment.
Interior and exterior walls of country villas were decorated
with frescoes of garden landscapes, and the excavations of
Pompeii and Herculaneum, buried by the ashes of Vesuvius
in AD 79, revealed that many wealthy houses had scenic
murals depicting plants and birds. Earlier Roman villas
had been planned with reception rooms overlooking a
small garden plot, but at Pompeii colonnaded courtyards
were built with fountains and statuary interspersed with

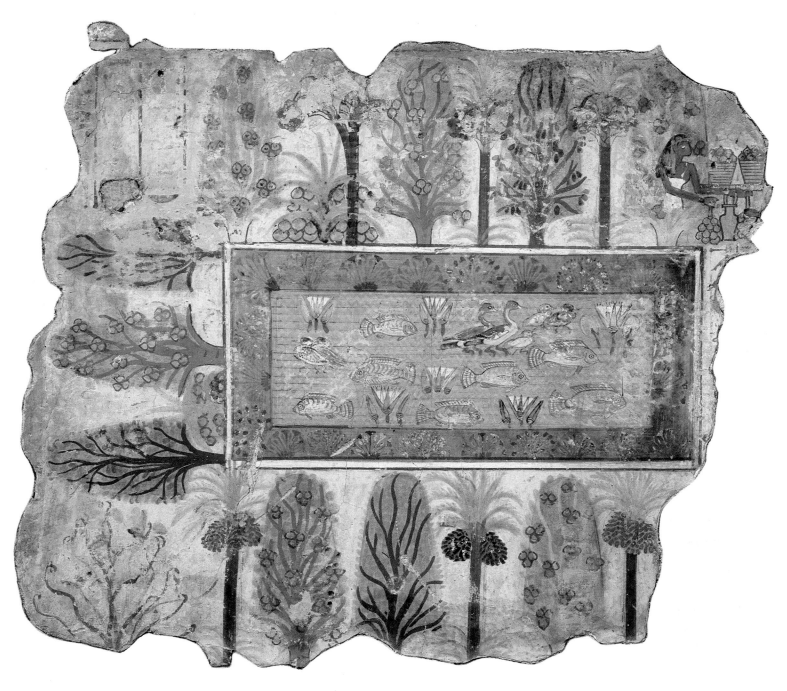

DUCKS AND GEESE

In this painting from Nebamun's tomb, the birds are
shown swimming in an ornamental pool.

GEESE HERDED BY A CAT

A scene from the *Satirical Papyrus*, painted *c.* 1500–1200
BC, in which animals engage in human activities. *(TOP)*

RED-BREASTED GEESE
···································

*Branta ruficollis.* Facsimile painting of part of a goose
frieze in the tomb of Nefermaat and Itet at Maidum,
painted *c.* 2600 BC. A very early illustration of an
identifiable species of bird. *(ABOVE)*

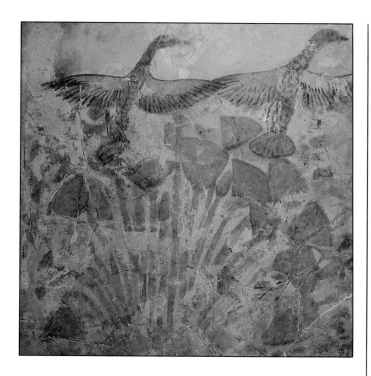

DUCKS FLY OUT OF A PAPYRUS THICKET

A fragment of painted pavement from a royal palace called
Maruaten at El-Amarna. About 1370 BC.

shrubs and flowers. On some walls landscape vistas were painted with flowering trees and ornamental plants which created the illusion of continuous parkland. Amongst this greenery, birds in movement were depicted: flying swallows, doves drinking from a fountain or a crouched heron pecking at a lizard.

The Romans were fond both of aviaries, with peacocks and doves, and of tamed birds. The poet Catullus, who lived in the first century BC, immortalized a pet sparrow (which may have actually been a bullfinch) belonging to his beloved, Lesbia, a playful bird which pecked and sported with its owner, nestled in her lap, consoled her when sad, and chirruped for her alone. Parrots, too, were favourite pets, and the death of one inspired an elegy by the slightly later poet Ovid. This bird, which had belonged to his mistress Corinna, was of Indian origin, had feathers greener than brittle emeralds, a red and saffron beak, and was a paragon amongst birds, an articulate talker and a master of impersonation. In his poem Ovid called upon other birds, especially the turtledove, to mourn for this beloved pet, whose last weak words had been 'Corinna, vale!' ('farewell, Corinna'). The epitaph on his miniature headstone reads, 'In loving memory of Polly, A highly educated bird'.

The parrots depicted in Roman paintings and mosaics were green birds which came from the East after the invasion of India by Alexander the Great. Sometimes they were embellished with the addition of a red neck band of feathers forming a collar, and flecks of red on their wing feathers. A mosaic preserved in Cologne shows two green parrots harnessed to a small cart loaded with agricultural implements, and in the Piazza Armerina in Sicily there is a fourth-century mosaic known as the 'Little Circus', designed for the amusement of children. It depicts a miniature chariot race with child gladiators and birds, wood pigeons, ducks and flamingoes in harness. The African grey parrot does not feature in Classical art, surprisingly, since Italy is so much closer to Africa than to India.

The Pompeian artists were skilful painters of still-life subjects celebrating the pleasures of the table, with fish, game and produce from local farmyards. Partridges and cockerel were shown hanging in larders, and bunches of song thrushes strung from large hoops – unfortunately the tradition of serving song thrushes as a delicacy still survives in Italian cuisine.

Although many of the live birds and animals depicted in Roman art were carefully observed and described with affection, it is a sad fact that the Romans could also take great pleasure in the slaughter of creatures at the circus. The birds to suffer most at the hands of the circus gladiators were the flightless ostriches. These large birds were then more prolific in north Africa, and were rounded up in the hunting-field for live transport to Italy. In the British Museum there is a fourth-century mosaic floor decoration from Utica, Tunisia, which is thought to depict a fantasy hunt. A prancing ostrich, a boar, a gazelle, a stag and a leopard are being enmeshed in a huge weighted net stretched in a semicircle and held by four men in boats.

Many Roman gods were associated with a particular bird or animal: Jupiter with the eagle, Venus with the dove and Juno with the peacock. Minerva adopted the owl from the Greek goddess Athena, who gave her name to both the city of Athens and the little owl (Athene noctua). The eagle of Jupiter was adopted as the symbol of Roman imperialism, an emblem of victory, and the sacred bird of the Roman army. A Roman legion regarded its standard, a large gold eagle with outspread wings, as a divine protector, and its capture in battle was the greatest disaster that could occur.

A favourite Classical myth – most of which were taken over wholesale by the Romans from the Greeks – was the story of Leda and the swan, in which Zeus (the Roman Jupiter) disguised himself as a swan to approach Leda while she was bathing in the river. As a result of their union Leda laid two eggs, out of which came the divine twins Castor and Pollux, and Helen of Troy, whose beauty was later to provoke the Trojan wars. Roman illustrations of Leda and the swan were often erotic, portraying the sensual pleasure of the naked Leda in her embrace with the huge swan, and many centuries later (c. 1506) Leonardo da Vinci was equally fascinated by the story. His large panel of *Leda and the Swan* is lost, but in the Royal Collection at Windsor Castle there are experimental studies for the theme, pen and ink drawings in which the rhythmic twisting forms are used as a basis for many complex ideas of pictorial composition.

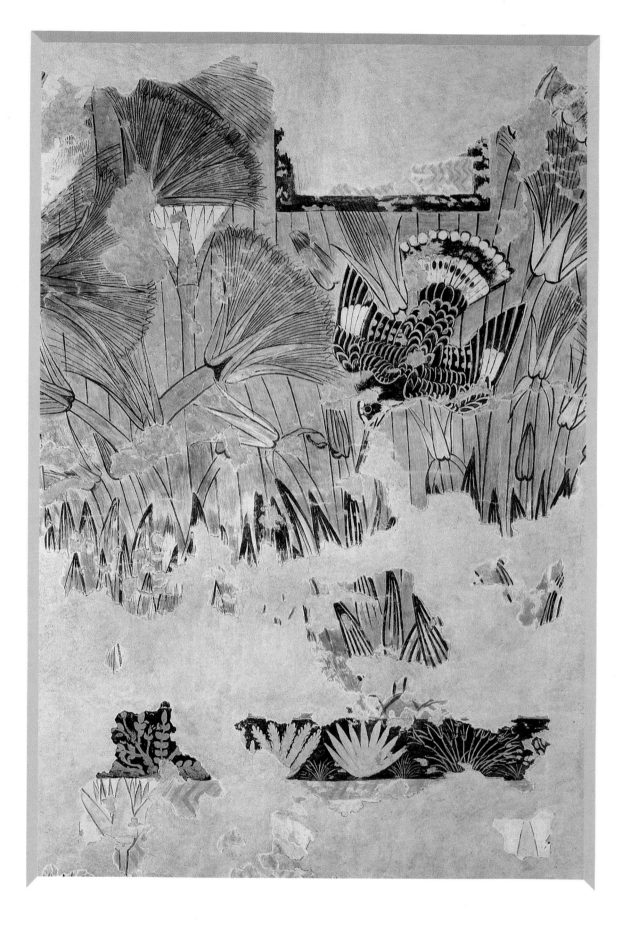

**A KINGFISHER AMONG LOTUS FLOWERS**

Part of the wall decoration in the Green Room of the
Northern Palace at El-Amarna. About 1370 BC.

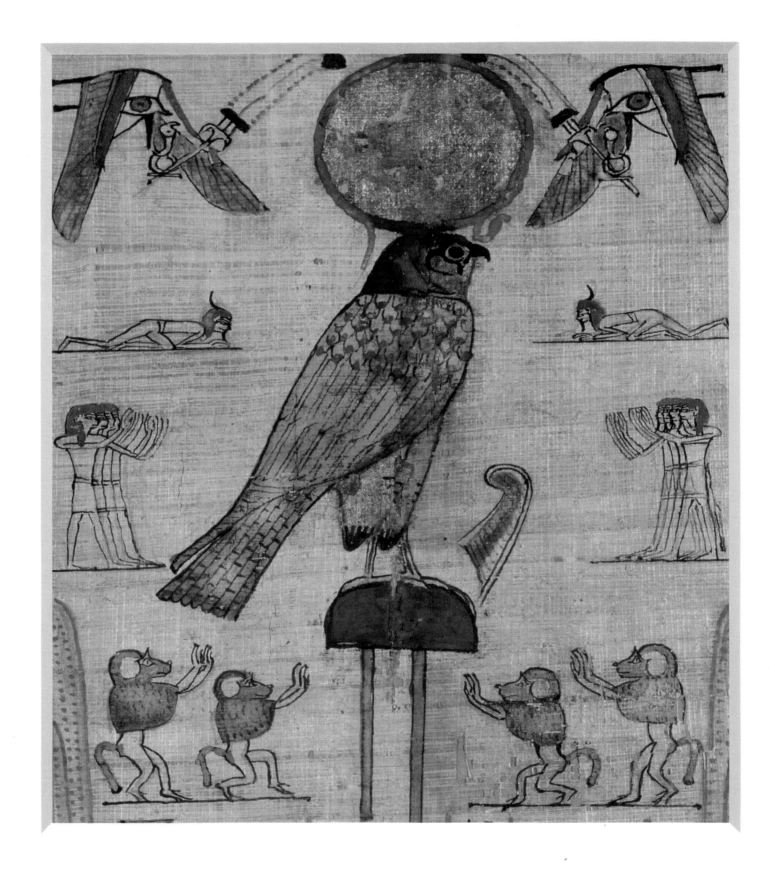

THE DIVINE FALCON RE-HORUS

From the illuminated papyrus Book of the Dead of the
priestess Anhai, *c.* 1150 BC. The god is shown on a perch,
representing the rising sun. He supports a gilded sun disc
and is surrounded by adoring figures and baboons.

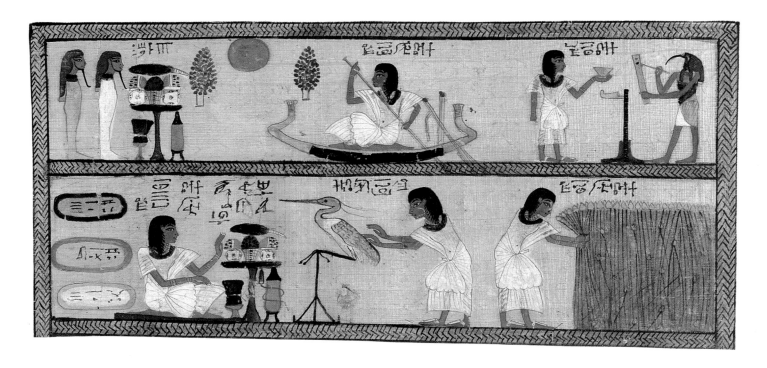

### Scenes from the life of Nakhte
......................................

From the papyrus Nakhte's Book of the Dead *c.* 1320–1290
BC. In the top panel, Nakhte, the royal scribe, is shown
making offerings to the divine scribe, the ibis-headed god
Thoth. The lower one shows him making devotions to the
heron, symbol of plenty.

### Herons
......................................

The birds also appear as an illustrative motif in the text of
the papyrus Book of the Dead.

A ROSE-RINGED PARAKEET WITH CHERRIES
...............................................
Fragment of wall-painting from Pompeii, first century AD.
Green parrots from India were favourite Roman pets.
(*TOP*)

BIRD WITH PEAR AND APPLE
............................................
Panel from a Romano-British mosaic of the fourth
century AD. (*ABOVE*)

AN IMMATURE PEACOCK

Byzantine mosaic possibly from Cyprus, third to fifth
century AD. Because Classical myth held that the
peacock's flesh did not decay, the bird became an Early
Christian symbol for the Resurrection.

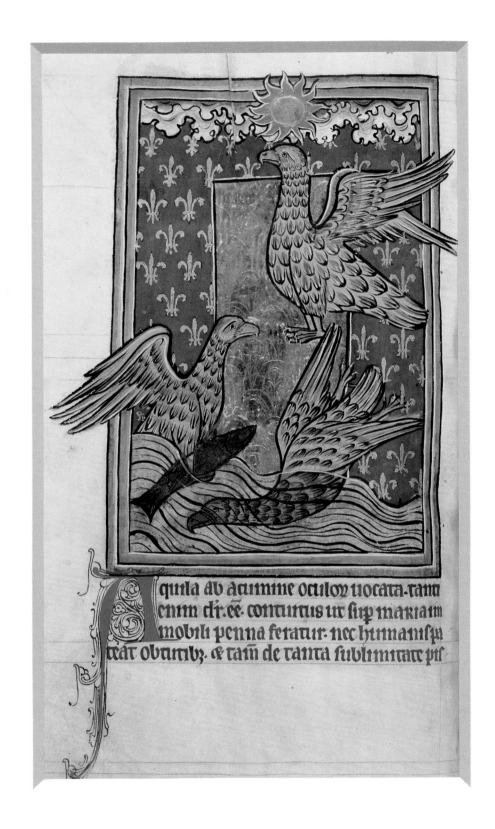

**EAGLE**

..............................................

English illuminated bestiary, mid-thirteenth century. MS
Bodley 764 fol.57v. The bird is shown flying towards the
sun, plunging into water and rising from it with a fish.

# From Medieval Manuscript to the Printed Book

## THE BESTIARY BIRD

ON A DIFFERENT PLANE from the sheer pictorial pleasure derived from the depiction of birds and animals in Roman art are the serious writings on natural history by Pliny the Elder (in the first century AD). His *Naturalis Historia*, which ran to thirty-seven volumes, is an immense scholastic encyclopedia of birds, beasts, stones and stars, medicines and magic, and this compendium of speculation and quaint knowledge became one of the many literary sources of the medieval bestiary.

These bestiaries were natural-history books of animal illustrations and descriptive text which became popular, predominantly in England, during the twelfth to fourteenth centuries. Their pictures were illuminated by limners (artists) skilled in the decoration of the psalters and missals of the period, while the texts were the work of scribes who either wrote from dictation or copied from earlier manuscripts. Each animal was introduced with an account of its character; historical references were made to its place in scripture or mythology, and a conclusion contained a moral, allegorical message.

In the Middle Ages, it was believed that, since God had given a place to 'the beasts of the earth' in his scheme of the Creation, there was much to be learned by man from the behaviour of animals. 'Ask the beast' Job had said (12:7) 'and it will teach you, and the birds of heaven and they will tell thee'. But God had also given man 'dominion over the fowl of the air, and everything that moveth upon the earth' (Genesis 1:26, 28), and an extreme example of man's 'dominion' was practised in parts of France, where animals were even put on trial and penalized in secular and ecclesiastical courts for misdemeanours against the law. Mice were tried for crimes such as eating crops, and sparrows for chattering in church.

The bestiary texts are a fascinating jumble of religious thought, folklore, Classical mythology and natural history observation compiled by many hands. One origin was a work called the *Physiologus* (natural philosopher), which had been written by an anonymous Greek in Alexandria during the fourth or fifth century AD, and had in turn been influenced by the writings of Herodotus, Aristotle and Pliny. Through the centuries the texts in the *Physiologus*

were expanded, and additional animals were brought in.

Some of the pictures in the bestiaries depict purely legendary birds, such as the phoenix (fenix) and the caladrius. Others – the ostrich (assida) and the hoopoe (upupa) – seem quaint and scarcely credible, but a few could be recognizable today; for example the eagle (aquila), the storks (ciconidae) and the peacock (pavo). Many of the illustrations and descriptions seem comic and crude to modern eyes, but scientific accuracy was not the concern of the bestiary artists; their job was to portray the birds and animals in a stylized manner to illustrate the allegories of the texts.

Of the fabulous birds, the phoenix from Arabia is still well known in the modern world as a symbol of rebirth. According to the bestiaries, it was a reddish-purple bird with a lifespan of some 500 years. When it became old it built itself a funeral pyre with spice branches, set fire to itself by flapping its wings towards the rays of the sun, and on the ninth day afterwards rose from its ashes with new life. The pictures of it are not identifiable with any real bird, but it has been suggested it was based on the bird of paradise.

One of the stories that features in the bestiaries, that of the sentinel crane, was also a subject for wood carving, and appears on a fifteenth-century misericord at St Nicholas Church, Denston, Suffolk. A crane on watchful guard at night keeps itself awake by holding a stone in its claw. If it should doze the stone is dropped, this awakes the sentinel and another crane takes over his duty.

Sometimes the descriptions of the birds are derived from accurate observation. The eagle, for instance, was admired for its acute eyesight, for from a height it could see small fishes swimming, and would descend like a thunderbolt to carry off its captured prey and fly up towards the mountains. This gave rise to the belief that the eagle, like the phoenix, had the power to rejuvenate itself, flying up to the sun when it became old and weak-sighted, to burn away the film over its eyes. Then, suffering from sunstroke and singed wings, it plunged into a cool fountain three times, thus renewing its splendid plumage and strong vision.

The bestiary artist was unlikely to have seen an ostrich alive, and not surprisingly, its portrait was a poor one.

THE PEACOCK
...........................
Illumination from the *Ashmole Bestiary,* made in England
*c.* 1210. MS Ashmole 1511 fol.72r.

gaze and flew towards the sun, either to die itself or to have the poison burned away. The caladrius thus resembled Christ, in being without blemish and taking upon itself the spiritual disease and sins of the world.

The bestiaries represent the strange bird as somewhat like a seagull, but it may have been based on an albino or as the author T. H. White suggested in *The Book of Beasts,* a white wagtail. This bird, he said, was long regarded in Ireland with superstitious dread because of its skull-like head markings.

Many other fascinating birds are listed in White's book, an enchanting translation of a twelfth-century bestiary now preserved in Cambridge University. The author's witty and erudite comments provide a delightful and sympathetic introduction to medieval natural history.

## THE ILLUMINATED BIRD

The lively yet unlifelike creatures of the bestiaries were not the only examples of birds to be depicted in medieval manuscripts; there are pictures of birds in the margins of other illuminated books, and by about the twelfth and thirteenth centuries these began to be more recognizable and naturalistic.

The early masterpieces of calligraphy, the sumptuous *Lindisfarne Gospels* (*c.* 700) and the *Book of Kells* (late eighth century) contain elaborately formalized birds which form part of complicated interlaced patterns. The Lindisfarne birds are extraordinary creatures, their strange heads and bodies twisting and weaving into meandering designs based on Celtic and Saxon metalwork and woodcarving. In the rich decoration of the *Book of Kells* the eagle of St John, recognizable by its large beak, is placed amongst the exuberant patterning surrounding the saint.

These magnificent gospels were intended for liturgical reading in church, and in the eleventh and twelfth centuries large bibles and psalters were made for placing on lecterns. One such was the *Luttrell Psalter,* written *c.* 1340 for Sir Geoffrey Luttrell, a well-to-do Lincolnshire landowner. Its large margins are decorated with pictures of everyday life, among them a goose with five goslings honking at a swooping rook, a sower scattering seeds while a dog chases rooks, and a farm labourer using a slingshot against similar marauding birds.

During the late Middle Ages smaller devotional manuals known as Books of Hours were made for private use, containing prayers to be said at different hours of the day and a calendar of the months with saints' and feast days. Their illuminated pictures of the life of the Virgin and seasonal occupations through the year were painted with meticulous attention to detail, and often these delightfully realistic scenes were surrounded with ornamental borders of decorative foliage and wild flowers, among which are brightly painted tiny birds.

Brunsdon Yapp, author of *Birds in Mediaeval Manu-*

There were many curious tales about the ostrich: one was that it deposited its eggs in the sand to be hatched by the warmth of the sun; while another credited it with such a voracious appetite that it could eat iron (a misericord at Holy Trinity Church, Stratford-upon-Avon shows the ostrich eating a horseshoe). Both these legends have a basis in fact. The ostrich does leave the eggs partly covered during some hours of the day to incubate in the heat, and can swallow metal as roughage. Captive ostriches are known to be attracted by shining objects and will eat watches, brooches and bottle tops, which do little harm unless they have sharp points. These remain in the gizzard to be slowly ground down among stones which the birds swallow to aid their digestion. The bestiary describes the ostrich's foot as like that of a camel, and this is also borne out by scientific fact. The evolutionary process has given the bird an almost hoof-like foot with two toes, one much smaller than the other, instead of the four toes common to most modern birds.

The peacock, with its sumptuous colours, gave the medieval limner a wonderful opportunity to show off his expertise in his craft. Its train trailed into the margin of the manuscript, opening into a jewelled fan of blue, green and red embellished with gold. As in Roman times, the peacock was valued for its beauty, and although its flesh was hard to cook, was a showpiece at banquets, where it was served up complete with feathers. The bestiaries quote the epigram of the Roman satirist Martial: 'How can you be surprised that he often ruffles his jewelled wings at you, O you hard-hearted woman, when you can find it in your heart to hand him over to the cruel cook?'

The oddest of all was the legendary caladrius, a dazzling white bird which could foretell death by gazing into a sick man's eyes. Perched at the bedside, it would turn its head away if the patient was doomed to die, but towards him if he was to recover. If the prognosis was favourable, the caladrius absorbed the patient's sickness with a piercing

Aspis uocata quod morsu uenena immittat et spargat. As enim grece uenenum dñt. unde as pis quod morsu uenenato intimat. hui diuisa sĩ geña. & species dispares ad nocendũ. tert autem as pis cum cepit pati incantatore q eam qbsdam car minibz pprius euocat ut eam de cauina sua pducat cum illa exire noluerit unam aute in tram pme re. altam caudam obturare i pmere. atq; ita uoce illas magicas ñ audiens. ñ erit ad incantantem. Bi psa genus aspidis quilatine stala dr. qz quem mo morderit siti pit. Prialis geñ aspidis eo qd sonno necat. Hunc sibi cleopatra apposuit. et ita morte quasi sonno soluta ē. Emorois aspis nuncupat. eo quod sanguine suadet. Qui ab ea morsus fuit. ita dis solutis uenis qcqd uite ē. p sanguine effundit. Gre ce enim sanguis emach dr. Prester aspis semp ore patenti i uaporante currens. Cui poeta sic memi nit. oraq; distendens auid fumantia prester. Quem puslerit distendit. enormiq; corpulentia necatur. i tabefacta putredo seqt. Aspis quidem si momor derit hominem. statim eũ consumit. ita ut lique fiat totus in ore serpentis.

 Ostrich depositing its eggs in the sand

English illuminated bestiary, twelfth century. MS Bodley
602 fol.25

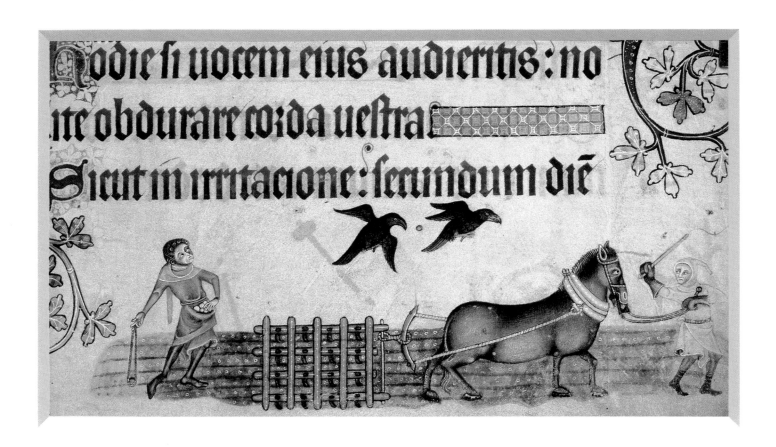

**HARROWING THE SOIL**

A labourer slings stones at crows. Illuminated margin
from the *Luttrell Psalter*. English 1335-40. Add MS 42130
fol. 171.

**ROMAN EAGLE**

This was copied in 1436 in Basle from a Carolingean copy
of a late antique manuscript.

*scripts* (1981), has identified more than eighty-three species of birds in manuscripts ranging in date from 698 to 1482. He includes both the bestiary birds and those of the early gospels, but the greatest variety of identifiable birds appeared in the English psalters of the early fourteenth century and in the French and Franco-Flemish Books of Hours of about a hundred years later.

The medieval artist worked in the tradition of copying from other manuscripts or drawings, and as a result the same birds often recur. But many of them – the peacock, jay, magpie, mallard duck, white swan and goldfinch – could also have been observed from life, for in the period when the bird illustrations in French manuscripts were at their most decorative, the nobles had large woodland estates, and many kept elaborate aviaries, regarded their pet birds and animals as valuable possessions and were passionate about falconry.

The subject of falconry is a very specialized one: an illustrated book on the art and other observations about birds was produced in the early thirteenth century. This was called *De Arte Venandi cum Avibus (Concerning the Art of Hunting with Birds)* and was compiled by Frederick II of Hohenstaufen (1194–1250), Holy Roman Emperor and King of Sicily and Jerusalem. His own manuscript was lost in battle, but his son prepared a copy from original notes, and this is now in the Vatican Museum.

Of the small birds, the goldfinch was the favourite for use as a decorative detail in the margins of manuscripts. This was partly because of its distinctive markings of red, black and gold, bright colours which were easily available to the limner, and showed up well against the green foliage. It was also familiar to many people as a cage bird (it is probably still trapped in Europe, though protected in England) and this made it easily recognizable.

The goldfinch was frequently depicted in Renaissance paintings of the Holy Family as a symbol of the Crucifixion; according to legend the bird, seeing Christ on the cross, flew down to console him and wounded itself on a thorn in his crown. Consequently, the red on the goldfinch's head symbolized compassion, and the bird's partiality for thorns and thistle seeds was a further sign of its association with Christ's suffering. In hundreds of paintings of the Madonna and Child, the infant Jesus clasps a goldfinch, or is shown one held by an angel, a poignant indication of the Agony on the Cross.

The bullfinch, also kept as a cage bird, appears in manuscript decoration, the cock being identifiable by its distinctive red-pink breast and black head. Less frequent was the chaffinch, now the commonest finch in England, perhaps because its colours are less showy and its distribution less widespread. Many other countryside birds still well known today are listed in Yapp's survey, among them the blue tit, kingfisher, green woodpecker, wren, crow, jackdaw, the woodcock and snipe, the pied wagtail and the swallow. The unique bill of the spoonbill can be seen in several manuscripts, and also in a misericord carving in Lavenham Church, Suffolk. Now rare in England, the spoonbill formerly nested in Norfolk and the east coast, but now its only regular breeding place in western Europe is the Netherlands.

The robin features in some manuscripts, but did not have the popularity it enjoys today; it only became linked with Christmas when the commercial Christmas card was introduced in the mid-nineteenth century. Traditionally the robin and the wren (which were thought to be related) are associated with St Stephen's Day, the day after Christmas. Groups of 'Wren Boys' dressed in costumes similar to mummers and carrying a dead wren in a holly bush attached to a be-ribboned pole would perform a ritual play and dance. It was considered bad luck to kill a robin or wren at other times of the year, but on St Stephen's Day these birds were ritually killed to commemorate the stoning of the saint, a sacrificial ceremony which probably had its origins in the pre-Christian era.

Although the sources for medieval illustration are few, one magnificent book of drawings has survived, known as the 'Pepysian Sketchbook' or 'Monk's Drawbook', and held in Magdalene College, Cambridge. It dates from about 1400, and is French or Italian in origin. On several manuscript pages naturalistic birds mingle with mythical birds and creatures, while other drawings are of human figures, draperies and animals. Their purpose is not fully known, but it may have been a student's sketchbook or a compilation of drawings to be copied in manuscripts or embroideries. The birds, although carefully drawn, are not all clearly identifiable, but there are recognizable portraits of the kingfisher, partridge, water-rail and woodpecker as well as an excellent herring-gull with the characteristic red mark on its yellow bill.

Some of the most beautifully presented birds are in the Sherborne Missal, made for the Sherborne Priory in Dorset about 1400, and in the collection of the Duke of Northumberland at Alnwick Castle. Many of these birds, surrounded by decorative flowers and cartouches, have carefully penned labels, and Yapp has found that among the 170 or so birds there are 40 identifiable species. Amongst these are the heron (heyrun), barnacle goose (bornet), gannet (ganett), cormorant (cormerant), snipe (scnite), lark (larke), linnet (linet), teal (tel) and cock and hen chaffinch (cayfynch cok and hen).

Although a portrait of John Syferwas, the chief illuminator, believed to have come from Hampshire, appears in the book, Yapp suggests that an assistant artist from the northern counties may have contributed, as many of the birds' names are in northern dialect, and the sea birds depicted are commoner in the north. The artist appears to have studied and carefully observed the birds of the seashore and the countryside from nature, and this interest in individual species heralded the new spirit of enquiry that was to come to fruition in the Renaissance.

PRESENTATION IN THE TEMPLE

Scene from a Book of Hours of 1407. MS Douce 14. fol 76v.
The birds that appear in the margins are swan, mallard,
peacock, goldfinch and heron.

A GREAT TIT, GOLDFINCH AND OWL
.........................................
These birds are charmingly rendered in the margins of a
French illuminated manuscript, the *Missal of St Denys*,
*c.*1350.

## THE PAINTED BIRD

The medieval illuminators used bright, pure pigments, and the colours – lapis lazuli blue, vermilion red and gold leaf – retain their original brilliance in books that have been protected from strong light. The colours of the wall paintings of Northern Italy are more muted, partly because they have faded with time, but also because the damp plaster ground on which the paints were applied had a mellowing effect on the pigments.

These softer colours seem particularly appropriate to the landscape backgrounds of the frescoes depicting the life of St Francis, associated with humbleness, poverty, and love of nature, particularly birds. In 1228, two years after the saint's death, foundations were laid for a church in honour of his name, and among the frescoes is the well-known *St Francis preaching to the birds* attributed to the painter Giotto (1267?–1337). Although it is but a shadow of its former self, the birds, fluttering about and forming an audience in front of the saint, have much more substance and reality than the decorative birds of the manuscripts, and the painting is still very moving and impressive.

Most of the Italian paintings of the fourteenth and fifteenth centuries were religious subjects commissioned by the Church, and as birds only feature occasionally in Bible texts, they do not play a large part. However, one bird of great significance in Bible literature was the dove, which was released by Noah from his ark after the floods subsided, and returned with an olive branch in its bill. The dove also became associated with the Holy Spirit, and appeared as a symbol of the Holy Ghost in scenes of the Annunciation and the Baptism. To represent the dove hovering in the air or flying was difficult, but there is a beautiful example in *The Baptism* by Piero della Francesca (1410?–92) where the symbolic dove is seen frontally, above the figure of Christ. Today the white dove is universally recognized as a symbol of purity and peace.

Tantalizing glimpses of beautifully painted birds can be seen in other Italian paintings, for instance a peacock with trailing train is sometimes perched on a roof or balustrade in paintings of the Nativity. Both the *Adoration of the Magi* by Sandro Botticelli (c.1446–1510) and *The Annunciation* by Carlo Crivelli (active 1457–d.1495), feature splendidly poised peacocks, which were painted for their decorative attractions and for their symbolic significance – the flesh of the peacock was said to be impervious to decay, and the presence of the bird was thus a symbol of immortality.

Birds sometimes gave a warning or foretold doom. In the *Madonna of the Meadow* by Giovanni Bellini (c.1430–1516), a black bird, either a large crow or a raven, watches down on the Mother and Child from the bare trees, and a similar bird attends the praying Christ in *The Agony in the Garden* by Andrea Mantegna (c.1431–1506). In Piero della Francesca's *The Nativity*, a lone magpie occupies a prominent position on the stable roof above the singing angels and crowd surrounding the infant Christ. This single bird must have had the same significance as the magpie of popular folklore: 'one for sorrow, two for joy.'

The goldfinch, symbol of Christ's Passion, features again and again in paintings of the Holy Family, painted in the Renaissance period with greater realism. The Christ-child in the *Madonna of the Goldfinch* by Giovanni Battista Tiepolo (1696–1770), clutches the bird in his hand, and in the *Holy Family* by a lesser-known artist, Federico Barocci (1535?–1612), St John the Baptist displays the bird in front of the younger child.

A fairly uncommon bird in Italy is the wallcreeper which, as its name suggests, creeps about on walls and rocks looking for insects in crevices. This attractive blue and black bird with crimson wings appears appropriately in the rocky desert background of a painting of *St Jerome* by Cosimo Tura (c.1431–95). The saint was said to have spent four years in this barren setting living an ascetic life as a hermit. According to the ancient Greek writer Aelian (170–235), the wallcreeper was a rock bird which hated city life and domestic dwellings, and preferred to live in grim, infertile, uninhabited areas away from mankind.

The great master Raphael (1483–1520) was primarily interested in drawing the human body and arranging groups of figures in large and ambitious compositions. He allocated the work of painting landscape or animals to assistants who specialized in these areas, and the birds in *The Miraculous Draught of Fishes*, one of the cartoons (working drawings) for a set of tapestries commissioned by Pope Leo X for the Sistine Chapel in 1515, are probably the work of his young assistant Giovanni da Udine (1487–1564). The cartoons are now in the Royal Collection, but are housed in the Victoria and Albert Museum, London.

Prominent in the foreground are almost life-size cranes, which form an important element in Raphael's composition. They seem almost to leap forward to point out the three fishermen in the boat, and echo the shapes of the men's brawny arms and billowing drapery. Da Udine has captured the characteristic traits of the crane, their peculiar stance, and their habit of walking stiffly and stretching excitedly forward with wings half spread.

The common crane, recognizable by its red crown, once inhabited the marshy areas of Italy, but today its numbers are very restricted. Their presence in the picture may also have been symbolic, as cranes were traditionally known as guardian birds and emblems of vigilance. In the background is a flock of flying ravens, diminishing in size as they turn away across the water. These birds too are valuable to the composition, giving a feeling of depth to the picture. They may also have had a symbolic meaning, recalling the raven that failed to return to Noah's ark, representing sin and deceit.

Later Renaissance art, particularly that of the Venetian school, reached extravagant heights in its wealth of rich and finely observed detail. The painting by Jacobo Bassano

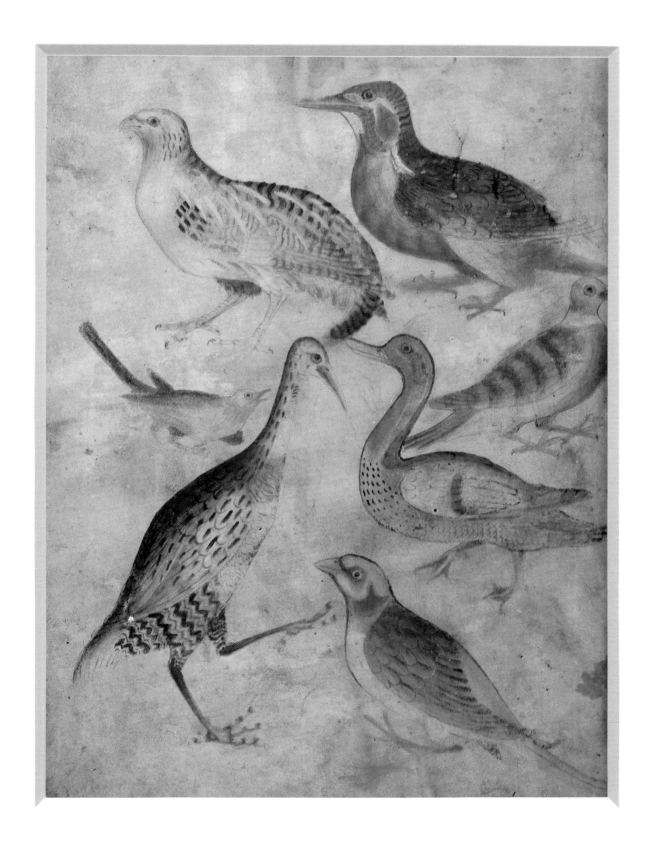

A PAGE FROM THE PEPYSIAN SKETCHBOOK OR MONK'S
DRAWBOOK
..................................
French or Italian, *c.* 1400. From top left to right; partridge,
kingfisher, possible blackbird, pigeon, duck, a sprightly
water rail, and a house sparrow.

29

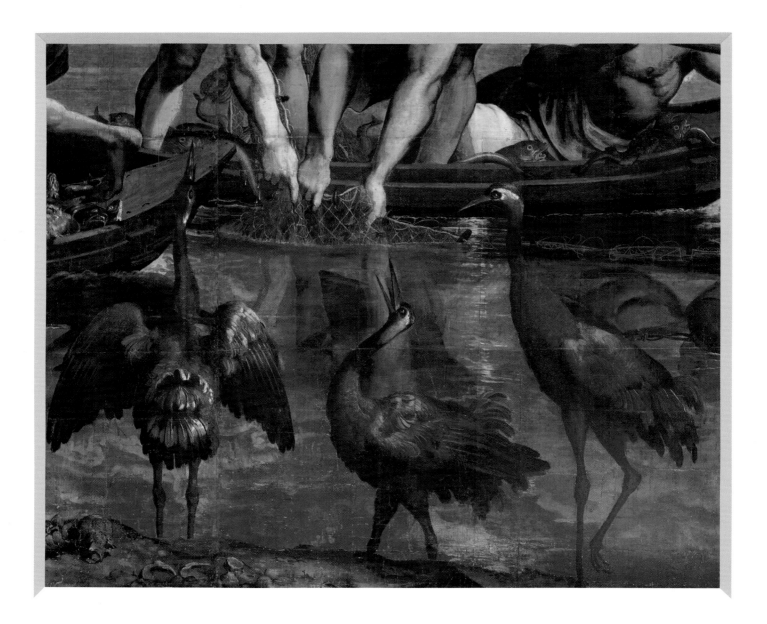

CRANES BY THE LAKESIDE
.....................................
Detail from Raphael's *Miraculous Draught of Fishes*, one
of a set of cartoons for tapestries commissioned for the
Sistine Chapel in 1515–16. The birds were probably the
work of Raphael's assistant Giovanni da Udine.

TOUCAN

Woodcut from Conrad Gesner's *Historica Animalium*, 1555, Zurich.

(active *c.*1535–92) of *The Animals going into the Ark* has a profusion of birds (all in pairs) too numerous to list. This was followed by many pictures of the Flemish school, and paintings by Jan Brueghel (1568–1625) and Roelandt Savery (1576–1639) show Adam and Eve surrounded by birds and animals in a make-believe environment of perfect harmony.

## THE PRINTED BOOK

The invention of moveable metal type by Johann Gutenberg (*c.*1398–1468) in Germany, followed by the introduction of printing, caused a revolution in communication of knowledge in Europe. Printing from metal-cast letters took over from the slow process of fine penmanship – hundreds of books could be printed in the same time that it took a scribe to make a single volume.

Magnificent bibles were the first products of the new technology. The traditional format of the written manuscript books was retained, and the new bibles were printed on vellum in double columns, with type imitating the splendid black and red Gothic letters of the scribes. Spaces were left in the margins and around the capital letters for decoration to be illuminated by hand. About 200 copies were made of the first *Gutenberg Bible*, known as the '42-line bible', and printed at Mainz in 1453–55. The copy in the British Museum, London, has some exquisite hand-painted borders with tiny bright birds: the hoopoe, gold-finch, green woodpecker and parrot perched amongst a scrollwork of stems and flowers.

The art of printing spread with remarkable speed beyond the borders of Germany, and by the year 1500 there were presses in almost every country in Europe, from Spain to Sweden. Letter-press printing was introduced into England at Westminster in 1476. The illustrations that accompanied the text were made by printing from woodcuts, at first separately, but later the blocks of wood were cut at the same height as the type to allow text and pictures to be run through the press together.

The rigidity of the woodblock technique imposed considerable limitations on the work of the illustrators of these early printed books. Sharp knives and gouges were used to cut clean, clear grooves and channels in the plank side of the block, and the parts of the wood that remained were coated in ink or pigments with pads or rollers. Paper was then laid on the block and pressure was applied by a means of a press to make prints in relief. Fine or flowing lines were difficult to achieve, and the first woodcut pictures were often crude and clumsy. The earliest-known printed book to contain woodcut animal illustrations was Konrad von Magenberg's *Das Buch der Natur*, published

CURLEW
..............................
A characteristically bold woodcut from Conrad Gesner's
*Historica Animalium*.

in Augsburg in 1475, with one page depicting birds. Inevitably at this early stage the animals seem awkwardly drawn and show less sophistication of draughtsmanship than the skilled work of the illuminators.

Flowers were depicted more successfully than animals, and some herbals of the sixteenth century have delightful illustrations showing a considerable degree of exactitude and realism. Flowers were, of course, easier and more accessible subjects than specimens of birds and animals, and as plants were frequently used for pharmaceutical purposes as well as for food, accurate illustrations in botanical books were of vital importance.

The inquiring spirit of the Renaissance was a stimulus to the study of science, anatomy and medicine, and in the second half of the sixteenth century three scholars, Conrad Gesner from Zurich, Ulisse Aldrovandi from Bologna and

the Frenchman Pierre Belon published a trio of great illustrated books about many aspects of birds and other zoological subjects. The foremost of these scholars was Conrad Gesner (1515–65), whose *Historica Animalium* was published between 1551 and 1558. The third volume contained 222 woodcuts devoted to birds. He was the first person to write a comprehensive account of all the known animals with references to Classical sources, medieval authors and contemporary records.

Gesner studied the classics, science and medicine in France and Switzerland, and was appointed Professor of Philosophy and Medicine at his native city in 1541. One of the most comprehensive scholars of his age, he was also a pioneer in bibliography and comparative linguistics, and is said to have written the Lord's Prayer in twenty-two languages. He had a wide correspondence with scientific scholars throughout Europe, including Dr William Turner (1508–68), sometime Dean of Wells Cathedral in England. Turner, a reformist, was often in trouble with the established church, and after an imprisonment in about 1540

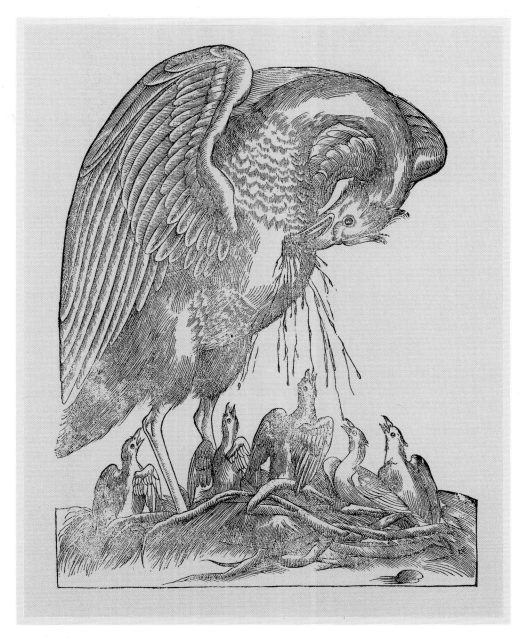

THE PELICAN IN ITS PIETY

A favourite medieval subject symbolizing self-sacrifice.
Woodcut from Ulisse Aldrovandi's *Ornithologiae,*
1559–1603.

travelled on the Continent. He was the first British author to publish a list and describe English birds in an unillustrated Latin book, *Avium Praecipuarum*, printed in Cologne in 1544.

The Latin text of Gesner's book was accompanied by bold woodcuts, and the best artists were employed to make good-quality illustrations. These, by Lukas Schan of Strasbourg, Jean Asper, Jean Thomas and other artists, were strong and forceful images; some pictures were taken from previous sources including Albrecht Dürer's woodcut of a rhinoceros dated 1515, while others were cut especially for the book. The pictures were immensely popular; a pictorial volume was made with brief captions, and copies of the illustrations appeared frequently in other books.

The portrait of the toucan is particularly striking, with the thick outlines of the woodcut emphasizing its shape and extra-large bill. (Although a toucan's beak appears disproportionate in relation to its body, it is not as cumbersome as it looks, as it is made of a lightweight honey-comb of fibres inside a horny sheath.) Descriptions and probably skins of the toucan which lives in the South American tropical forests, were brought back by European explorers in the early sixteenth century.

Pierre Belon (1517–64), Gesner's almost exact contemporary, wrote the first monograph devoted entirely to birds, *L'Histoire de la nature des oyseaux*, in 1555. A few years earlier he had written both the first treatise on fishes and that on a single group of plants, the conifer trees. The bird monograph has 144 woodcuts based on specimens Belon acquired from visits to markets throughout Europe. He was a pioneer in the study of comparative anatomy, and the book includes parallel diagrams of human and bird skeletons, with annotations pointing out their differences and similarities.

BARNACLE GEESE IN SHELLS

The strange myth that the barnacle goose hatched from
shells was widely accepted as true in the Middle Ages.
Woodcut from Aldrovandi's *Ornithologiae*.

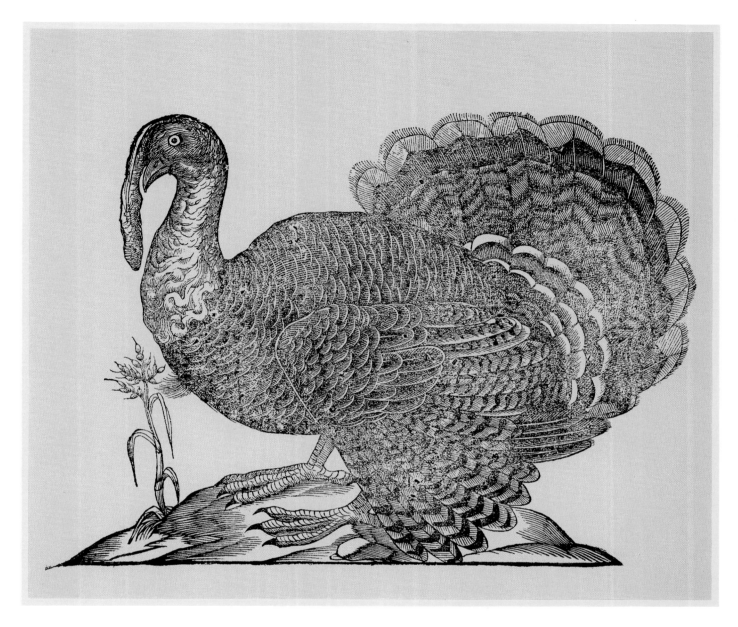

Woodcut from Aldrovandi's *Ornithologiae*, Turkeys were introduced to Europe from Mexico in the early sixteenth century.

After a three-year journey to the Near East, Belon wrote a further book *Pourtraicts d'oyseaux, animaux, . . . d'Arabie, et d'Egypte* (1557), with 174 woodcuts of birds. Many of these were from his own drawings, and each had an appropriate verse. The white stork is accompanied by a poem based on the legend of the bird's consideration for its elderly parents, and describing its exemplary behaviour in feeding and caring for its mother and father throughout their old age.

Like Gesner, Belon achieved a remarkable amount in a short time. They both died prematurely in their late forties, Gesner died of overwork during an outbreak of the plague in Zurich, and Belon murdered by robbers in the Bois de Boulogne near Paris.

Ulisse Aldrovandi of Bologna (1522–1605), the longest-living of the three, also had wide-ranging interests – medicine, philosophy, the classics, pharmacy and botany. His encyclopedia of natural history was completed by pupils after his death, but three volumes of birds, *Ornithologiae hoc est de avibus historiae* with 685 illustrations, were published during his lifetime (1599–1603).

Aldrovandi was more credulous than his two predecessors. He included mythical birds in his books, and drew on fables and Classical legends as well as the books of Gesner and Belon. The story of The Pelican in her Piety was a favourite medieval subject that appears over and over again in woodcarving, sculpture, pottery and heraldry, as well as in the bestiaries. According to the legend, the pelican was excessively devoted to its children. As the young began to grow up, they became obstreperous and flapped their parents in the face with their wings. Striking back, the parents accidentally killed them, but three days later the mother pierced her breast, opened her side, and poured out her blood, which revived the children and brought them to life. The self-sacrifice of the pelican in this strange story was adopted by the Church as a symbol of charity, piety and the Redemption.

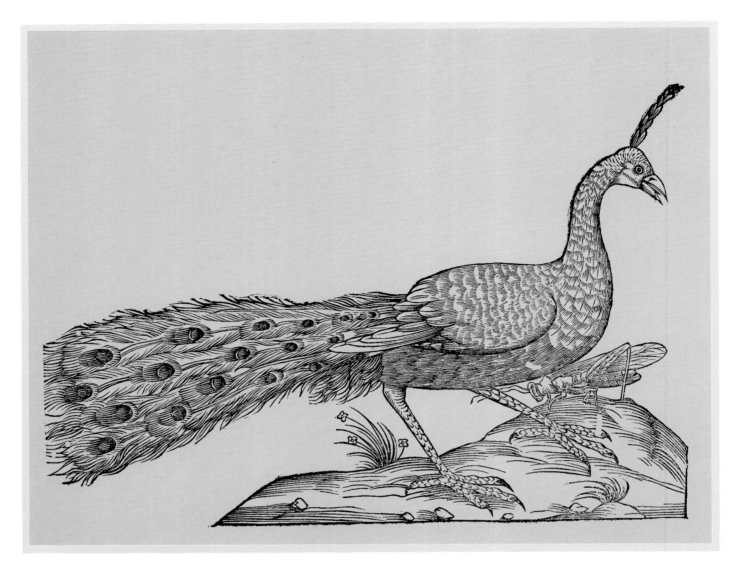

PEACOCK WITH LOCUST

Woodcut from Aldrovandi's *Ornithologiae*. The flesh of
the peacock was believed to be impervious to decay.

The fable may have had a factual foundation, as the pelican feeds its young by regurgitating half-digested fish, and the hungry chicks almost disappear inside their parent's enormous pouch in their effort to reach the food. Preening is also a necessary activity, as the pelican has to keep its feathers in good waterproofed condition and coated with oil from a special gland. The sight of the bird preening its front with its large beak could have given the impression that it was plucking at its feathers and drawing blood from its breast.

An even stranger story current in the Middle Ages was that the barnacle goose hatched from barnacle shells. Aldrovandi had some doubts about this myth, but in deference to the judgment of so many other authorities, thought it might be authentic. An account had been given in 1187 by Giraldus Cambrensis in his *Topographia Hiberniae*. On a journey to Ireland he had seen thousands of tiny embryo 'barnacle' birds by the sea-shore hanging down from a piece of timber, and claimed that the Irish believed them

to develop from gummy excrescences enclosed in shells. They were nourished by the juices of the wood in sea water, and when their feathers grew, they fell out into the water or flew away.

This description was further elaborated to grow into the idea that the geese sprang from shells which clung to waterside trees, a story actively promoted by the Church, which claimed that the geese thus generated were not truly flesh and could be eaten in Lent and Fast days. An explanation for the long survival of this fantasy is that Europeans at this time had little knowledge of migration; it was not known that certain species of geese bred in the northern Arctic regions and were thus absent from the fields of southern Europe during the summer. The annual arrival of barnacle geese, flying inland over the water in autumn, must have been very perplexing.

Aldrovandi's knowledge did not stem entirely from the past, for he amassed his own great natural history collection of skins and paintings. The Latin text in his books was aptly illustrated with bold woodcuts made by accomplished artists, and the pictures of the turkey, peacock, owl, and the ruff in its display plumage, with their strong contours and broad handling, are examples of the woodcut process at its best.

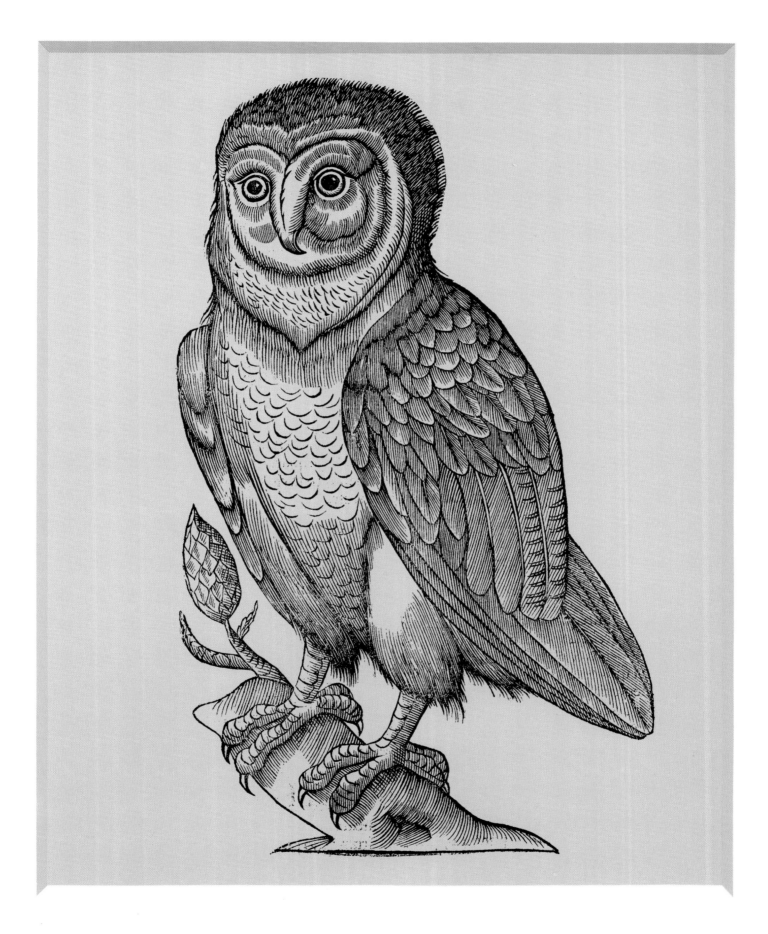

OWL, PROBABLY A BARN OWL

Woodcut from Aldrovandi's *Ornithologiae*. Owls have
been regarded as both symbols of good and omens of evil.

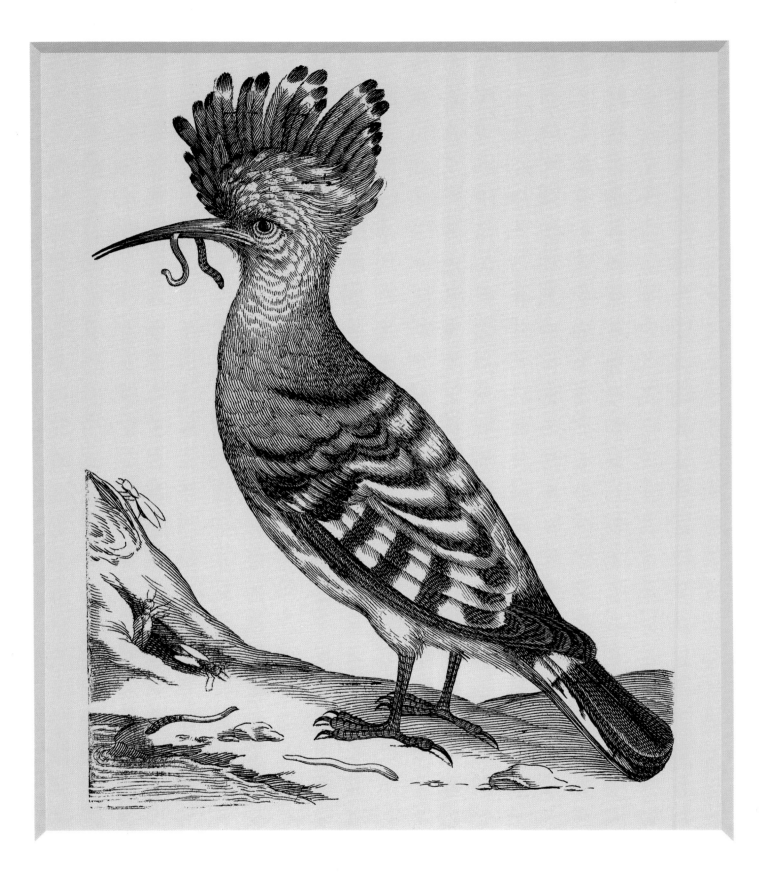

HOOPOE

Engraving from G. P. Olina's *Uccelliera*. 1662, Rome.

RUFF
.....................................
Woodcut from Aldrovandi's *Ornithologiae.* The male in
display breeding plumage showing its characteristic ruff.

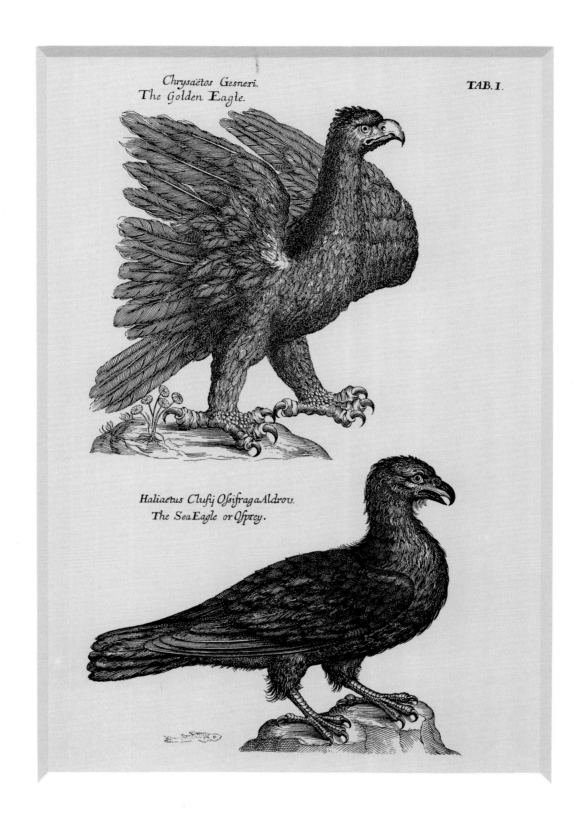

**GOLDEN EAGLE AND SEA EAGLE**

Engraving in Ray and Willughby's *Ornithologiae libri tres*,
1676. A similar picture of the golden eagle appeared in
both Gesner's and Aldrovandi's books.

# Engravings and Paintings:
## from 1660 to 1800

'THE FOUNDATION OF SCIENTIFIC ORNITHOLOGY was laid by the joint labours of Francis Willughby and John Ray.' So wrote Alfred Newton, Victorian ornithologist and Professor of Zoology at Cambridge, in the introduction to his *Dictionary of Birds* (1893–6). Ray and Willughby's *Ornithologia libri tres* (1676) was an illustrated treatise on birds designed to replace the strange mixture of fact, fable and fantasy of previous zoological literature. Its two authors, close friends and colleagues, were devoted to the pursuit of natural history knowledge, and together they worked out a scheme of pre-Linnean botanical and zoological classification in advance of any previous system.

### JOHN RAY AND FRANCIS WILLUGHBY

They originated from very different backgrounds. Ray (1627–1705) was the son of a blacksmith and was born in the Essex village of Black Notley. Educated in classics at Braintree Grammar School, he entered Cambridge University at sixteen, intending to follow a career in the Church. He took an MA degree, was ordained, lectured in Greek and mathematics and became junior dean of Trinity College, Cambridge. His first publication in natural history was a catalogue of plants in the neighbourhood of Cambridge, some of which he grew in a private garden at his college. Here he met Willughby (1635–72), eight years his junior, who came from an aristocratic family, with estates in Warwickshire and Nottinghamshire. The family seat, Wollaton Hall, now belongs to the City of Nottingham, and the great hall houses their natural history collection of stuffed animals and birds.

After the Restoration of the monarchy in 1660, Ray refused to sign the new religious acts, resigned from his Fellowship at Trinity, and was forced to abandon his practice as a clergyman. He now depended on the patronage of his friend for his livelihood, and together they went on several botanical field trips in England, observing and collecting data for a treatise on the natural history world.

The foundation of the Royal Society in 1660 for the promotion of scientific knowledge, and the granting of its Charter by Charles II in 1662 were indications that experiment and direct observation had taken over from learning acquired solely from books. Willughby and Ray were both Fellows, and other early members were Robert Boyle, a chemist and physicist, the diarists John Evelyn and Samuel Pepys, and the architect, mathematician and astronomer Sir Christopher Wren. Evelyn was primarily an authority on trees and gardens, but he was also curious about ornithology, and in 1665 paid a visit to London's St James' Park to examine the throat of a pelican, a present to Charles II from Russia. He described it as 'a fowle between a Stork and Swan, – a melancholy Water foule; brought from Astracan by the Russian Ambassador'. The pelicans were amongst many other water birds, including a voracious 'penguin of America' (probably an auk), collected by the enthusiastic monarch for the royal bird sanctuary, which still exists today.

Starting in 1663, Willughby and Ray travelled for three years throughout Europe, Willughby promoting his research in zoology and Ray his interests in botany. At Bologna they marvelled at the great natural history collection of Ulisse Aldrovandi, and at Strasbourg they bought a beautiful series of watercolours, dating from 1653, from a naturalist named Leonhard Baldner. These were exquisite studies of waterbirds, animals and insects by a local artist, with decorative calligraphic captions in black ink and gold leaf in the tradition of the illuminated manuscripts. Baldner lived at the junction of three rivers, and had observed and collected specimens of the avocet, bittern, shoveller, wagtails and grebe.

Sadly, Willughby died a few years after their tour, at the early age of thirty-seven, and his bird researches were left unfinished. He bequeathed a generous annuity to Ray, who was diligent in completing his patron's work, and in 1676 the *Ornithologia libri tres* was published, followed by an English edition two years later.

The seventy-seven illustrations commissioned by Emma Willughby, Francis's widow, were made by the foremost engravers of the day, William Faithorne, William Sherwin, and Frederick van Hove, a Dutch immigrant from The Hague. By the late seventeenth century, metal engraving had taken over from the woodcut, enabling a finer line with more detail. A sharp burin, or graver, was used to cut incised lines into a metal plate usually made of copper, the softest metal and the easiest to cut. Curved lines could be achieved by holding the burin still and turning the plate itself. Ink was rolled and dabbed into the incised design, and the excess wiped off the surface with rags.

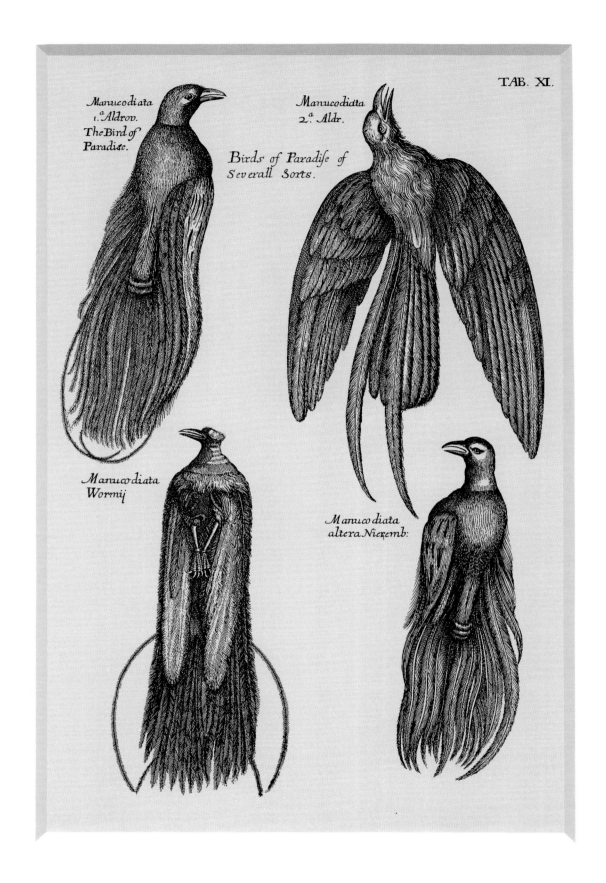

TAB. XI.

*Manucodiata 1.ª Aldrov. The Bird of Paradise.*

*Manucodiata 2.ª Aldr.*

Birds of Paradise of Severall Sorts.

*Manucodiata Wormij*

*Manucodiata altera Nieremb:*

**BIRDS OF PARADISE**

Engraving from Ray and Willughby's *Ornithologiae libri tres.* Skins were imported to Europe by the East India Companies from New Guinea. The birds were thought to live entirely in the air and to rest by hanging from trees by their wiry tail-feathers.

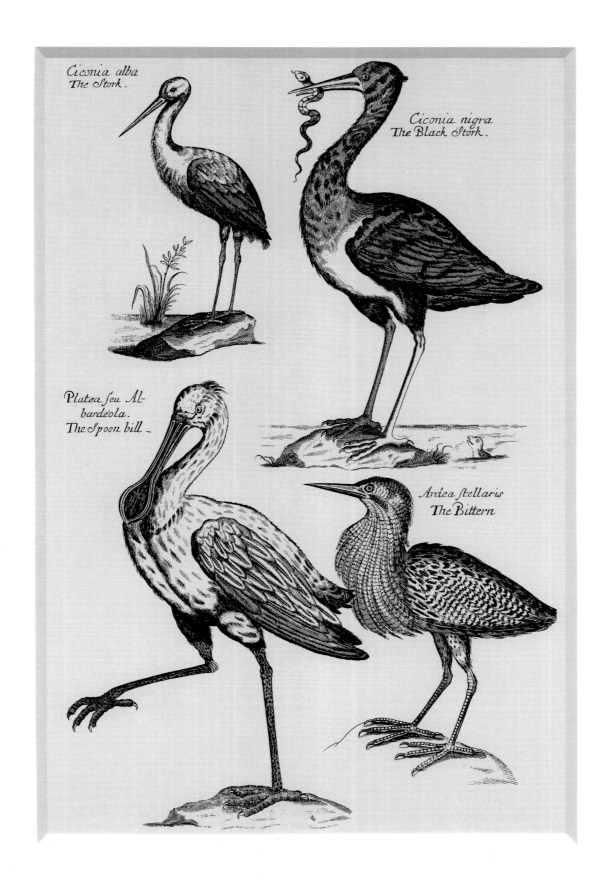

STORK, BLACK STORK, SPOONBILL AND BITTERN

Four fenland birds engraved in Ray and Willughby's
*Ornithologiae.*

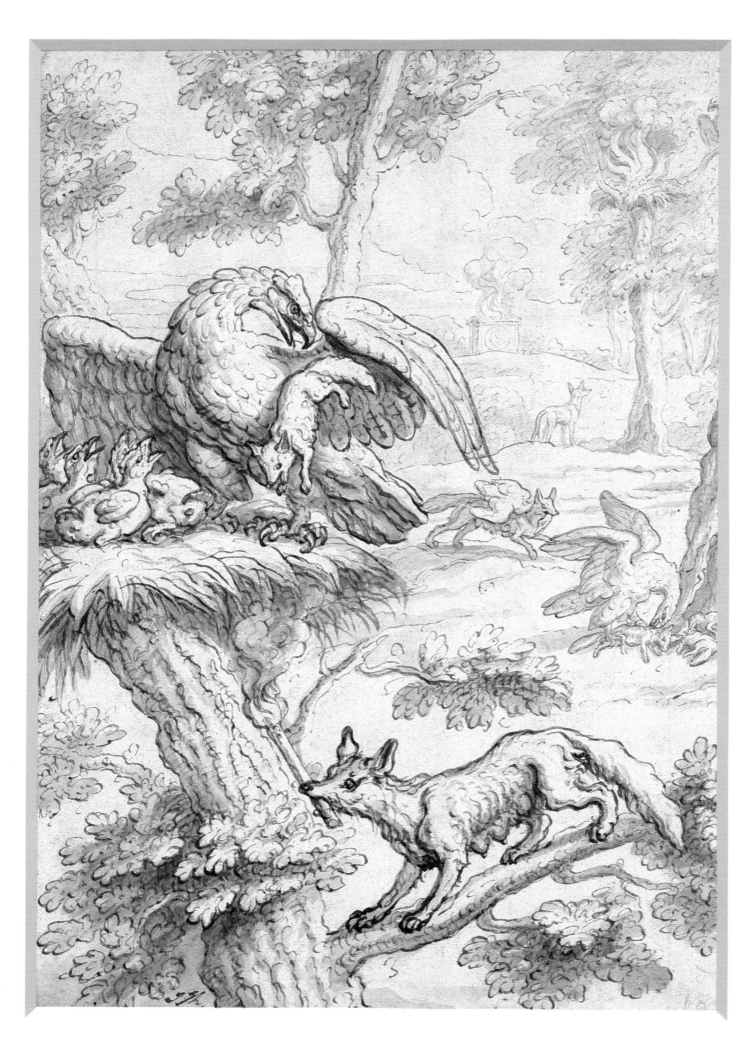

Damp paper was then laid on the plate and strong pressure applied by means of a printing press, forcing the ink out of the fine lines and transferring the image onto the paper.

In spite of the new techniques, the bird illustrations in Willughby and Ray's book were often stiff and inaccurate, and Ray expressed his dissatisfaction with them in his preface. He complained that due to distance he had not been able to supervise the engravers fully, so that they had misunderstood his ornithological instructions.

William Faithorne (*c.*1616–91) (who combined engraving with a print-selling business) was an expert craftsman, and had written his own book on technique, *The Art of Graveing and Etching* (1662), but the majority of his engravings were reproductive, and his engraved figures copied from such artists as Dobson, Lely and Van Dyck. Although very accomplished, they were dull compared to the original paintings.

In the *Ornithologia*, the smaller birds were cramped together six or seven to a page, and depicted generally in profile, placed on little mounds, rocks or sawn-off branches – a formula for bird illustration which persisted for over a hundred years. The larger, more distinctive birds – the black stork, spoonbill and bittern – were more vigorous pictures. The two last-named were then familiar in the English fenlands, but later, when the great drainage schemes of the seventeenth century were introduced, their numbers became dramatically decreased.

During their natural history expeditions Willughby and Ray had made many outdoor field notes, but some plates in the *Ornithologia* were based on birds known in England only as specimens. The picture of the birds of paradise, for instance, was drawn from the skins brought to Europe by traders of the Dutch East India Company and explorers from New Guinea and Asia. In order to facilitate packing, these skins had been prepared in the traditional manner of the New Guineans, with the legs and sometimes the wings removed. The arrival of these footless birds gave rise to the quaint but understandable belief that the birds floated endlessly in the heavens, unable to rest, feeding, sleeping and even breeding in the air.

## FRANCIS BARLOW

Ray's ambition was that the *Ornithologia* should be an accurately illustrated and descriptive book of bird species, and in this it was a forerunner of the identification guide book so essential to the birdwatcher today. Of a very different character were the livelier pictures of his contemporary Francis Barlow (*c.*1626–1704), whose birds and animals were depicted in the breezy atmosphere of the English countryside.

Barlow's background is obscure, his birth in Lincolnshire being only tentatively dated *c.*1626. Although he lived in London he painted the English rural scene with great gusto, and was described in John Evelyn's diary as 'ye famous painter of fowls, birds and beasts'. While best known in his lifetime as a painter, Barlow's books of animal prints have survived in greater quantity than his paintings. The method of illustration he used was etching, a variation on engraving which became popular because of its versatility and fine, strong line. Etchers used a sharp-pointed metal pencil or etching needle, which scratched rather than cut into the metal – an easier tool to manipulate than the engraver's burin. A copper or zinc metal plate was coated with an acid-resistant mixture of waxes, resin and gum. The design was drawn into the wax covering, and the plate was then dipped briefly into an acid bath so that the acid bit into the exposed lines (the word etching comes from the Dutch word *etsen* meaning 'to eat', which refers to this process). The wax was removed, ink was rolled into the grooves, and the plate was wiped with a stiff cloth before being printed through a press.

Barlow etched many of his own plates, but he also had etchings made from his drawings by Francis Place, Wenceslaus Hollar, Pierce Tempest, E. Cooper and others. His best-known etchings were for a new translation of *Aesop's Fables*, published in 1666 and followed by many later editions. The fables were popular texts whose moral instruction could be understood by both children and adults, and Barlow's lively and vivacious pictures complemented them beautifully, his animals and birds playing an animated role in conveying the meaning of the stories. A pen and wash drawing in the Ashmolean Museum, a study for the story of the Fox and the Eagle, illustrates a characteristic 'tit-for-tat' plot. It shows a vixen holding a flaming torch to the eagle's nest and frightening the bird into dropping the fox cub which she was about to feed to her young; in the background a second eagle attacks the remaining cubs in their lair.

One of Barlow's earlier works was *Birds and Fowles of Various Species* (1658), published by the same William Faithorne who had worked on Willughby and Ray's book. The birds were described by Barlow as 'Drawn after Life in their Natural Attitudes', and one of the scenes in the book is 'the Mobbing of the Owl' a subject which recurs in medieval manuscripts and woodcarvings. Sometimes the owl was shown to be a decoy, a model placed to lure other birds, but the original idea for the theme must have come from nature itself. There is a painting by Barlow of this subject (which may have had a political significance at the time) at Ham House, Richmond, Surrey, positioned high up over a doorway. The owl can be dimly perceived

THE FOX AND THE EAGLE

Pen and wash drawing by Francis Barlow for an illustration to *Aesop's Fables*, 1666.

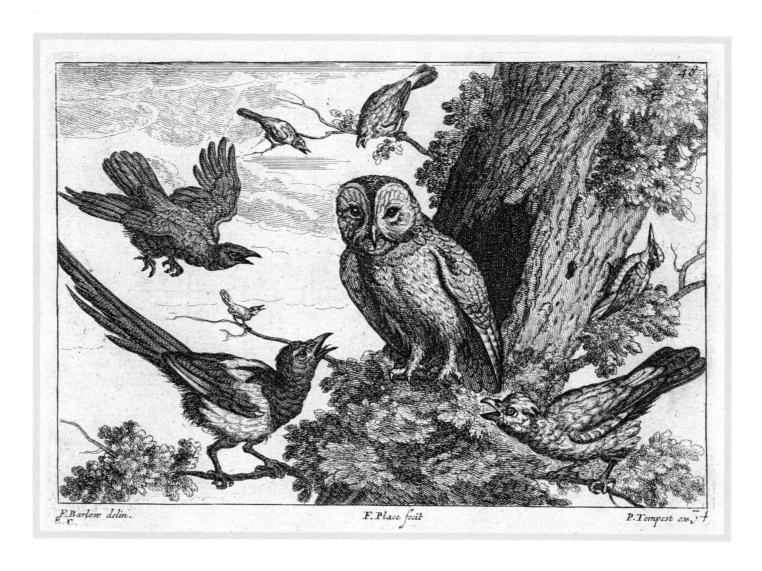

F.Barlow delin.
g. C.

F. Place fecit

P.Tempest exc.

### THE MOBBING OF AN OWL
..............................................

Etching from Francis Barlow's *Birds and Fowles of
Various Species*, 1665. The owl is being attacked by the jay,
magpie, crow, woodpecker and small birds. This mobbing
is a real occurrence, and the subject became popular from
medieval times as it symbolized a sinner under attack
from the righteous.

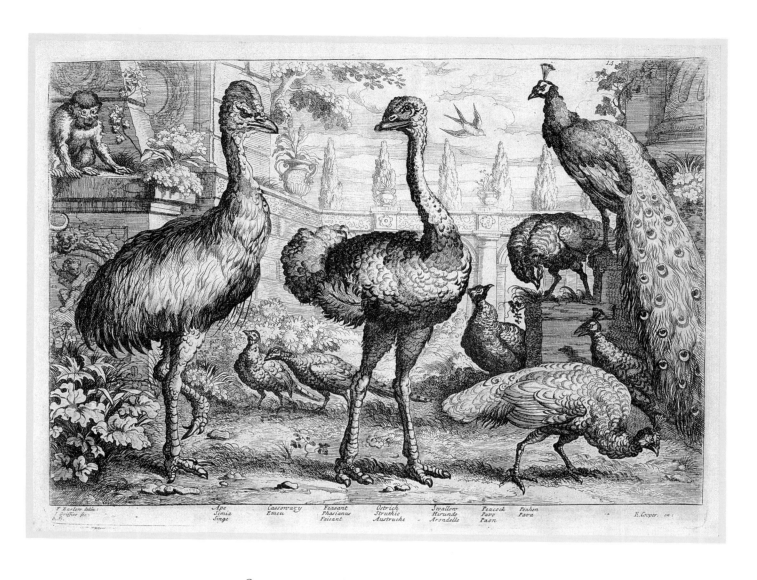

CASSOWARY, PHEASANT, OSTRICH, PEACOCK, PEAHEN,
SWALLOW AND APE

Etching from Barlow's *Birds and Fowles*, 1665.
Cassowaries from the East Indies were kept in the Royal
Aviary in St James's Park, London.

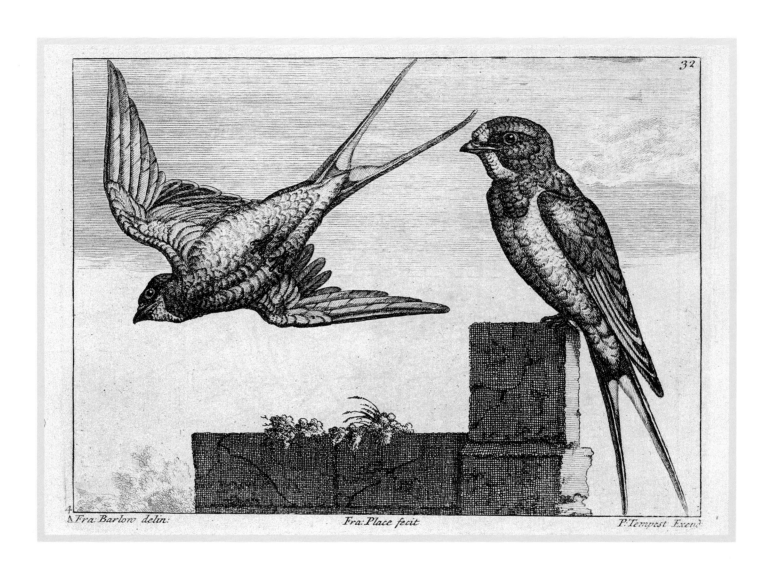

SWALLOWS

Etching from Francis Barlow's *Birds and Fowles*.

FARMYARD SCENE

Etching showing a turkey, cock, magpie, dove and
sparrows, from *Barlow's Birds and Beasts in Sixty-Seven
Excellent and Useful Prints*, 1775, first edition 1655.

looking down and is surrounded by angry jays, a magpie, a woodpecker, a great tit, swallows and various other birds.

Another subject painted by Barlow and etched by E. Cooper was a group of birds – a cassowary, an ostrich, a peacock and four peahens, a cock and hen pheasant and a pair of swallows – and a monkey, all in the setting of a formal country house garden with Classical architecture and picturesque ruins. In the British Museum there is a pen and ink drawing, indented so that the lines could be transferred to an etching plate, and in an oil painting of the same subject, called *The Cassowary and various birds*, the exotic creatures parade like courtiers in the park at Versailles, gazed at by the ape, crouched on a monument. The monkey, a symbol of man's conceit and folly, may have represented an ironic comment on the luxuriousness of the Restoration court at the time.

Barlow may have drawn the cassowary from life at the royal menageries, as the creatures had arrived in England, imported from New Guinea via the Dutch and English East India Companies. In the background of the picture are swallows, which symbolized the transience of time – although migration was still not fully understood, it was realized that swallows disappear from the skies in winter. They appear in the distance in many of Barlow's pictures, and there is an etching of swallows alone in *Birds and Fowles of Various Species*.

Farmyard creatures were also among his favourite subjects: in scenes packed with lively incident, turkeys strut, cocks and hens seem to crow and cluck, and ducks waddle. Domesticated turkeys were known in England after about the 1540s when the Spaniards had brought them to Europe from Mexico.

Barlow is also remembered for his sporting prints of hunting, hawking and fishing. Another book of sport – of a kind – was *Uccelliera, overa della natura* by the Italian Giovanni Pietro Olina. This book, first published in 1622, with sixty-six engravings by Francesco Villamena from drawings by Antonio Tempesta, is not for the squeamish or for those sensitive to the interests of birds, as it describes devious means of trapping, hunting and catching birds for cooking. However, various species of birds are also illustrated individually, and the picture of the hoopoe is a good example of an engraving done before the fashion for coloured pictures set in during the following century.

## DECORATIVE BIRD PAINTINGS

Charles II had spent part of his exile in Holland, and during his reign and that of the Dutch William III, who ruled England from 1689 with his wife Mary, Dutch art was greatly admired in England. A specialized field was flower

### POULTRY

Oil painting by Melchior de Hondecoeter. The birds are peacock, cock, hen and chicks, chaffinch and goldfinch.

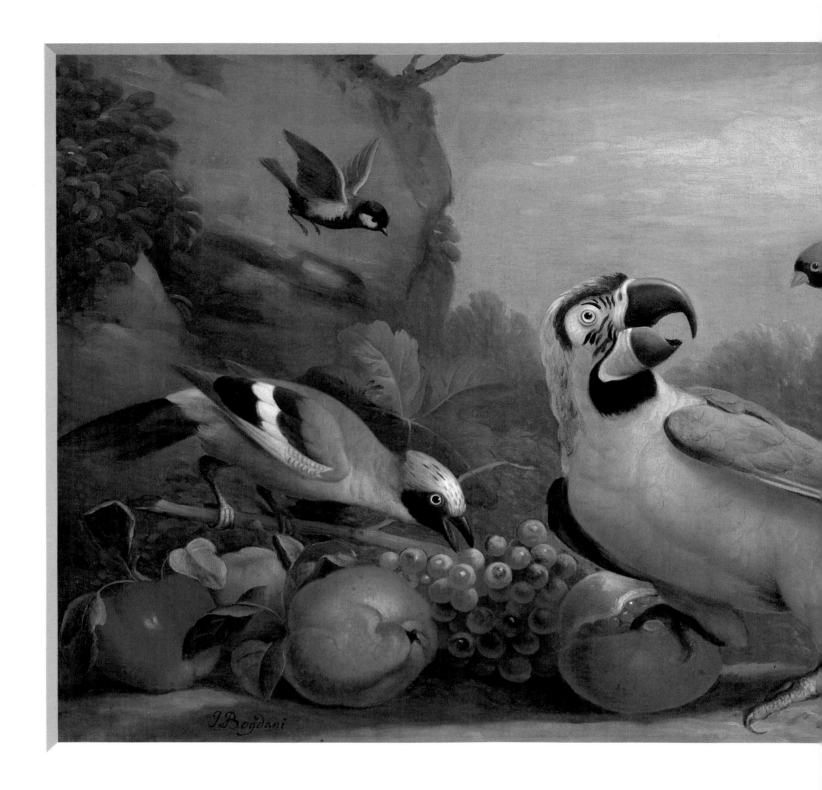

A BLUE AND YELLOW MACAW WITH A JAY, HOOPOE AND
STILL LIFE OF FRUIT

Oil painting by Jacob Bogdani. Also present are a great tit,
cardinal, thrush and green woodpecker. The American
red cardinal, the 'Virginian Nightingale', was kept in
captivity in England.

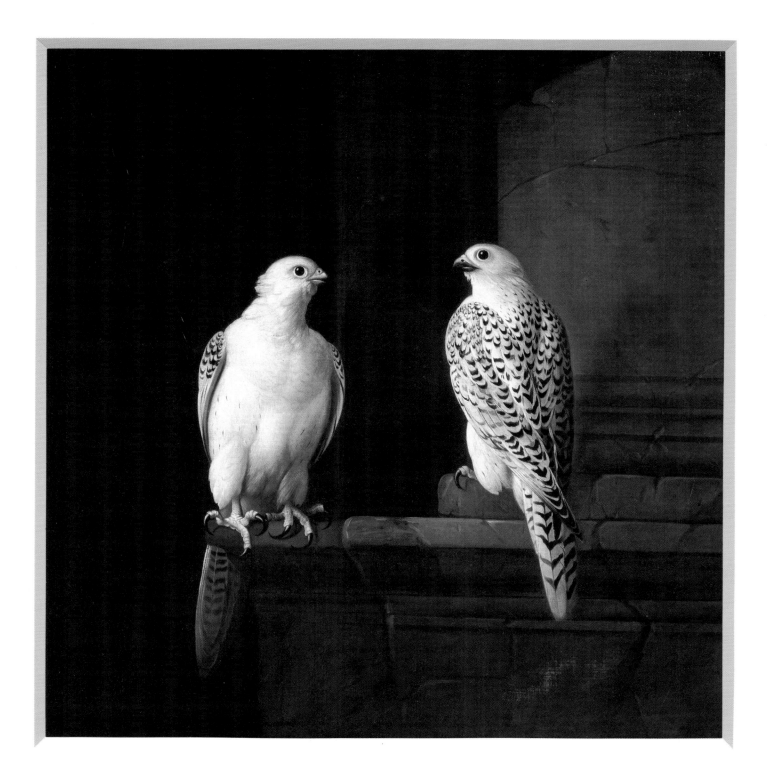

TWO ICELANDIC FALCONS

Oil painting of gyrfalcon signed by Jacob Bogdani.

painting, and elaborate virtuoso flower pictures became popular as decorative pieces on walls and inset over doors and mantelpieces. Some painters of floral subjects included birds as lively additions to their compositions, and sometimes a bright macaw or peacock would be posed on a urn beside a bouquet of English flowers.

The Flemish artist Peter Casteels (1684–1749), who was resident in England for forty years, painted many flower compositions, and also arrangements of aviary birds: white pheasant, peacock and doves placed in the settings of stately home gardens. He also painted countryside birds, and in *The Fable of a Raven* (dated 1719), similar to Barlow's 'Mobbing of the Owl', the raven is surrounded by a kingfisher, woodpecker, jay, bullfinch, swallow, snipe and grouse.

The paintings by the Dutch artist Melchior de Hondecoeter (1636–1695), are less fanciful and more robust. Hondecoeter planned his compositions in the manner of the Baroque painters, with large figures, striking gestures and Classical architectural backgrounds. The birds have well-rounded shapes, and recline, strut or pose in a grand manner. They seem to be noisy creatures, and often have their beaks open ready to quack, squawk or cluck at each other. When they take to the air they appear almost too heavy to fly, rather resembling the chubby floating *putti* (cherubs) on Baroque painted ceilings. Hondecoeter's birds are always alert and can look menacing, but are painted with great vitality and in rich strong colours.

Hondecoeter's counterpart in England was Jacob Bogdani (c. 1660–1724), who came to England via Amsterdam in 1688. Recent biographies of seventeenth-century decorative bird artists are scarce, but Bogdani's paintings and life are being researched by Dr Miklos Rajnai, who wrote a fascinating introduction to a catalogue of Bogdani's work exhibited at the Richard Green Gallery, London, in 1989. Many of his bird paintings are in the Royal Collection. Some were painted for Hampton Court palace and inserted into the wood panelling, while others were inspired in Queen Anne's reign by a lodge near an aviary at Windsor Great Park.

His career began as a painter of elaborate displays of flowers and fruit, but some time after his arrival in England he made a transition to painting groups of colourful birds in parkland settings. His assemblies are often of incongruous species which would not be seen together in nature, and are chosen without regard to place or season. Just as some Dutch flower painters arranged bouquets of seasonally incompatible flowers, Bogdani's exotic macaws and cockatoos mingle with native English species such as lapwings, ruffs, jays and bullfinches. The scale of the birds is also haphazard, with birds placed prominently in the foreground tending to dwarf surrounding ones, regardless of their correct size. As pictorial compositions, his birds are less carefully planned and staged than those in Hondecoeter's paintings, but they make attractive undulating patterns and bright splashes of colour against the dark greenery of landscape background.

The same birds recur frequently, especially the exotic scarlet, blue and yellow macaws and sulphur-crested cockatoos. Other birds, among them the European great tit and jay, as well as the more uncommon chough and stone curlew, hold identical poses in several different paintings – it seems that Bogdani used the same images again and again in different arrangements. In his will he left all his 'modells' to his son and son-in-law Tobias Stanover, also painters, and the latter borrowed many of Bogdani's birds for his pictures.

It would be intriguing to know if these 'modells' were painted studies, wooden figures or stuffed birds. Although skins of birds were preserved in spirits and alcohol at this period, the art of taxidermy was in its infancy. The oldest stuffed bird in existence is the African grey parrot that belonged to 'la Belle Stuart', Frances, Duchess of Richmond and Lennox, one of Charles II's mistresses. The parrot lived with her for forty years and died a few days after its owner in 1702. It was placed beside her wax effigy in the crypt of Westminster Abbey.

Bogdani's lovely painting of *Two Icelandic Falcons*, although not typical of his work, is a wonderful portrait of birds silhouetted against a stark background. Dr Rajnai suggests that it might be a picture, not of two birds, but of one prized possession in two different positions. In its austerity it recalls a painting by the Dutch Carel Fabritius (1622–54) of *A Goldfinch* (1654). Fabritius is sometimes seen as the link between his master, Rembrandt, and his pupil, Vermeer, but his life was tragically cut short in the explosion of a powder magazine at Delft. He died aged thirty-two, and only a handful of his paintings survive. *A Goldfinch* was painted in the year of his death.

Although Bogdani's pictures may seem somewhat artificial with their mixture of aviary and wild creatures in romantic rustic and Classical backgrounds, his painting of birds is exact enough for the clear identification of their species, and is a fascinating record of the birds that were known in the late seventeenth and early eighteenth centuries. One quaint group seen in his pictures is that of domestic ducks and hens bred to have tufts on the tops of their heads – powder-puff top-knots. Charles II was fond of these, and they must have been a delightfully ornamental attraction in parks and aviaries.

## THE HAND-COLOURED PRINT

With the exception of Barlow's lively tableaux, the skill of portraying birds was less advanced in ornithological prints than in oil paintings. A new landmark was set, however, when the first English book containing prints painted in colour was published. This was Eleazar Albin's *A Natural History of Birds*, with 306 plates, issued in three volumes from 1731–38.

Albin (d.1741–2), was probably of German extraction and anglicized his name from Weiss. He was a drawing master and watercolourist who, according to the preface in his book, was attracted to natural history subjects – insects, flowers, and birds – because of their colours.

Although successful experiments in printing with coloured inks and overprinting with separate wood blocks and metal plates in different tones and shades had been made in the early eighteenth century by Elisha Kirkall, J. C. Le Blon, Arthur Pond, and John Baptist Jackson, these processes had proved very expensive and time consuming. Also, although the colours obtained by these methods were sometimes magnificent, they were unreliable. They could be harsh, and were limited by the number of blocks or plates that could be used. Albin chose for his books the simpler method of using an etched outline and adding colour by hand to each one individually.

His first book (1714) was of insects, a subject that remained an enduring interest; while he was preparing his bird pictures he was also compiling paintings of 180 different spiders. *A Natural History of Spiders, and other Curious Insects* (1736) has as its frontispiece a vignette portrait of Albin himself on horseback surrounded by a border of large-scale mites, spiders and scorpions.

The birds in Albin's pictures are generally stiff, silhouetted figures perched on sawn-off branches or little grass mounds, like the earlier engravings in Willughby and Ray's *Ornithologia*. Some birds are slightly more active, and the wryneck, bittern and 'laurey of the Brazils' are depicted reaching for a caterpillar, frog or locust. The smaller birds are sometimes shown as pairs, the bluetit and the redpoll perched on attractive sprigs of blossom or berries. Elizabeth Albin, Eleazar's daughter and pupil, assisted her father in the drawing and colouring, and her name is written next to the sparse Latin and English captions below many of the prints. Although Albin claimed that the prints were carefully and correctly coloured, the choice of colours was often rather inaccurate, restricted by the expense of pigments and the limited range available. The tints were applied simply and sparingly, and sometimes vary considerably from print to print.

Albin added a subtitle to *A Natural History of Birds* to the effect that the plates were 'Curiously Engraven from the Life', but it appears that most of his bird studies were from skins. The picture of the hen hoopoe, for example, was drawn from a bird shot by Mr Starkey Mayor in his garden at Woodford, Epping Forest. In his first volume Albin asked readers to send 'any curious birds (which shall be drawn and graved for the second Volume, and their names shall be mentioned as Encouragers of the Work) to Eleazar Albin near the Dog & Duck in Tottenham-court Road'. This request implies that Albin was expecting to receive either live cage birds or unusual specimens that had been acquired or shot.

As portraits of birds Albin's pictures have a naive quality and decorative period charm that is very appealing. Because he was a professional artist, his interests were primarily pictorial, but although not a pioneer in the study of ornithology, his coloured pictures started a long tradition which has been followed even to the present day.

The books of George Edwards (1694–1773), *A Natural History of Uncommon Birds* (1743–51) and *Gleanings of Natural History* (1758–64), were illustrated in the same way, but although he adopted the format of Albin's books, he was critical of their scholarship, and resolved to make his own work more thorough by using references to Aldrovandi, Willughby and contemporary naturalists.

## GEORGE EDWARDS AND SIR HANS SLOANE

Before publishing his work after twenty years of research, Edwards travelled extensively through Europe pursuing natural history interests, and on his return to England he was appointed Librarian at the College of Physicians, which enabled him to continue his studies.

The President, and Edwards' patron, was Sir Hans Sloane (1660–1753), a wealthy man as well as a scholar and philanthropist; he was also President of the Royal Society for fourteen years after the death of Sir Isaac Newton in 1727. Born in Ireland, he had studied medicine at London and European universities, and became physician to the Duke of Albemarle, Governor of Jamaica. While in the West Indies he collected specimens of flora and fauna, and later wrote about the herbs, trees and plants of Jamaica. In 1712 he purchased the Manor of Chelsea and became benefactor of the Apothecaries' Physic Garden; the Chelsea Physic Garden, a delightful oasis in the centre of London, is still an important educational centre for botanical research and maintains its eighteenth-century character.

Sloane formed a fabulous private collection of 'curiosities', which included over 1000 bird specimens. He was an avid collector in the tradition of the two John Tradescants, father and son, who over a hundred years earlier had gathered together 'rarities' from their travels – exotic shells, precious stones, carvings, dried animals, birds, snakes and worms – for their museum named The Ark. Some of the Tradescants' 'curios' have survived 300 years, and are now on display in a specially designed setting at the Ashmolean Museum, Oxford. Similar 'cabinets' of natural history and artefacts became fashionable in Europe

BARN OWL

*Tyto alba*. Hand-coloured etching entitled 'The White Owl' from Eleazar Albin's *Natural History of Birds*, 1731–38.

*Aluco Minor,*          *Lucheran*          *The White-Owl*

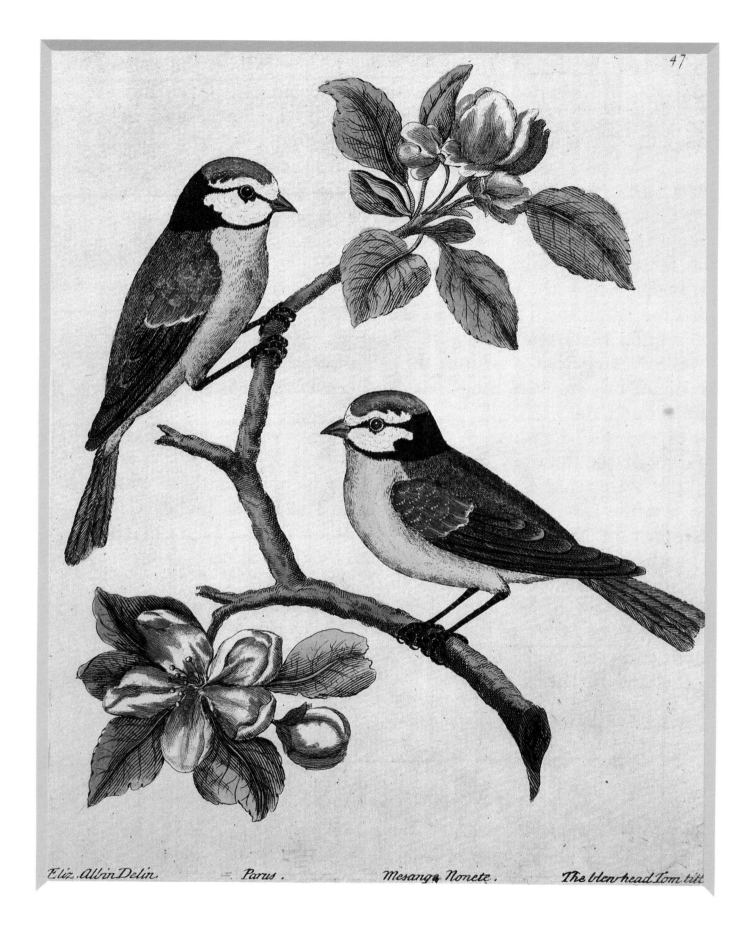

Eliz. Albin Delin.  Parus.  Mesange Nonete.  The blewhead Tom.tit

### BLUE TIT

*Parus caeruleus*. Hand-coloured etching entitled 'The
Blue Titmouse or Nun' from a drawing by Elizabeth Albin
in her father's *Natural History of Birds*.

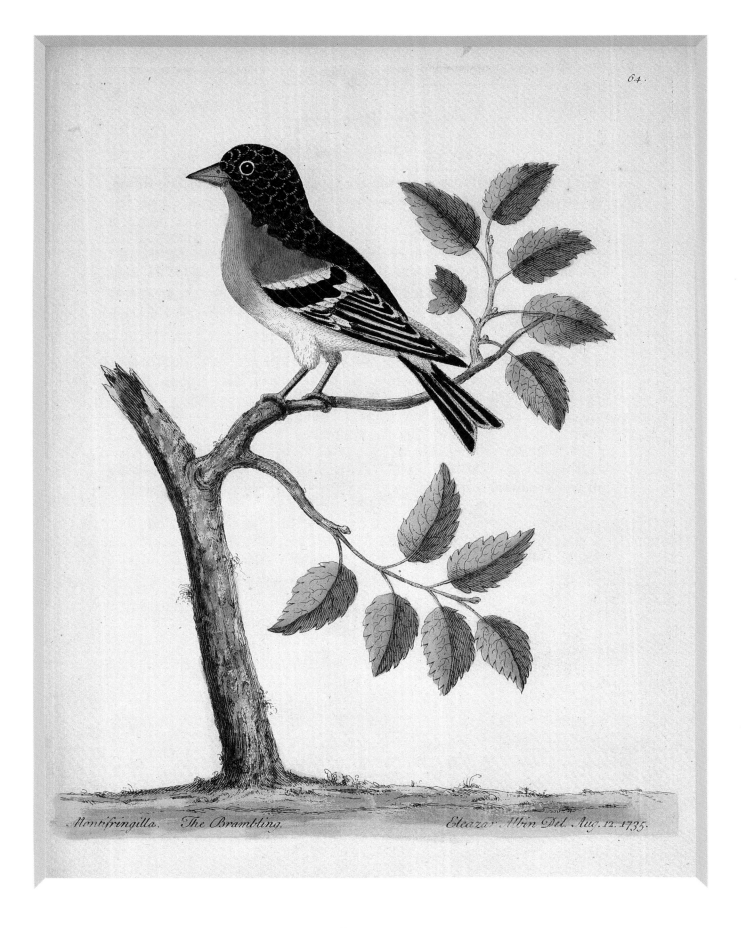

*Montifringilla.    The Brambling.                    Eleazar Albin Del. Aug. 12. 1735.*

BRAMBLING
...................................
*Fringilla montifringilla*. Hand-coloured etching from
Albin's *Natural History of Birds*, dated Aug. 12 1735.

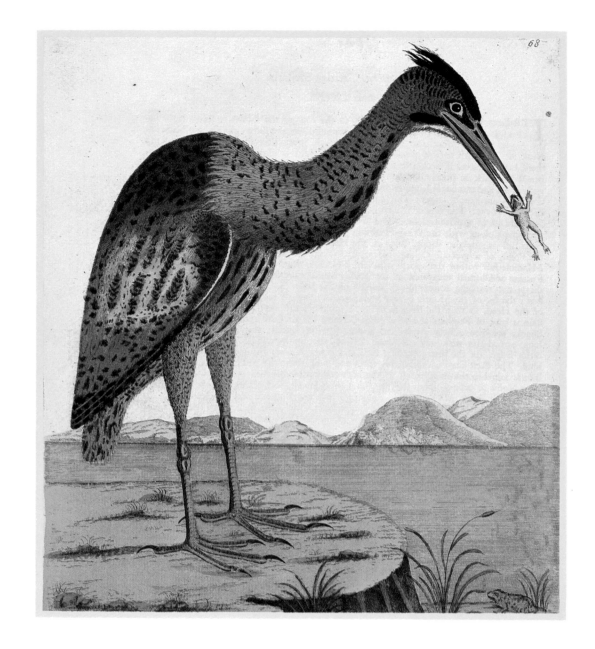

BITTERN

*Botaurus stellaris*. Hand-coloured etching from Albin's
*Natural History of Birds*. (ABOVE)

REDPOLL

*Acanthis flammea*. Hand-coloured etching entitled 'The
Red Pole Cock and Hen', and dated Aug. 9 1735, from
Albin's *Natural History of Birds*. (RIGHT)

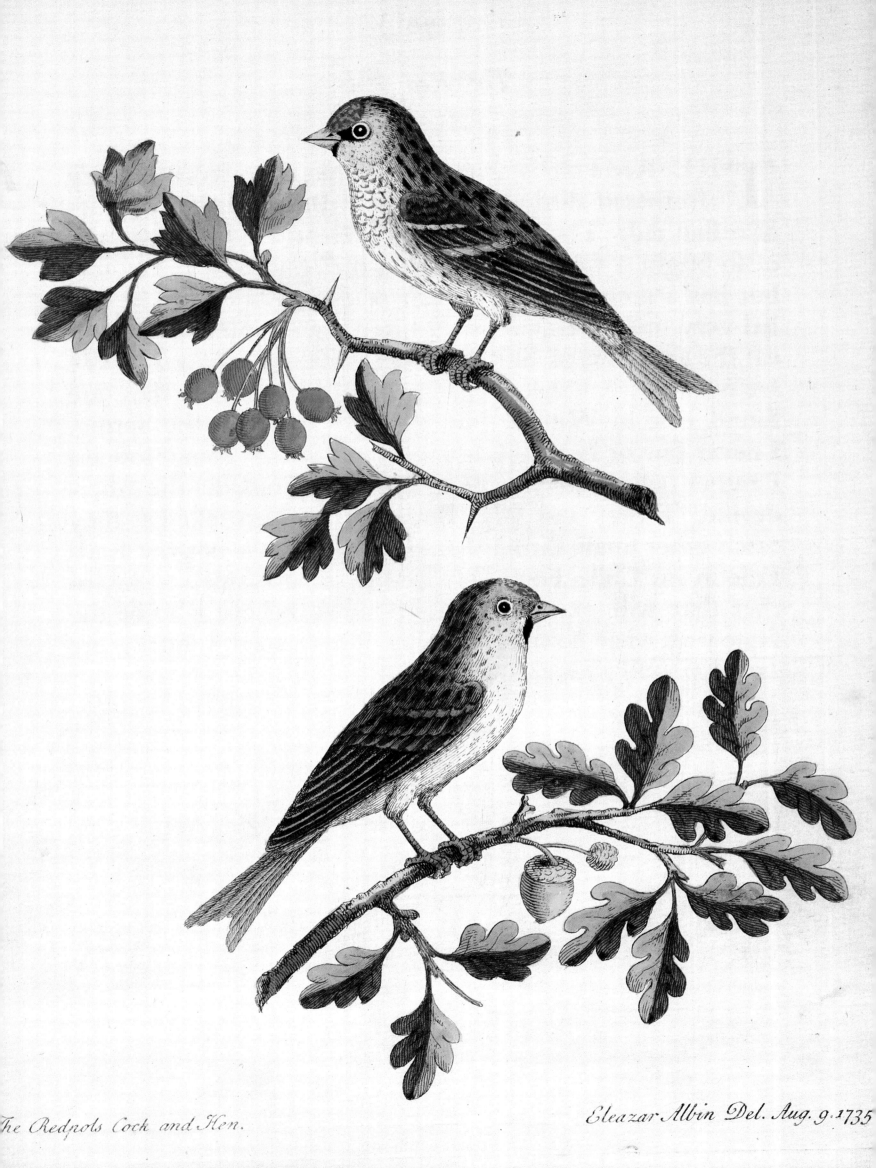

The Redpols Cock and Hen.

Eleazar Albin Del. Aug. 9. 1735.

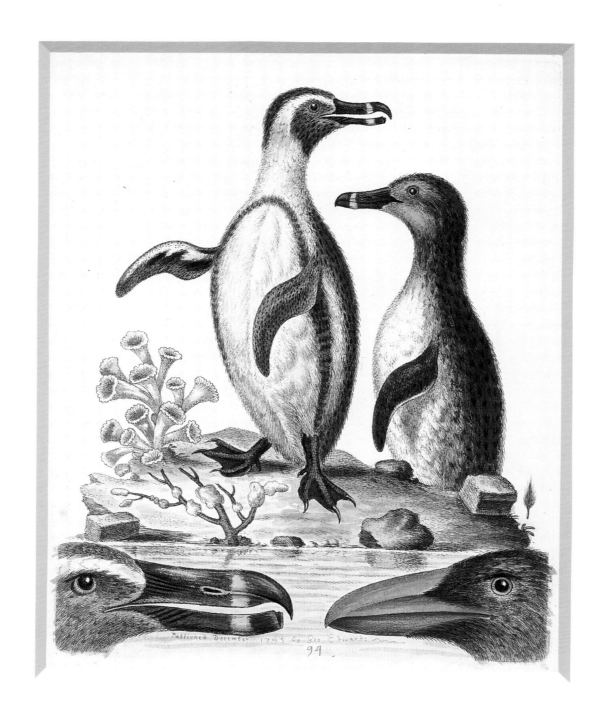

### BLACK-FOOTED PENGUIN

.....................................

*Spheniscus demersus*. Etching dated December 1745
from George Edwards' *Natural History of Uncommon
Birds*. This penguin is also known as the jackass penguin
because of its donkey-like call. *(ABOVE)*

### PUFFIN (TOP) AND RAZORBILL (BOTTOM)

.....................................

*Fratercula arctica* and *Alca torda*. Etching dated Aug. 7
1761, from Edwards' *Gleanings of Natural History*.
Edwards observed these birds 'thick in rows' on the rocks
at the Needles, Isle of Wight, England. *(RIGHT)*

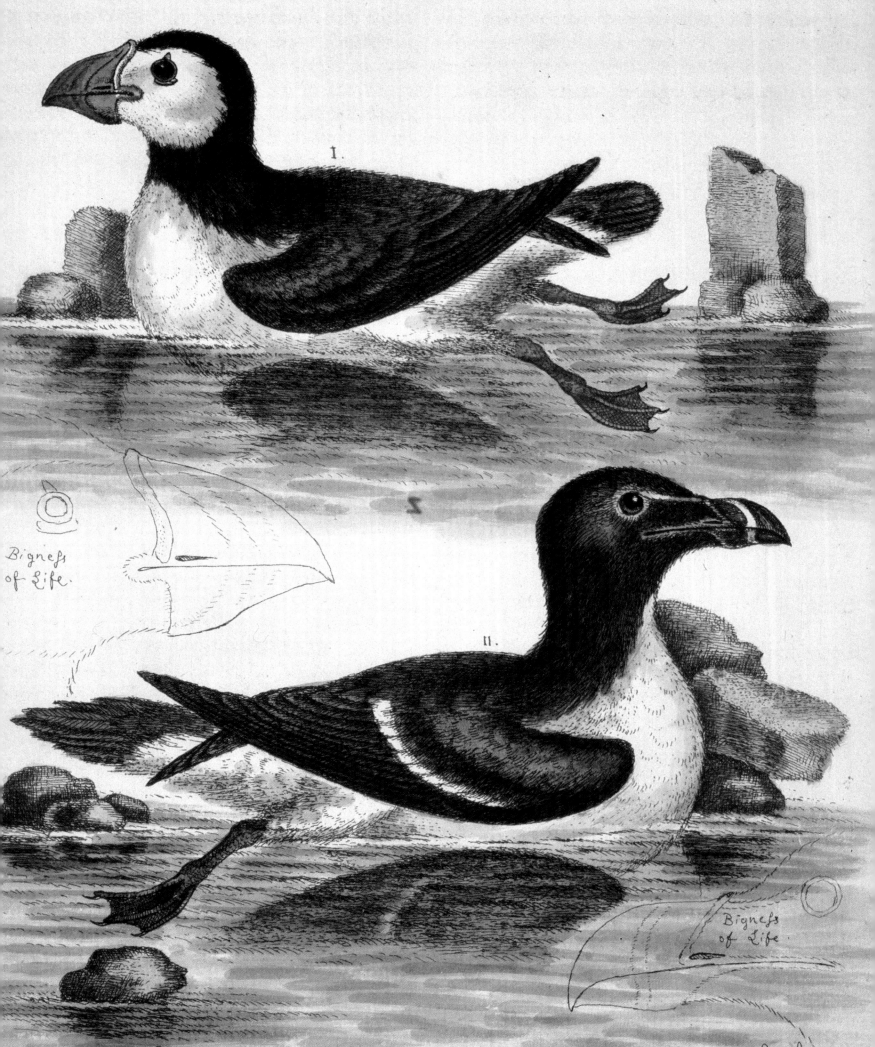

Bigneſs
of Life.

Bigneſs
of Life.

s Arctica, the Puffin or Coulternel. Fig. II Alca Hoieri, the Razor-bill or Auk. Drawn from life by G. Edwards, Aug. 7. 1761.

358

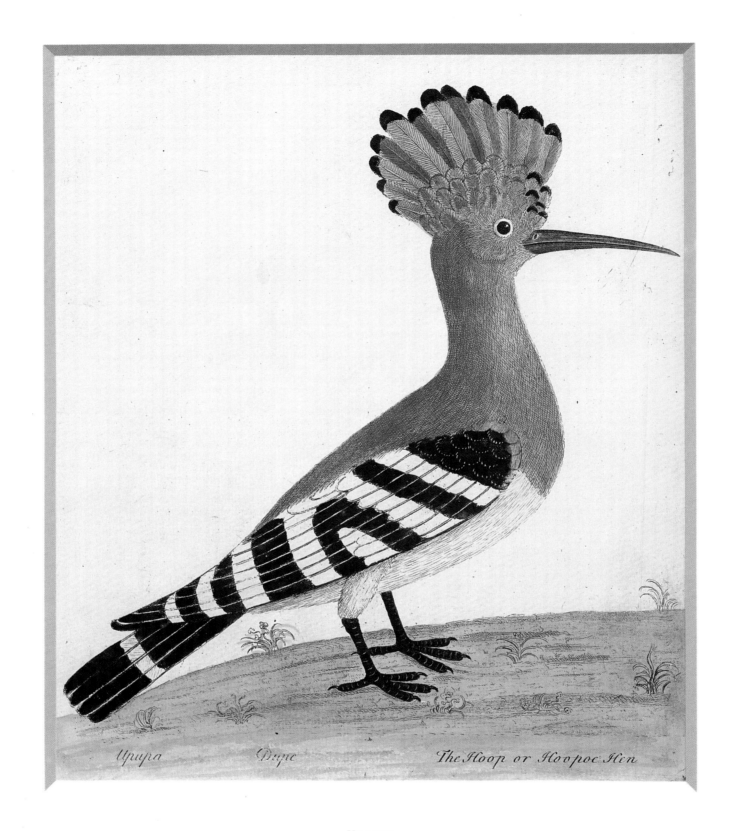

Upupa      Dupe      The Hoop or Hoopoe Hen

### HOOPOE

*Upupa epops*. 'The Hoop or Hoopoe Hen', etching from
Albin's *Natural History of Birds*. A vagrant in England,
this hoopoe was shot near Epping Forest, on the outskirts
of London.

as adjuncts to private libraries, and Sloane's museum was well known throughout the Continent. The great Swedish scholar Carl von Linné (or Carolus Linnaeus), then a young man, called on the ageing collector during a visit to England in 1736, while Edwards was librarian, and found the museum 'incomparable', though he had a poor opinion of its classification system.

Through his contacts with Sloane and his colleagues, Edwards had access to caged birds and specimens in private collections, and was also able to draw up a list of subscribers, or 'generous encouragers', for his books. In order to cover the expenses of publishing it was then necessary to find prospective clients, a harassing and unenviable chore which most publishers had to face for the next hundred years. Edwards' 120 subscribers for *A Natural History of Uncommon Birds*, listed alphabetically, included landed gentry, physicians, apothecaries, surgeons, merchants, booksellers, fellow naturalists and painters, and also patrons of the arts including the Earl of Burlington and Horace Walpole.

Edwards had lessons in etching from Mark Catesby, a naturalist friend who was a pioneer in the illustration of birds from America, and after some practice he felt confident enough to do the etching himself and save the expense of employing professionals. In his preface to *Uncommon Birds* Edwards complained about the flat, monotonous profiles of former bird artists, whose 'sameness' he found 'disagreeable', and aimed to make his birds more lifelike by giving them 'as many different Turns and Attitudes' as he could invent. Edwards' birds look more rounded than Albin's but are equally lacking in structure, and the tiny etched lines he used for shading give an appearance of fur rather than feathers. While Albin's birds have a cardboard cut-out appearance, Edwards' give the impression of soft, fuzzy toys.

As additional decoration, he drew charming details of fish, insects, butterflies and even a guinea pig, 'to fill up the naked Spaces on the Plates'. To show the exact scale of his birds, extra outline profiles were drawn of bills, heads and feet, made the 'Bigness of Life' (life size), and annotated in Edwards' neatly etched handwriting. Instead of the dull tree-stumps and mounds used by Albin and others, the birds were placed in more imaginative settings, often chosen for decoration rather than authenticity. An example of this kind of incongruity is the landscape given to the black-footed penguins – a rock with 'white coral-like substance . . . in the form of bells.'

Edwards' birds are drawn from many sources. As well as the usual preserved skins, there was a cage of birds captured from a Spanish ship, seabirds which had flown onto the ships of the Hudson's Bay Company, a stuffed specimen in a coffee house, and living birds in Sir Hans Sloane's garden. Dr George Wharton, Treasurer of the College of Physicians, commissioned a drawing of his mynah bird as a present for his wife, and Edwards commented on the mimicking ability of this species: 'For Whistling, Singing and Talking, it is accounted first Rank, expressing Words with an Accent nearer Human than Parrots or any other Birds usually taught to talk.'

The portrait of the 'Greater Minor' is quite recognizable, but pictures of birds that Edwards had never seen are sometimes bizarre. The penguins, for instance, were based on poor-quality skins and a traveller's account of a fowl 'that goes upright; his Wings without Feathers hanging down like Sleeves, faced with White, they do not fly, but only walk in Parcels, keeping regularly their own Quarters.'

The dodo of Mauritius had been extinct for over seventy years before Edwards produced his print, copied from an oil painting belonging to Sir Hans Sloane which in turn was based on a Dutch picture attributed to Roelandt Savery (c. 1626). This had been painted from live dodos in the menagerie of Prince Maurice of Nassau, and it became the inspiration for many engravings and copies through the centuries. Edwards' image seems familiar to us because it bears a close resemblance to John Tenniel's famous illustration in Lewis Carroll's *Alice's Adventures in Wonderland*; it seems that both conceptions were derived from the same source.

The history of the dodo is a tragic one, and it has become a symbol of extinction, of something lost and gone forever. Little is known about it except that it was flightless, of the size of a large turkey, and inhabited Mauritius. Sailors killed the helpless birds for food, but this was not the sole cause of their extermination; rats and monkeys introduced to Mauritius ate their eggs and their young.

A live dodo had been exhibited in London in 1626, and it was probably this that was preserved for the Tradescant Ark, later illustrated in Ray and Willughby's *Ornithology*. The stuffed specimen was eventually passed on to the Ashmolean Museum, where it gradually disintegrated until only the head and a foot remained. There are no other stuffed dodos which are considered authentic; models in museums are made from feathers of other birds.

## IMITATORS AND COPYISTS

The decorative charm of Edwards' birds appealed to the makers of china figures at the neighbouring Chelsea porcelain factory, and several models were made from his birds, including a delightful little hawk owl. But the porcelain painters, with their limited range of enamel paints, were unable to match the watercolour tints of Edwards' prints, and Edwards was indignant at the misuse of his pictures. At that time copyright laws were seldom effectively enforced, and artists were unable to protect their work. He was anxious that his prints should not be sold uncoloured, since unskilled colourists could spoil them, and in order to ensure that the correct colours of his

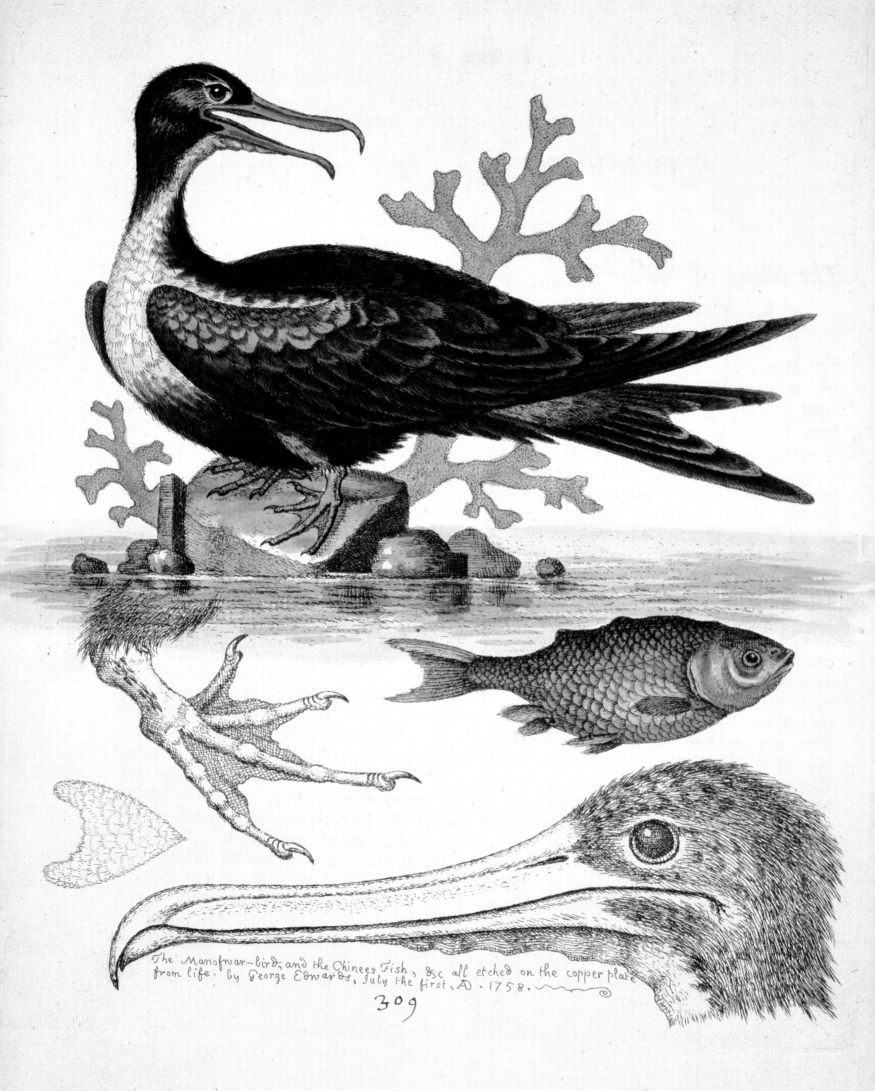

The Manofwar-bird, and the Chinees Fish, &c all etched on the copper plate from life. by George Edwards, July the first, A 1758.

309

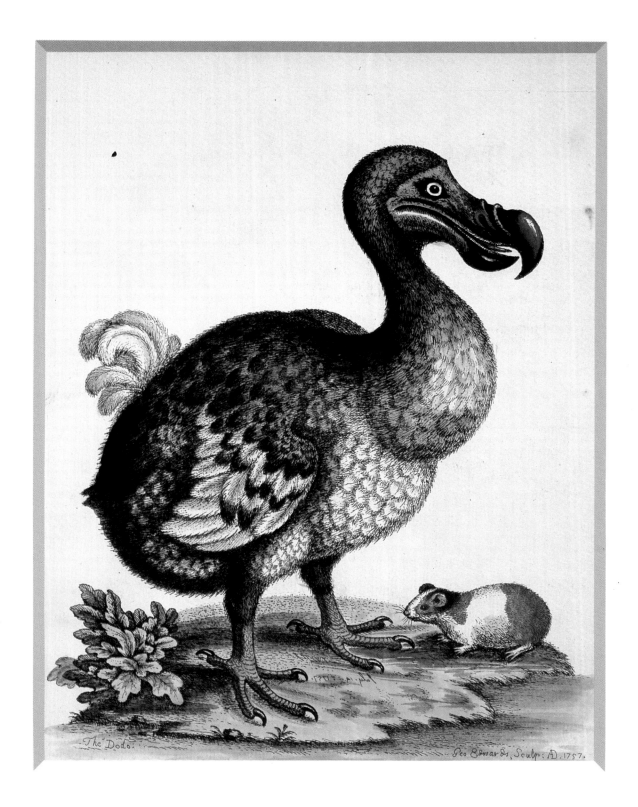

### DODO

*Raphus cucullatus*. Etching dated AD 1757, from
Edwards' *Gleanings of Natural History*. The dodo of
Mauritius had become extinct about sixty years earlier, *c.*
1690. It is shown with a guinea pig which comes from
South America. *(ABOVE)*

### GREAT FRIGATE BIRD

*Fregata minor*. Etching dated July 1 1758 from Edwards'
*Gleanings of Natural History*. Found in the tropical seas,
this bird was called the 'Man-of-War' bird from its habit of
chasing seabirds and making them drop or disgorge fish.
*(LEFT)*

prints could be seen, he deposited standard copies of his books in the Library of the College of Physicians, 'carefully and exactly colour'd', as a reference for future generations.

Edwards would not have approved of the copies of his prints by Samuel Dixon (fl.1757–69) of Dublin and his followers, who issued sets of decorative paintings adapted from *Uncommon Birds*. These pictures were three dimensional, made by an invention which Dixon named 'basso relievo', today described as 'embossed'. Copper plates were made with a raised design on the surface, and thick paper was pressed into them from behind so that the design stood out on the paper in low relief. The prints were later coloured by hand in gouache and watercolour.

Sets of twelve of these *Curious Foreign Bird Pieces* and *Foreign and Domestick Birds*, advertised by Dixon in 1749 and 1755, were mounted in japanned or lacquered frames and sold as suitable decoration for ladies' apartments. The macaws, doves, exotic ducks, humming-birds and canaries were intended to blend in with the Rococo chinoiserie taste of the period. Printed labels on the reverse gave the names of the birds, together with dedications to aristocratic ladies whose patronage Dixon sought. Dixon's work also reached London, where he opened a shop for three years from 1765, and similar embossed paintings by Isaac Spackman (fl.1754–71) of Islington were also made from Edwards' prints.

## THE HAYES FAMILY

After the 1760s embossed pictures were made by William Hayes and family, in a different style to Dixon's, with deeper embossing. These, of larger, more naturalistic birds, were adapted from Hayes's own hand-coloured prints in his two books, *A Natural History of British Birds, with Their Portraits* (1771–75), and *Portraits of Rare and Curious Birds from Species in the Menagerie at Osterley Park* (1794–99).

Hayes' career as an ornithological artist, unlike that of Edwards, was beset with financial problems. He suffered from ill-health, had a large family to support, and his patrons the 4th Earl of Sandwich, the Countess of Northumberland and Robert Child, all died within a period of sixteen years.

During the 1780s the Hayes family lived at Southall, Middlesex, near the large house and gardens of Osterley Park, home of Robert Child. The latter, a wealthy banker, was then completing plans for the transformation of the house into a Classical mansion by the fashionable architect Robert Adam. In the grounds was the menagerie, which Horace Walpole described as 'full of birds that come from a thousand islands', and Hayes was commissioned to paint the exotic birds, producing a small book of their portraits.

Unfortunately, his patron died prematurely at the age of forty-three, his end hastened, it was said, by grief at the runaway marriage of his only child, and as Hayes needed money, he added more material to the existing prints to make an enlarged book of hand-coloured plates. His wife and large family helped in this task, and at least seven of his twenty-one children – of whom only ten survived to adulthood – were involved in the drawing, etching and colouring of the plates. A plea for financial help, dated 1799 and written by a local clergyman, appeared in an advertisement for Hayes' *Rare and Curious Birds*. It described the artist as 'altogether unequal to the support of a very numerous family', and claimed that he suffered from angina, his wife was unable to use her limbs, six of the children had fever, one son was a permanent cripple, and his income scarcely ever exceeded £90 a year. The Rev. G. H. Glasse admitted that Hayes had another source of income – as village postmaster – but this was also poorly paid. On his death the job was transferred to his daughter Emily.

Hayes' life demonstrates the precariousness of an artist's career at a time when patronage was essential, and also provides an interesting example of a family 'cottage' industry. His work lacks the assured robustness of Edwards', and although the birds are more naturalistic, they sometimes seem pallid. An example of his work is *A Heron* (1789) in the Ashmolean Museum, Oxford, which shows a lean stately bird, painted in watercolour mixed with white, with feathers delineated by precise tiny dark brushstrokes in scale-like formation. It was perhaps based on one of the birds living at Osterley sanctuary and painted for the family to study while preparing the hand-coloured prints for their books.

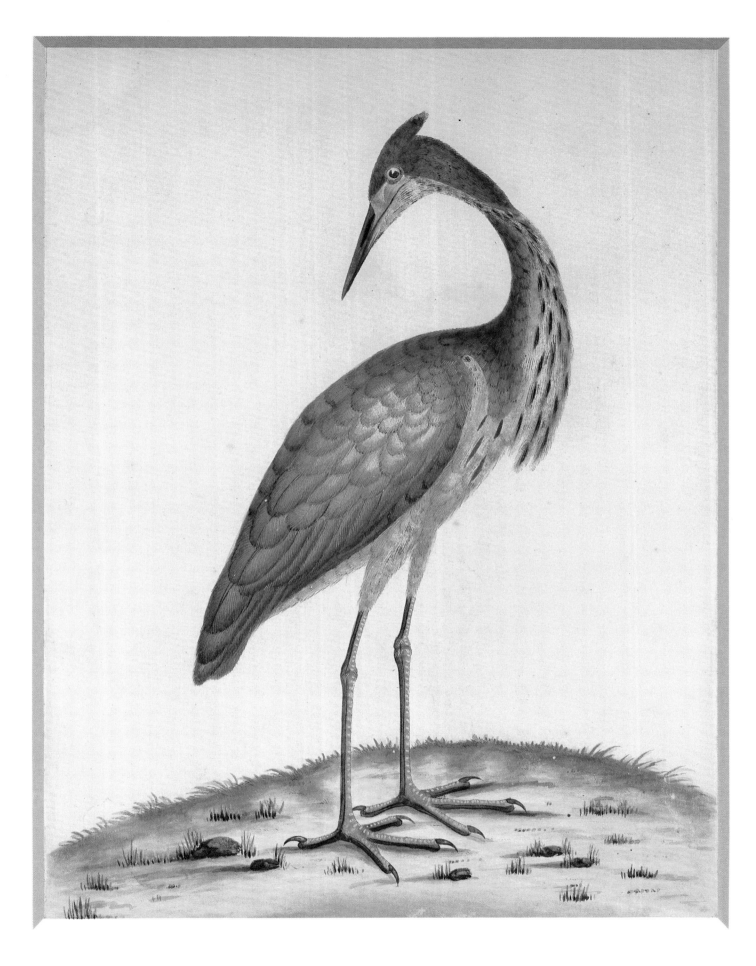

**A HERON**
...................................
Watercolour with pen and black ink and body colour by
William Hayes, signed W. Hayes 1789.

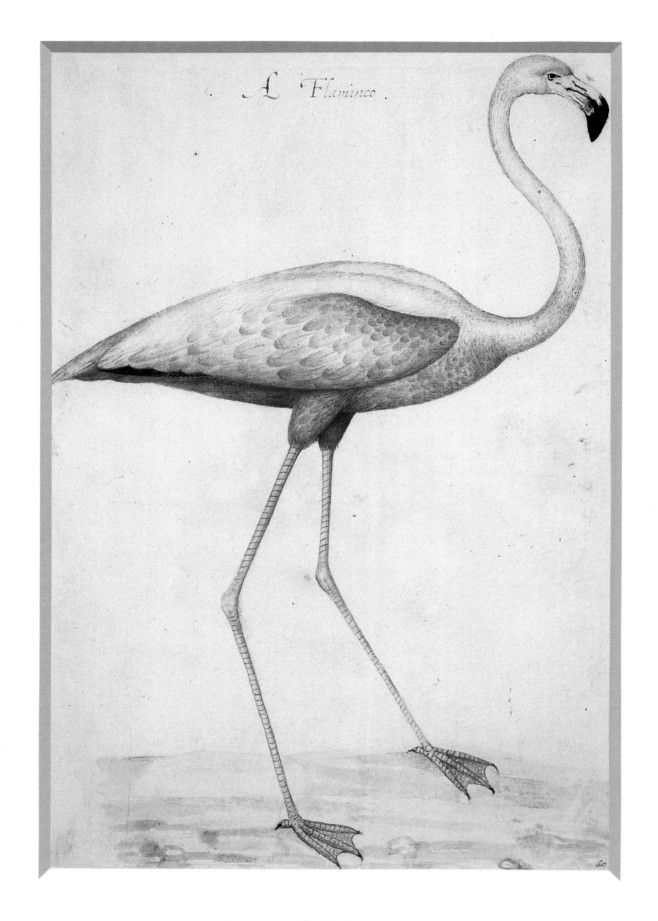

A Flaminco

### FLAMINGO

*Phoenicopterus ruber*. Watercolour by John White, who
travelled on an expedition to Roanoke, Virginia,
organized by Sir Walter Raleigh in 1585.

# America:
# from John White to J. J. Audubon

THE FIRST KNOWN ENGLISH ARTIST TO PAINT THE BIRDS, plants and fish of the New World was the traveller and adventurer John White (fl.1577–90) who sailed to North America five times during the reign of Queen Elizabeth I. His picture of a flamingo, painted in soft to deep crimson and scarlet shades with touches of black on its wings and beak, is a masterpiece of watercolour painting, perhaps one of the most sensitive portraits of a bird ever made.

The creation of an English colony in North America was Sir Walter Raleigh's great ambition in the 1580s, and after presenting a plan to the Queen, he organized an expedition for a settlement to be founded at Roanoke in the newly named colony Virginia (then parts of North Carolina and Virginia). In 1585 John White set out with a fleet of seven ships under the command of Sir Richard Grenville, Raleigh's cousin, sailing by way of Florida, the Bahamas and the Caribbean Islands. During his travels he made drawings of the tropic and frigate birds, noddy tern and brown booby, oceanic fish and tropical fruits including the pineapple and the banana.

He stayed for about a year at Roanoke, and in 1586 sailed back home with Sir Francis Drake, who had made contact with the colonists on his return journey from the West Indies. In England, further plans were made for the colony, and White was named 'Governor with 12 Assistants'. A year later he set sail again once again, with three boats and 113 potential settlers (84 men, 17 women and 11 children), thus swelling the numbers of the original group. However, due to various misunderstandings and disagreements, White was sent back to England to obtain further help and instructions, leaving behind his married daughter, whose child, christened Virginia Dare, was probably the first colonial child to be born in North America.

By now Raleigh and Grenville were preoccupied with the threat of the Spanish Armada, and their interest in the Virginia colony waned. It was not until 1590 that White managed to get a passage back to Roanoke, where no trace could be found of the colonists; after a fruitless search it was assumed that they had abandoned their site for another area. In the following years the names of John White and the settlers were forgotten, but his paintings remained, and his carefully observed pictures of the life and customs of the local Indians – fishing, dancing and burning their dead – were engraved (without a credit to White) by the Fleming Theodore de Bry in his great work *America: A brief and true report of the new found land of Virginia*, printed in 1590.

White's natural history work was rediscovered about a hundred years later when Sir Hans Sloane discovered a folio of paintings belonging to White's descendants. Sloane had a passionate interest in the flora and fauna of North America, and he introduced the pictures to other natural historians, and ordered copies to be made. A variety of bird species were redrawn, including a bald eagle, common loon, trumpeter swan, blue jay, red-headed woodpecker, yellow-shafted flicker, Baltimore oriole, cardinal and barn swallow, but unfortunately the copies of the birds were of poor quality compared to those of the fish, and compared unfavourably with White's originals. In 1964, nearly 400 years after the unsuccessful Roanoke expedition, all the known examples of White's pictures and the Sloane copies were brought together and reproduced in an excellent publication by the British Museum under the scholarly editorship of Paul Hulton and David B. Quinn.

## MARK CATESBY

The first illustrated book to be published with plates of birds, flowers, fish, and insects of the North American colonies was *The Natural History of Carolina, Florida, and the Bahama Islands* (1741–43) by Mark Catesby (1683–1749), who has been called the founder of American ornithology. Working in London under the patronage of Sloane, Catesby had access to the latter's copies of White's work, and seven of his illustrations, depicting different fish, a swallowtail butterfly, and a crab, are closely based on White's work.

Catesby was born at Castle Hedingham, Essex, and as a young man became a friend of the botanist and zoologist John Ray. At the age of twenty-nine, he travelled to North America to stay with a sister and her husband who lived in Virginia, and he continued his travels to the Carolinas and the West Indies, collecting plants and seeds which were sent back to botanists in England. These were received with such enthusiasm that he was chosen to go on another expedition to North America. In 1722, supported by the

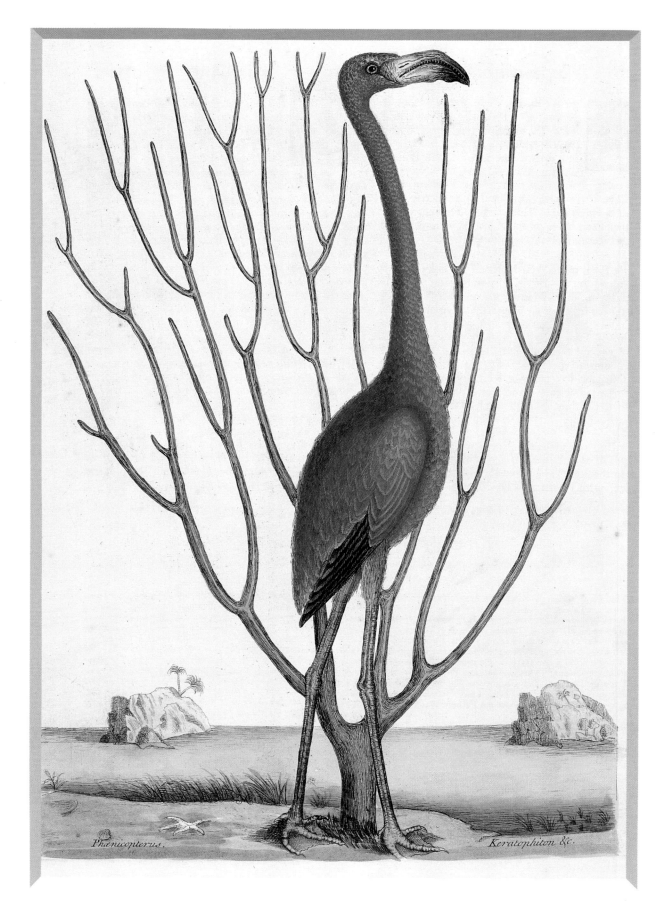

Phænicopterus.                                    Keratophiton &c.

### FLAMINGO

.......................................

*Phoenicopterus ruber*. Hand-coloured etching from Mark
Catesby's *The Natural History of Carolina, Florida and
the Bahama Islands*, 1731–43. The American flamingo
achieves its red or bright pink plumage when an adult.

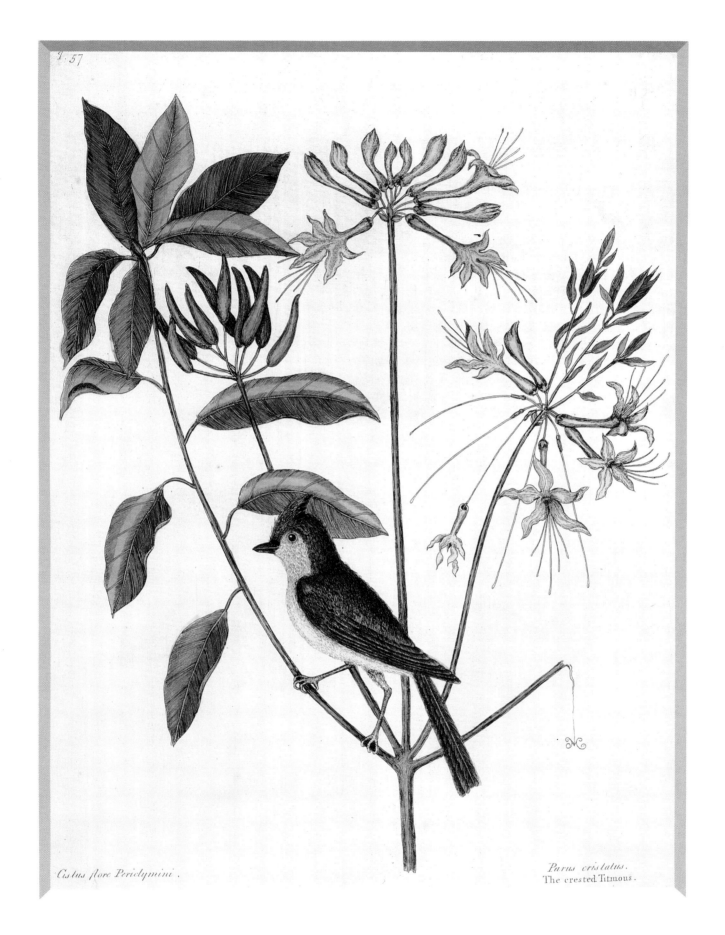

*Cistus flore Periclymini.*

*Parus cristatus.*
The crested Titmous.

**TUFTED TITMOUSE**
...............................................
*Parus bicolor.* From Catesby's *The Natural History of
Carolina*. The bird, which Catesby called the 'crested tit-
mouse', is shown on some 'upright honeysuckle'. His
monogram, MC, resembles a spider.

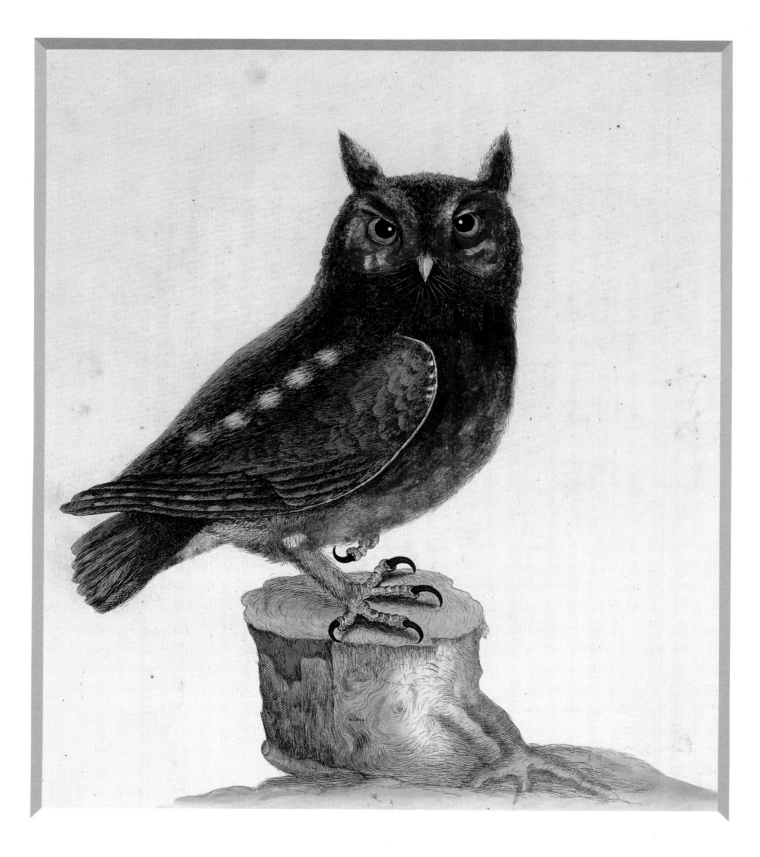

SCREECH OWL

*Otus asio*. Hand-coloured etching from Catesby's *The Natural History of Carolina*.

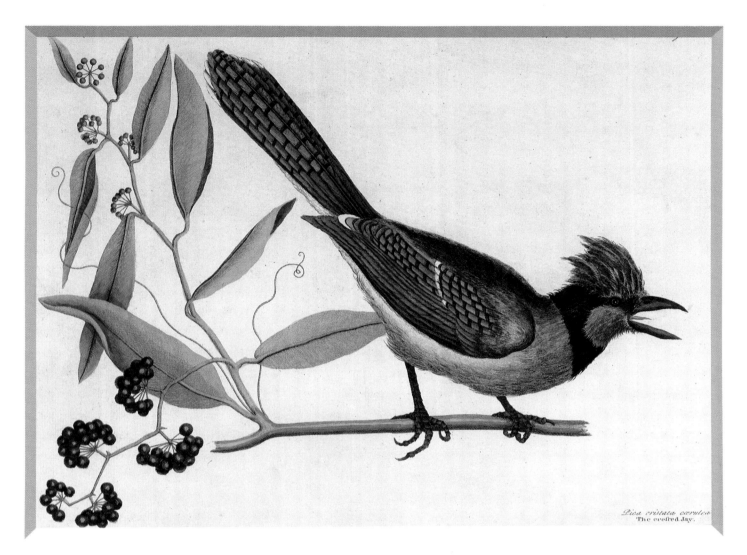

Pica cristata cærulea.
The crested Jay.

BLUE JAY
............................................
*Cyanocitta cristata*. Called the 'crested jay' by Catesby in
***The Natural History of Carolina***.

Royal Society and financially backed by Sir Hans Sloane and other distinguished naturalists, he set off to collect further specimens – birds, plants, shells and insects. The trip lasted four years, during which time he also made drawings of live birds and freshly gathered plants, travelling into unexplored Indian territory in Georgia and Florida. In 1725 he obtained permission from Sloane to continue his field studies in the islands of the Bahamas for a further year.

On his return Catesby spent the following fifteen years working on the illustrations of his book. The sponsorship for his expedition did not extend to financing his publication, and although he organized a list of 'encouragers', he decided to cut costs, as did his friend George Edwards, by drawing, etching and colouring the plates himself. Accordingly, he took lessons in etching from Joseph Goupy (1689–1763), a painter of French extraction, and drawing master to members of the royal family.

Catesby was interested in both botany and ornithology, and his plates are a charming combination of flora and fauna. Since he could not afford a separate plate for every subject, he found it economical to place birds and flowers together on large folio-sized paper, and in most plates he tried to relate the birds to the plants. The mocking-bird, for instance, was perched on a dogwood plant because

Catesby had observed that it ate the berries of that species. Sometimes the juxtaposition of birds and plants had incongruous effects, especially in scale: for example, a tall flamingo was shown to be of equal height to a piece of coral resembling a tree. The latter was described by Catesby as growing up to two feet high and found near the Bahama Islands at the bottom of shallow seas. Some of his bird illustrations seem a little wooden and quaint, but his use of plants as decorative adjuncts became a formula later adopted by many ornithological artists.

## ALEXANDER WILSON
.........................................

Through the contacts made with colleagues in the colonies by Sloane, Catesby and Edwards, new ideas and opinions began to be discussed through the exchange of letters, drawings and specimens. Philadelphia became a centre of art and scientific learning, a mecca for natural history students who visited the Bartram's botanical gardens and the amazing Peale's Museum. The latter was a

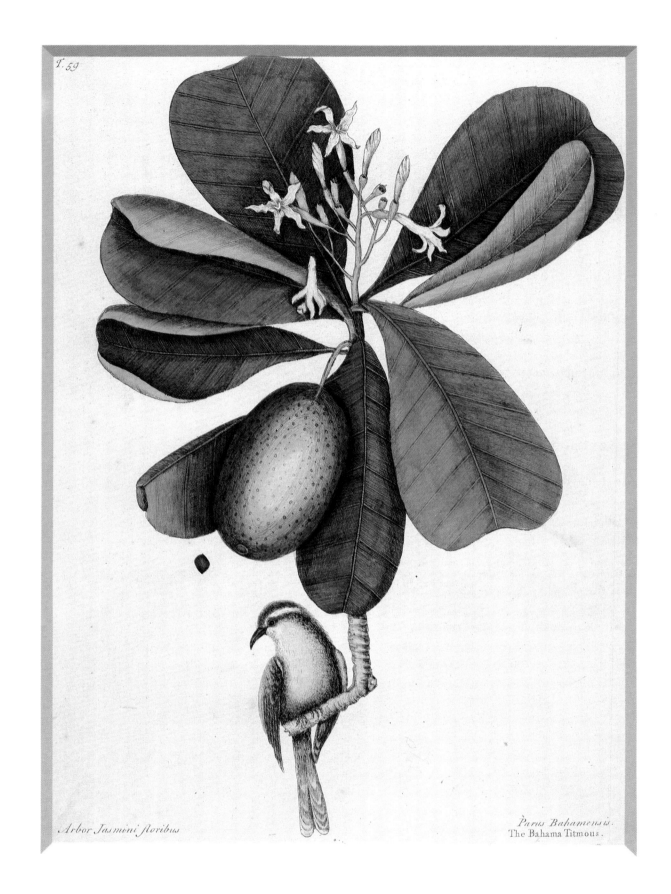

*T. 59*

*Arbor Jasmini floribus*

*Parus Bahamensis.*
The Bahama Titmous.

BANANAQUIT
.....................................
*Coereba flaveola*. Etching from Catesby's *The Natural History of Carolina*. He has depicted the bird, which he calls the 'Bahama titmouse', with some 'seven years apple'.

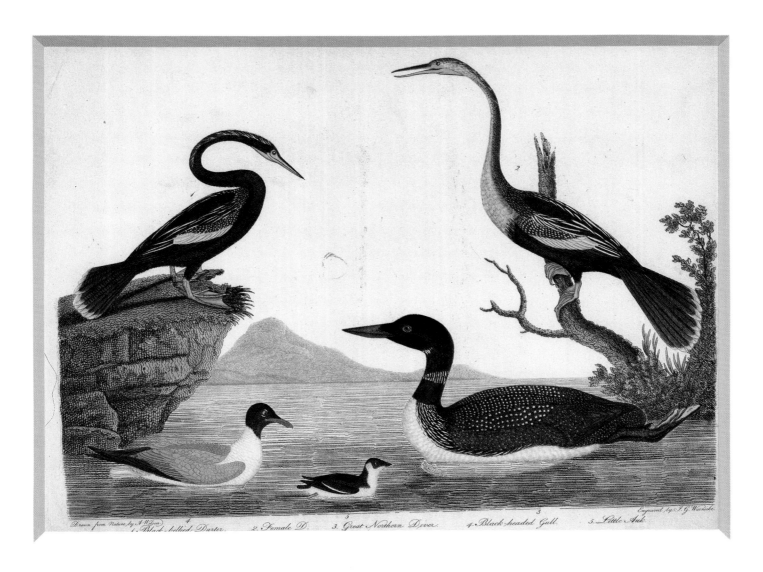

AMERICAN DARTER OR ANHINGA, GREAT NORTHERN
DIVER, BLACK-HEADED GULL, LITTLE AUK
..........................................
*Anhinga anhinga, Gavia immer, Larus ridibundus,
Alle alle.* Etching from Alexander Wilson's *American
Ornithology*, 1803–13.

collection in the tradition of the famous 'cabinets of curiosities', with paintings, stuffed birds and animals, fossils and excavated bones, plants, rocks and minerals, displayed with great panache by the portrait painter, taxidermist, archaeologist and patriot Charles Willson Peale.

The first comprehensive book of American birds to be published in the country itself was *American ornithology* (1808–14), written by Alexander Wilson (1766–1813), a Scotsman who became an American citizen. His work, which preceded Audubon's books by twenty years, was the result of many journeys throughout the American country, observing, collecting and drawing birds.

Wilson was the son of a weaver, born in Paisley, Renfrewshire. After a brief grammar-school education, he became an apprentice in his father's trade at the age of thirteen, but weaving bored him, and he turned to writing poetry. At twenty-three he became a travelling pedlar hoping to sell his verses along with his wares – this was the era when the popular Robert Burns wrote his best poems and songs – but unfortunately a galling satire on a local millowner resulted instead in a prison sentence and the public burning of the poem on the courthouse steps.

In 1794 he emigrated to America and, after landing at New Castle, Delaware, walked to Philadelphia. On the way he saw a red-headed woodpecker and remarked on its rich colours, so different from the sombre ones of birds in his native Scotland. He became a teacher at a school at Gray's Ferry on the Schuylkill river near the house of William Bartram (1760–1828), the naturalist and botanist. Bartram gave Wilson access to his museum of specimens and his library containing the volumes of Catesby, Edwards and the great French naturalist, the Comte de Buffon, but as these books contained little information about American birds, and Wilson found so many errors and absurdities in the texts, he decided to carry out his own comprehensive studies.

His intention was to make drawings of all the birds in his adopted country, from the shores of the St Lawrence to the mouth of the Mississippi, and from the Atlantic to the interior of Louisiana, and in 1804 he set out on the first of his many journeys, travelling mostly by foot from Philadelphia to the Great Lakes and Niagara Falls – a tour which he described in an epic poem of heroic couplets. His pictures were to be superior to anything previously published, and coloured with 'the most scrupulous adherence to the true tints of the original'. In order to record his specimens he taught himself drawing, but failed to master the technique of etching. By 1808 the first volume of his

work, with five plates, was published in Philadelphia with etchings prepared by a fellow Scot, Alexander Lawson (1773–1846), and coloured by hand.

On subsequent journeys north to New England and south to Georgia and Florida, Wilson took his first volume of plates as a sample to show prospective buyers. His first plate depicted familiar birds: the blue jay, yellowbird or goldfinch, and the Baltimore bird, or oriole. Those drawn in profile were rather stiff, with several species crowded onto a page with little attempt to place them in an appropriate background, and his text was an engaging combination of erudition, observation and flowery prose. He introduced the blue jay in the following manner: 'This elegant bird, which, as far as I can learn, is peculiar to North America, is distinguished as a kind of beau among the feathered tenants of our woods, by the brilliancy of his dress; and, like most other coxcombs, makes himself still more conspicuous by his loquacity, and the oddness of his tones and gestures.' Wilson's diligent research into the classification and habits of American birds paved the way for the monumental works of his successor.

## JOHN JAMES AUDUBON

In 1810 Wilson travelled west to Pittsburgh and then, navigating a small skiff named *The Ornithologist*, sailed down the Ohio river past Cincinnati to a small river town near Louisville. There he chanced to call in at the local general store, where he showed his volume of prints to the storekeeper. The latter, an artist and portrait painter, showed interest, and a subscription for the book was on the point of being procured when the joint-owner intervened: his partner, he said, could do better drawings of birds himself. His partner's name was John James Audubon.

Audubon (1785–1851) is the best known of all bird illustrators, and thought by some to be the greatest. His magnificent volumes of *The Birds of America* (1827–38) are the most expensive books in the world, reaching record auction prices at over two million pounds (3.96 million American dollars). Today he is also commemorated by the National Audubon Society in America, which promotes the conservation of living birds in their natural surroundings.

He was born at Les Cayes, Haiti (Santo Domingo) in the West Indies, the son of a French sea captain and his Creole mistress, Jeanne Rabin. She died soon after his birth, and the child was taken to France, christened Jean-Jacques Fougère Audubon, legally adopted by his father and his

BLUE JAY, AMERICAN GOLDFINCH, NORTHERN ORIOLE

*Cyanocitta cristata, Carduelis tristis, Icterus galbula*.
Hand-coloured etching from Alexander Wilson's
*American Ornithology*. The familiar yellow and black
oriole of the eastern states is also known as the Baltimore
oriole.

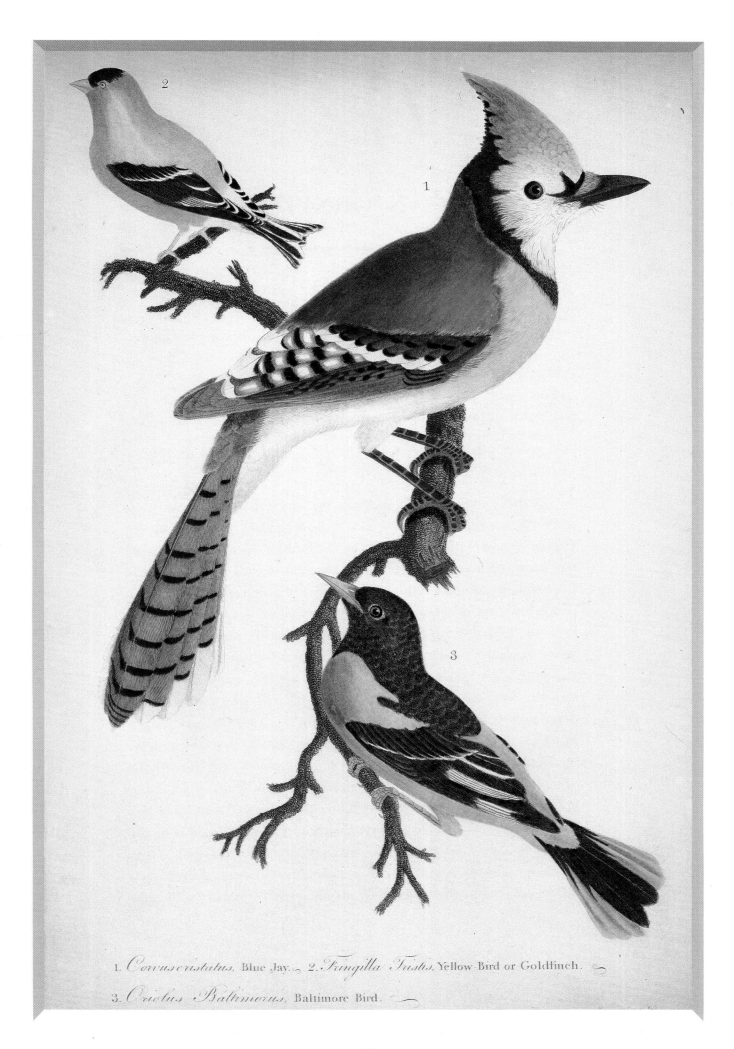

1. *Corvus cristatus*, Blue Jay. — 2. *Fringilla Tristis*, Yellow-Bird or Goldfinch. —
3. *Oriolus Baltimorus*, Baltimore Bird. —

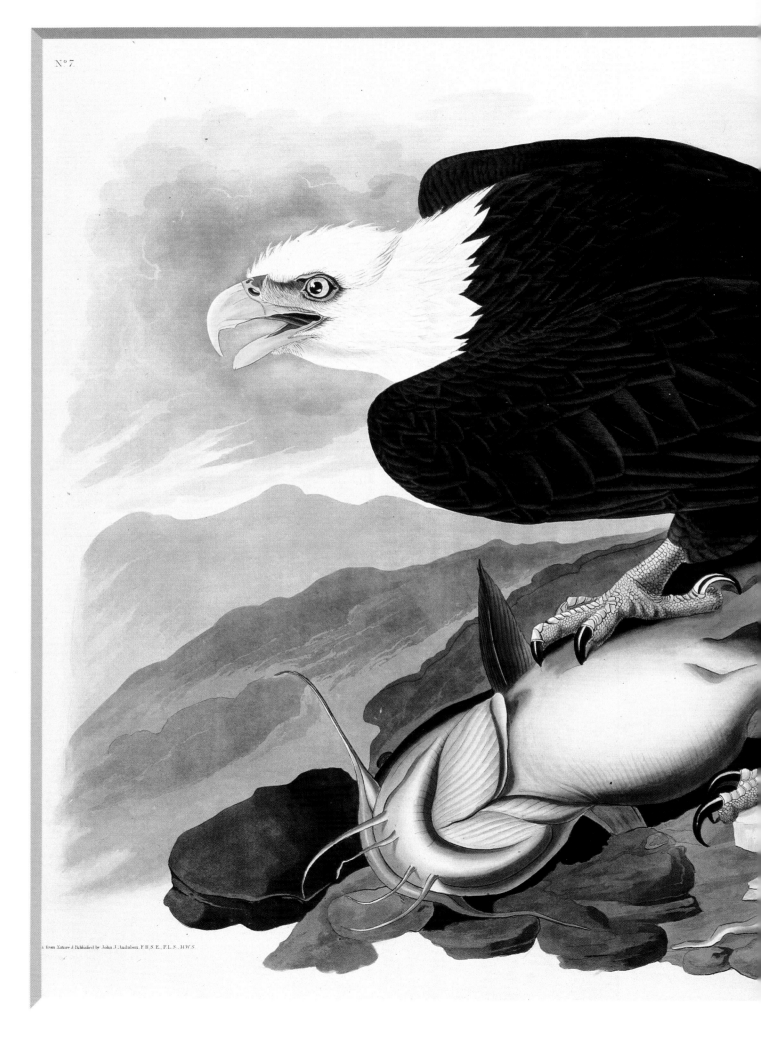

N°7.

Drawn from Nature & Published by John J. Audubon, F.R.S.E., F.L.S., M.W.S.

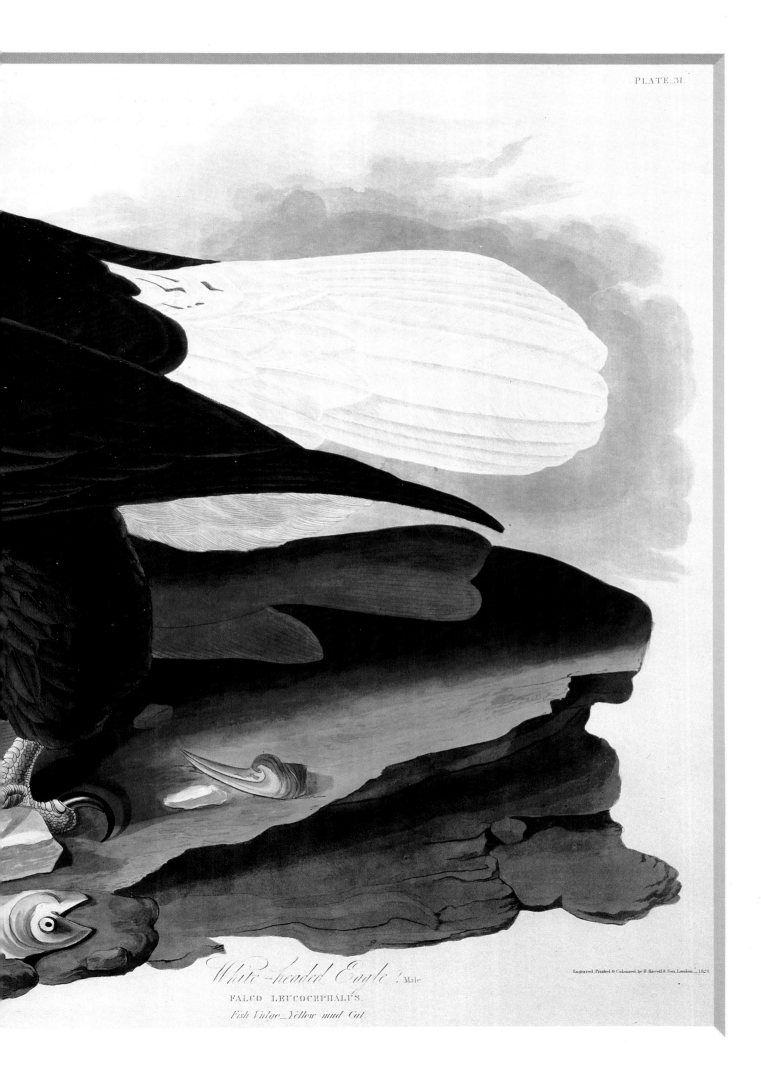

PLATE. 31.

*White-headed Eagle.* Male

FALCO LEUCOCEPHALUS

*Fish Vulgo—Yellow mud Cat.*

Engraved, Printed & Coloured by R. Havell & Son, London. 1828.

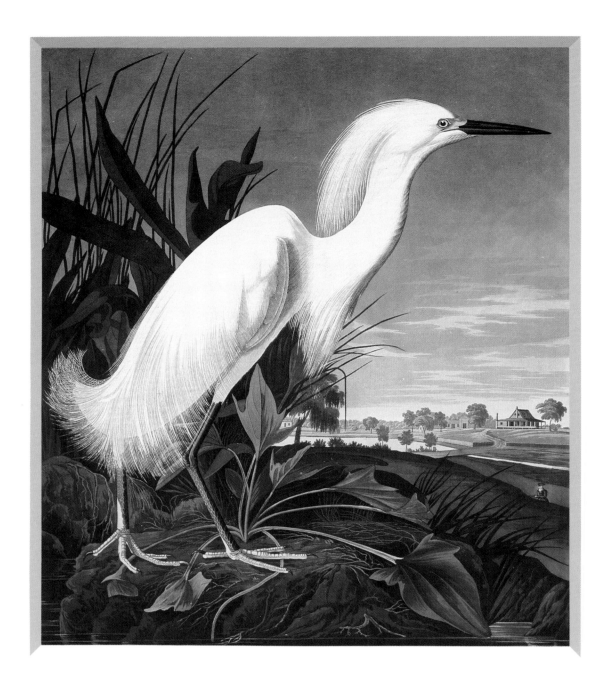

### SNOWY EGRET
..................................

*Egretta thula*. The background landscape is of a South
Carolina plantation. Aquatint from J. J. Audubon's *The
Birds of America,* 1827–38. In the last century the plumes
of the egret were much in demand for millinery
decoration. (ABOVE)

### WILD TURKEY
..................................

*Meleagris gallopavo*. The first of Audubon's 435 plates in
*The Birds of America*. Probably painted in 1825, the turkey
is shown striding through cane which grows on swamps
and riverbanks of the South-east states of America. *(RIGHT)*

### BALD EAGLE
..................................

*Haliaeetus leucocephalus*. Aquatint from J. J. Audubon's
*The Birds of America*, 1827–38. An Indian symbol of
freedom and independence, this bird is the national
emblem of the USA. After a decline in numbers through
shooting and pesticides it is now making a comeback.
Audubon substituted its prey of a Canada goose for catfish,
and sketched it near Little Prairie, Missouri. *(PREVIOUS PAGE)*

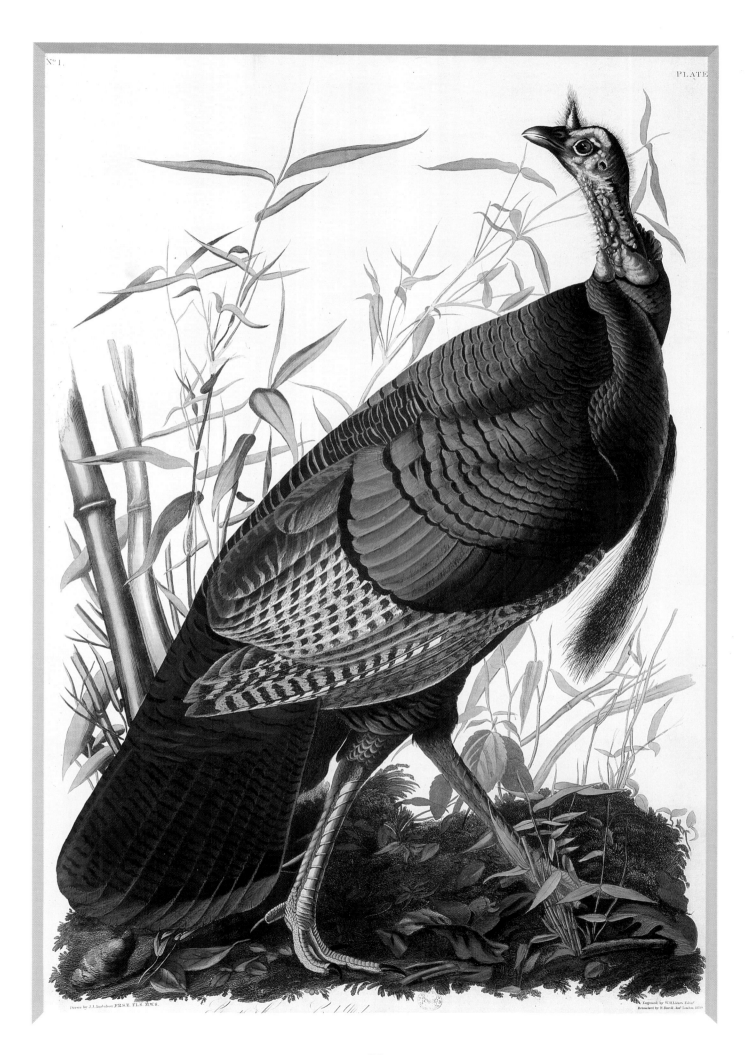

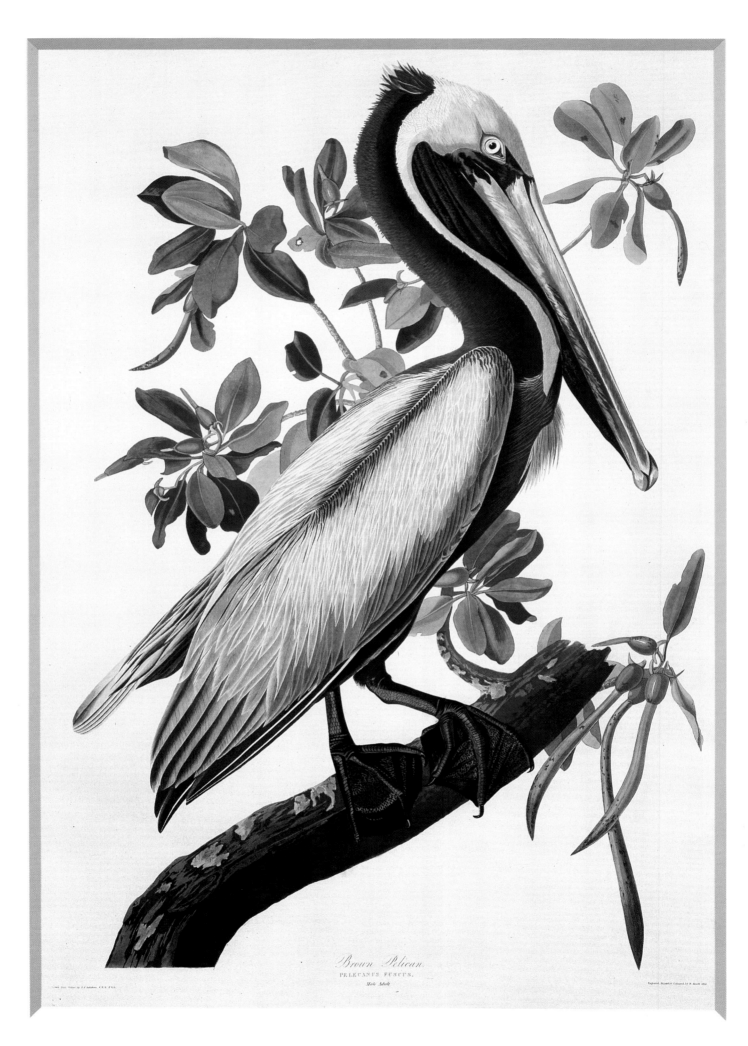

Brown Pelican.
PELECANUS FUSCUS.
Male Adult.

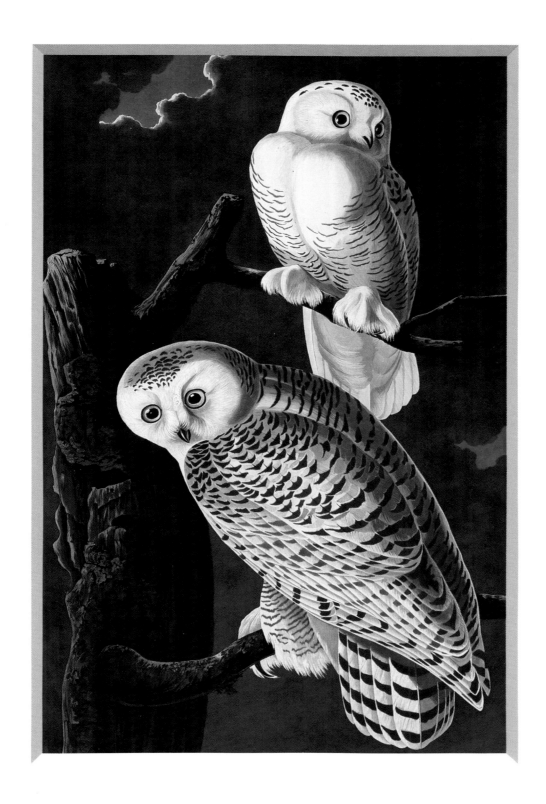

SNOWY OWL

*Nyctea scandiaca*. This is the only night scene painted by
Audubon for R. Havell's aquatints in *The Birds of
America*. (ABOVE)

BROWN PELICAN

*Pelecanus occidentalis*. Aquatint by R. Havell from *The
Birds of America*. Audubon probably drew this adult
pelican in the Florida Keys in April or May 1832. (LEFT)

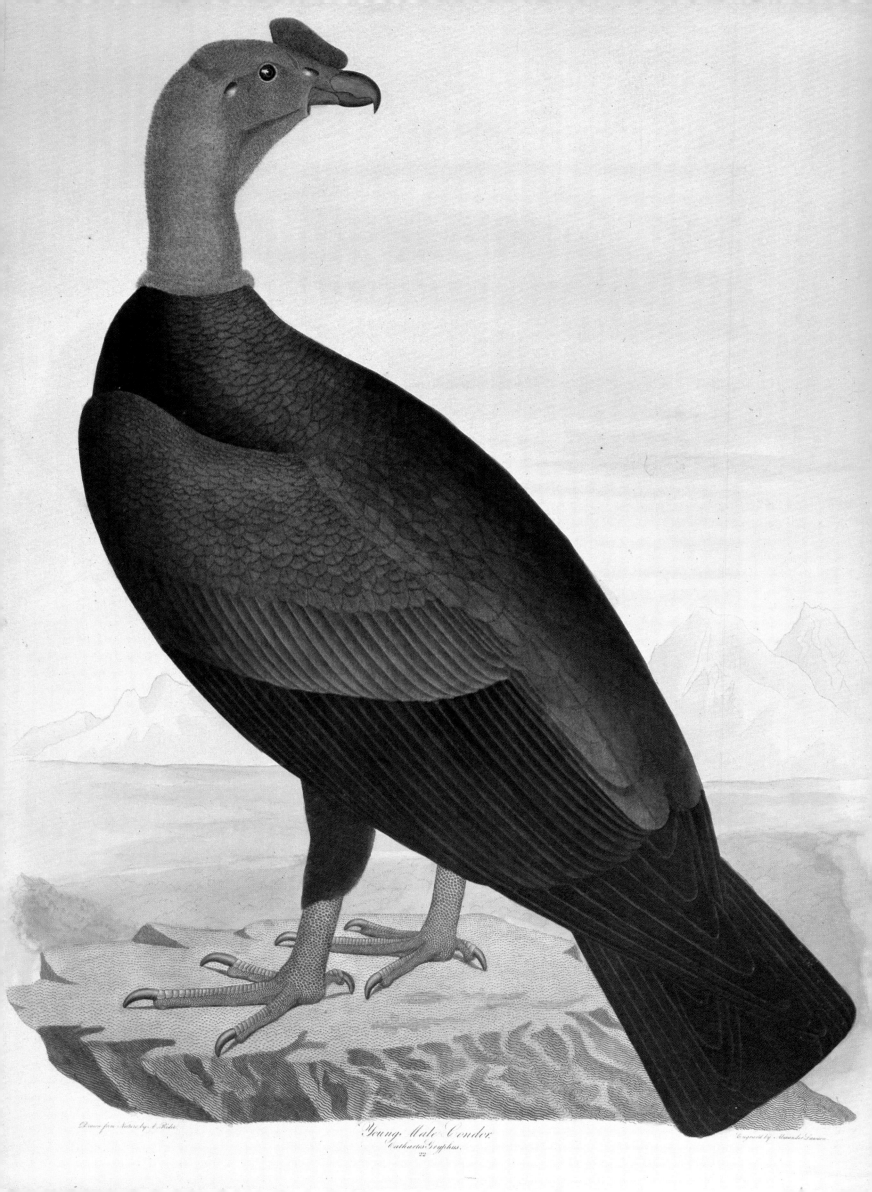

Drawn from Nature by J. Robi.

*Young Male Condor*
*Cathartes Gryphus.*
22

Engraved by Alexander Lawson

wife Anne, and brought up at the family villa near Nantes on the Loire.

Due to the political disturbances in revolutionary France and the indulgence of his family, he received little formal education, but was allowed to pursue his own interests: music, drawing, exploring the countryside, birds-nesting, tracking animals and searching for plants. In recent years his proud claim to have studied in Paris under Jacques-Louis David has been doubted, but in any event he certainly absorbed the current Neoclassical attitude to the representation of the heroic in dramatic compositions, and was later to adapt this to his avian themes.

When he was eighteen Audubon set out to America to stay at Mill Grove, an estate near Philadelphia owned by his father. There he lived a carefree social life, enjoying shooting and fishing, and became engaged to Lucy Bakewell, the daughter of an Englishman who lived on a neighbouring estate. As his proposed marriage was discouraged by his father, Audubon returned home to seek advice, and a business contract was made with Ferdinand Rozier, son of a family friend, to revive the lead mines at Mill Grove on his father's estate. This enterprise, the first of many such ventures, proved unsuccessful, and the partners decided to try their luck in the west. They set off on a long journey to Louisville, Kentucky, where they opened a general store at a nearby riverport – the scene of the meeting with Wilson. Audubon briefly returned to Pennsylvania to marry Lucy Bakewell, bringing her back to Kentucky, where their two sons, Victor and John Woodhouse were born, in 1809 and 1812.

Audubon was fascinated by the bird life of the area, and instead of minding the store, spent much of his time exploring the surrounding forests. Being an expert shot he collected birds, but also studied their habits, and made copious drawings and notes. But although his true interest was natural history rather than trade, he continued to plan feckless commercial ventures. After another attempt to run a store at Henderson, further down the Ohio river, the partnership with Rozier ended, but undeterred, Audubon decided to invest in a steam sawmill and a steamboat. Some of the money for this was lent by George Keats, brother of the English poet. Pursued by creditors, Audubon was jailed for debt, but released on a plea of bankruptcy. This crisis forced him to give up commerce at last and earn what he could from portrait painting, teaching, and finally as a taxidermist at the Western Museum, Cincinnati.

In 1820 he conceived the ambitious scheme of collecting material for illustrations of all the American bird species north of Mexico in order to publish a comprehensive book. Leaving his wife and two boys behind, he took his dog Dash, a gun and a young assistant, Joseph Mason, who was adept at painting flowers, and set off by flatboat down the Ohio and Mississippi rivers to New Orleans. The two naturalists lived as working passengers, hunting and fishing and accumulating material for the great work as they travelled. On the completion of their journey they stayed at a cotton plantation in Oakley, near St Francisville, Louisiana, where for some months Audubon was resident tutor in drawing, music and dancing, and had the opportunity to observe and paint more birds. When, after over a year's absence, Audubon was reunited with his family in New Orleans, his wife became a governess while Audubon painted portraits and worked on his bird pictures.

In 1823 he went to Philadelphia with the intention of arranging an exhibition of his work and finding a publisher. He had a mixed reception. Wilson had died ten years earlier, but the subscribers to his books were not interested in a new publication by an unknown illustrator. Also, a sequel to Wilson's work was about to be issued, Charles-Lucien Bonaparte's *American Ornithology* (1824–28) with illustrations by Ramsey Titan Peale, one of the many talented sons of the leading Philadelphian patron, Charles Willson Peale.

Charles-Lucien Bonaparte, Prince of Canino and nephew of the Emperor Napoleon, was a sophisticated and cosmopolitan figure, a collector, connoisseur and natural history scholar. He was well liked as an enthusiast and a generous sharer of knowledge. Realizing the difficulties which Audubon would face persuading the Philadelphia establishment to support his work, he advised looking for a printer and publisher in Europe.

Accordingly, after further journeys to New York and by the Great Lakes, Audubon set sail for England, arriving in Liverpool in July 1826 with a portfolio of over 200 paintings and an introduction to the Rathbones, a wealthy merchant family interested in the arts. An exhibition was held at the Royal Institute in Liverpool, which was received with great enthusiasm, and almost overnight Audubon found himself a star attraction. The Liverpudlians were fascinated by his flamboyant personality, his long chestnut ringlets which flowed loosely over his shoulders, and his fringed buckskin jacket. Nicknamed 'The American Woodsman' he was wined and dined by cultured society, who were delighted by his romantic accounts of adventures in the wilds of the New World.

From Liverpool, Audubon went via Manchester to Edinburgh to continue his search for a printer who would

ANDEAN CONDOR
....................................
*Vultur gryphus.* Etching from Charles Lucien Bonaparte's
*American Ornithology*, 1824–28. This is the largest flying
bird in the world, and ranges along the length of the
Andes.

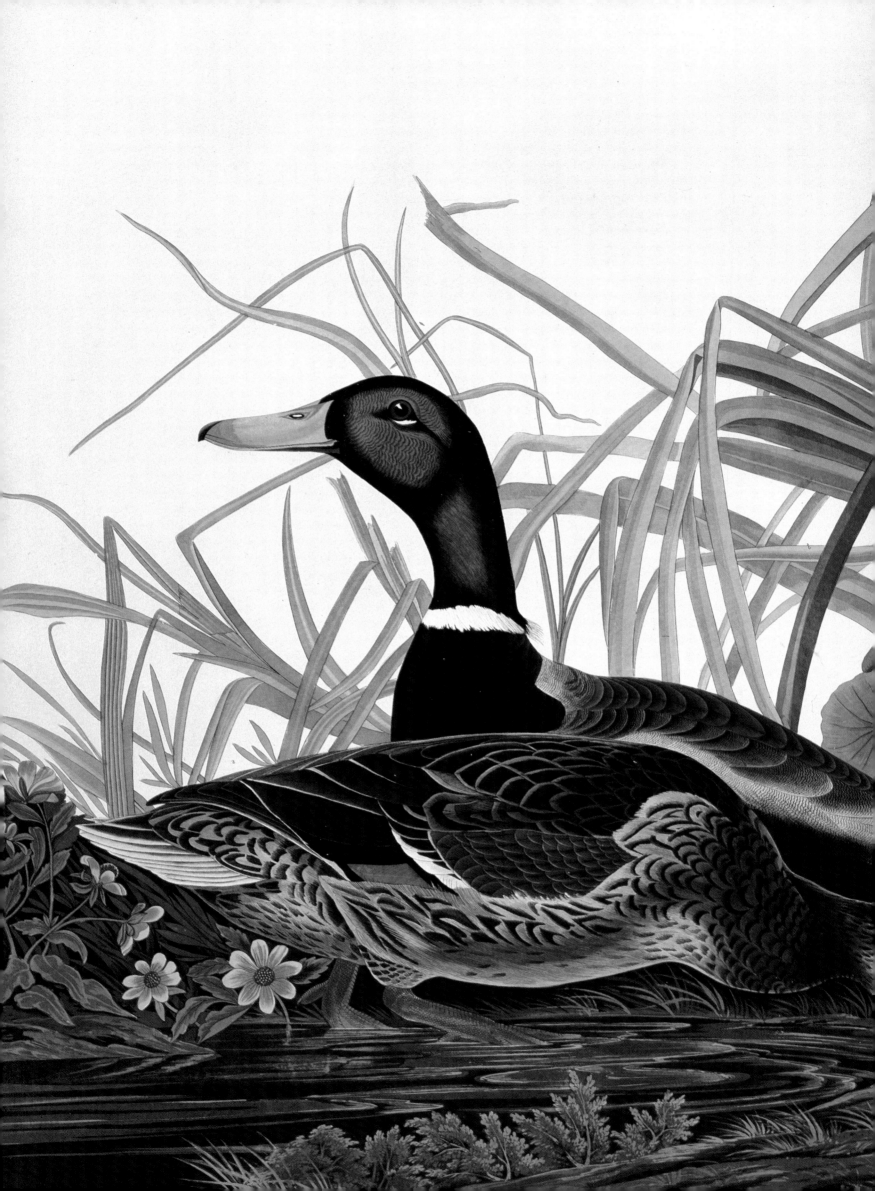

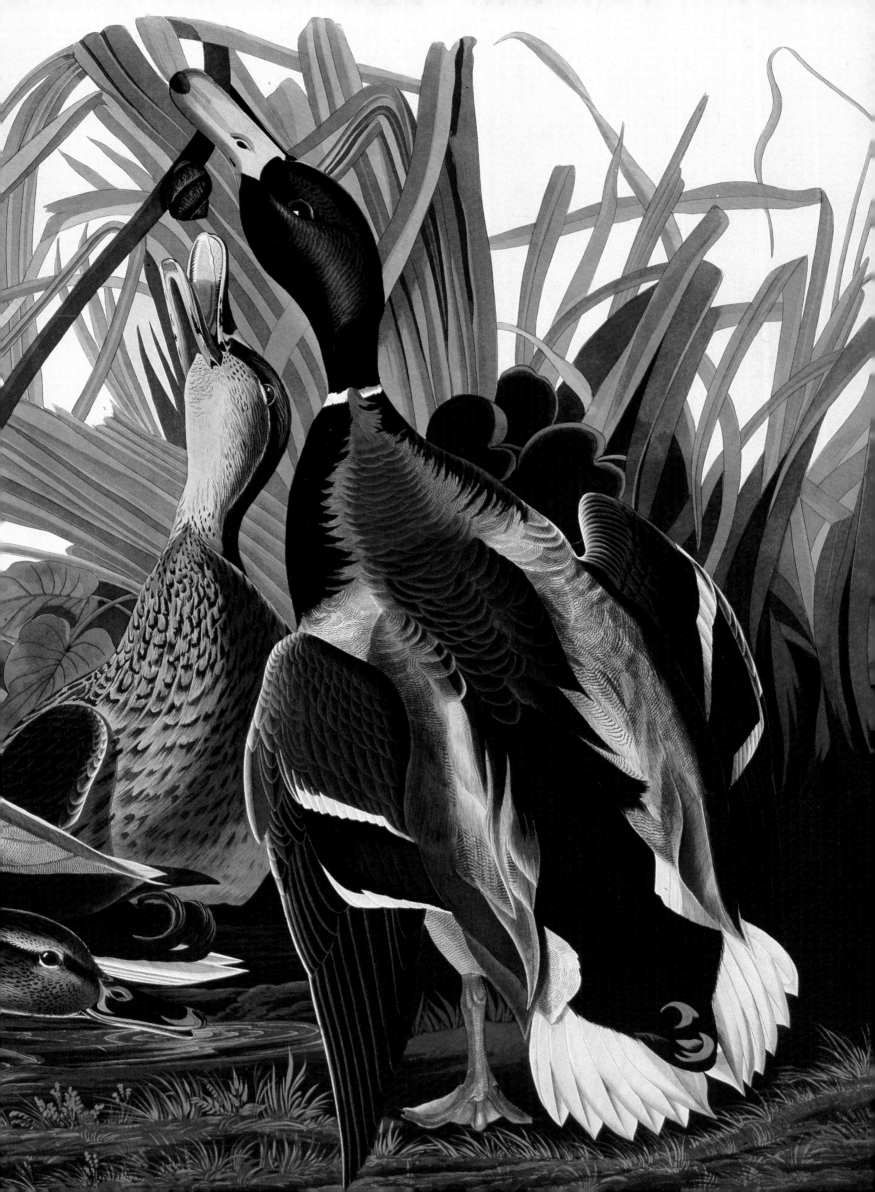

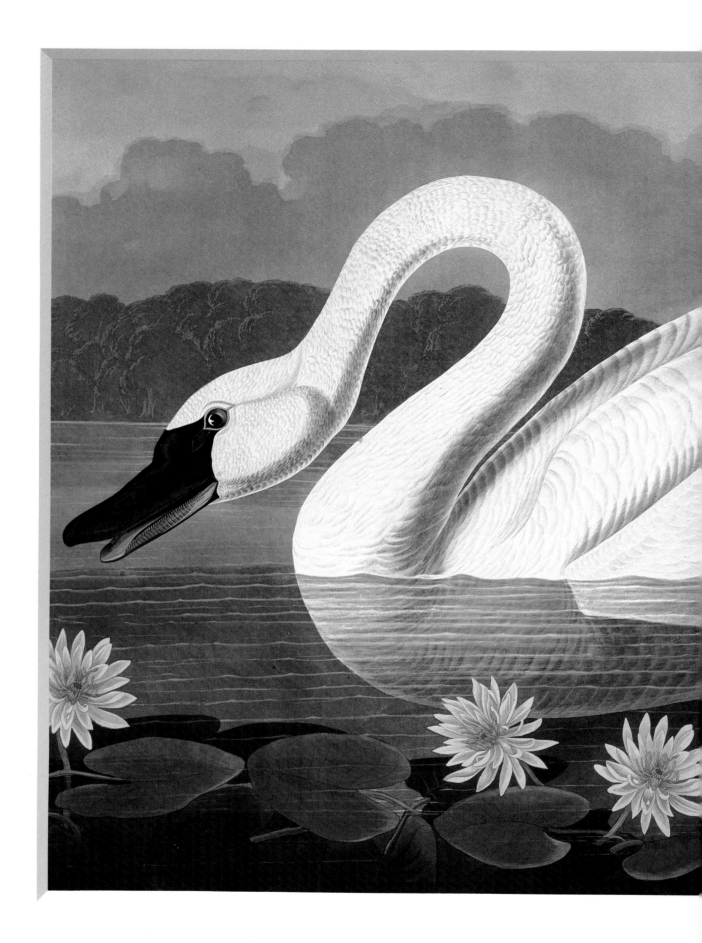

MALLARD
..................................
*Anas platyrhynchus*. Aquatint from *The Birds of America*.
Audubon drew these dabbling ducks and drakes in
Louisiana or Mississippi between 1821 and 1825.
(*PREVIOUS PAGE*)

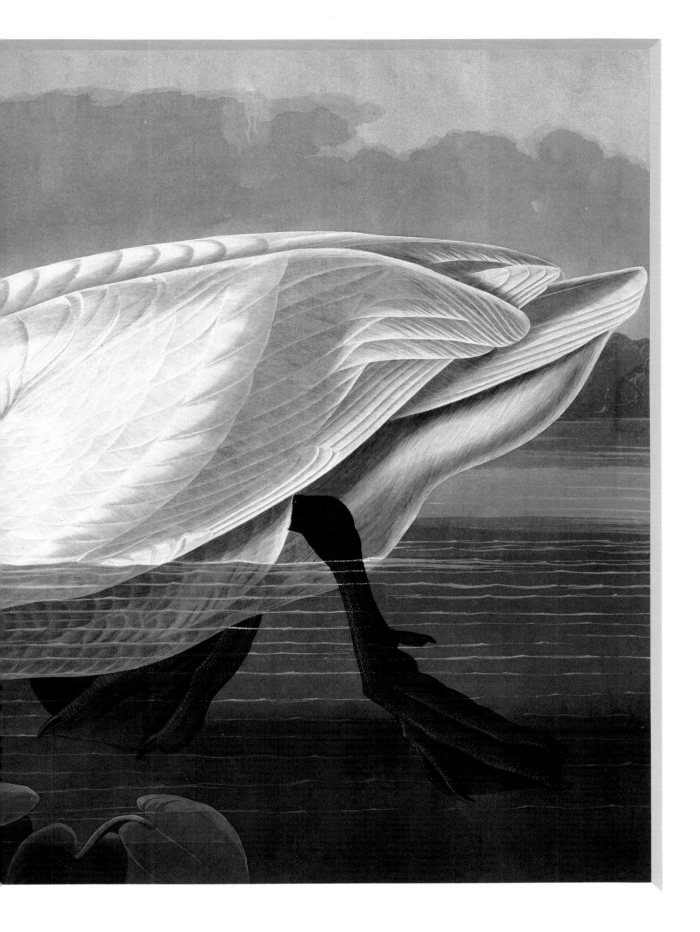

WHISTLING SWAN

*Cygnus columbianus*. Aquatint by R. Havell from *The
Birds of America*. The yellow waterlillies were long
thought to be Audubon's invention, but were
rediscovered in 1876 and are today known as *Nymphaea
mexicana*. (ABOVE)

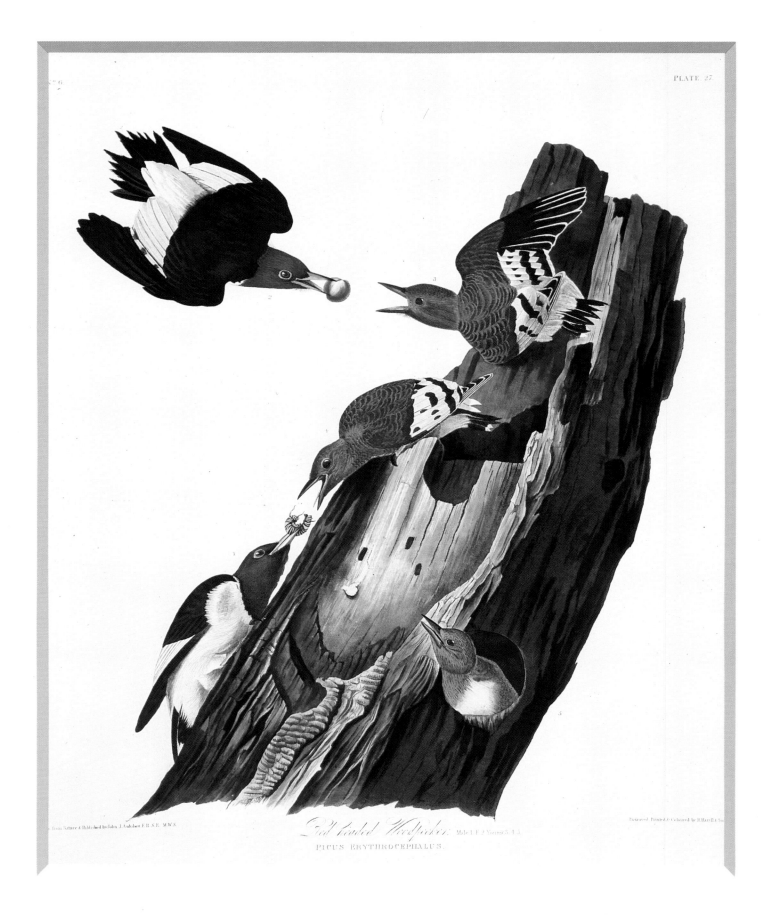

RED-HEADED WOODPECKER

*Melanerpes erythrocephalus*. Aquatint by R. Havell from
Audubon's *The Birds of America*.

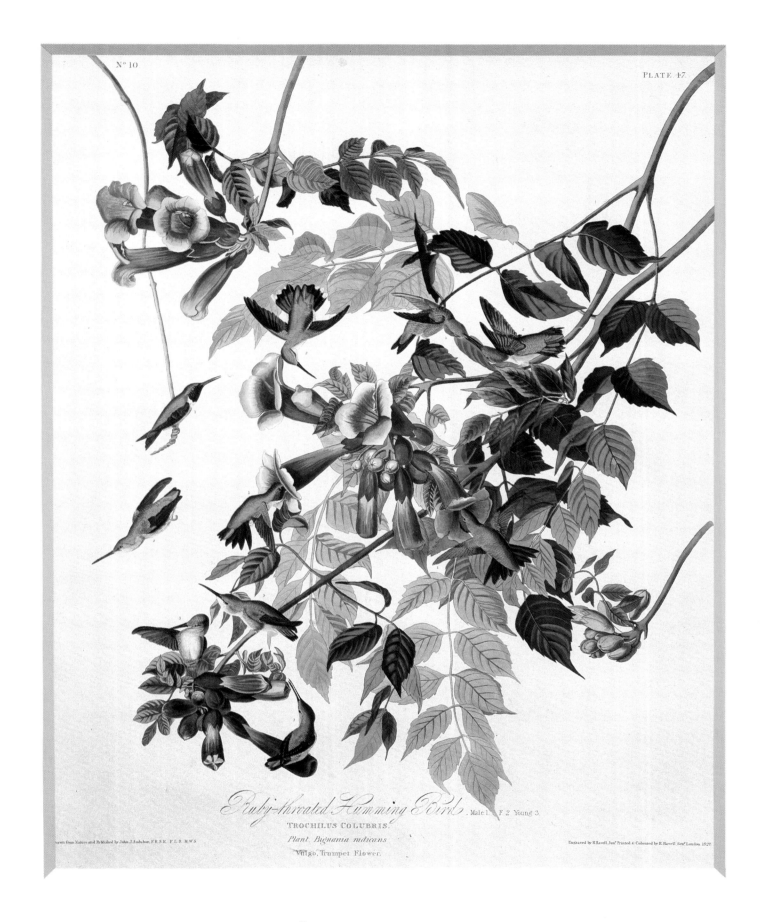

Nº 10

PLATE 47.

*Ruby-throated Humming Bird*. Male 1. ♀ F 2 Young 3.

TROCHILUS COLUBRIS.

*Plant, Bignonia radicans*

*Vulgo, Trumpet Flower.*

Drawn from Nature and Published by John J. Audubon, F.R.S.E. F.L.S. M.W.S.

Engraved by R.Havell, Junᵗ Printed & Coloured by R. Havell Senᵗ London. 1829.

### RUBY-THROATED HUMMINGBIRD

*Archilochus colubris*. From *The Birds of America*. These tiny birds migrate 2000 miles from Central America to the eastern USA, and Audubon probably saw them in Louisiana.

make life-size plates exactly to his specifications. There he met the well-known engraver William Home Lizars, who was then at work on Prideaux John Selby's *Illustrations of British Ornithology* (1821–34), a book of large-scale plates. Some of Audubon's illustrations were to be much larger, a size known as 'double elephant' (54 × 43 in/137 × 109.2 cm) and Lizars offered to engrave five plates to be published at Audubon's own expense. The first was the majestic wild turkey, a truly American bird which Benjamin Franklin once suggested would be more suitable as the symbol of America than the rapacious bald eagle. Audubon's plates are magnificent examples of the aquatint process, a method of tonal etching designed to imitate the soft tones of wash drawings. These black and white prints were coloured by hand using Audubon's magnificent paintings as models.

Audubon now had to find prospective subscribers. He wanted two guineas for each part of five plates, and intended to issue eighty parts (the four volumes finally consisted of 435 illustrations and 87 parts). After arriving in London he was dismayed to learn that a strike by Lizars' colourists in Edinburgh had caused a halt in production, and Lizars could only promise some black and white prints which could be coloured in London. In desperation, Audubon approached another well-known engraver, Robert Havell (1769–1832), and was fortunate to also meet his son, the younger Robert Havell, who had previously quarrelled with his father.

Now reconciled, father and son agreed to take on the momentous task of aquatinting all Audubon's birds and arranging for their colouring. The first plates by Lizars were reworked, and over a period of eleven years the set of 435 plates was completed. It was a tremendous undertaking, and the success of *The Birds of America* is largely due to the Havells' flair for interpreting in aquatint the liveliness of Audubon's paintings and supervising the careful hand colouring of the enormous prints.

About halfway through publication the elder Robert Havell retired, and he died in 1832, leaving the responsibility for the production of the remaining plates to his son. Audubon greatly esteemed the younger Havell's work, and when he was away from London seeking subscribers, he was able to rely on the latter's artistic expertise to carry out details of plants and landscape from his sketches and pencil notes. Havell maintained his contacts with the New World after the completion of the prints, emigrating to America with his family in 1839. He settled at Sing Sing and Tarrytown on the Hudson River, where he continued his work as a painter and engraver.

While the plates were in preparation Audubon returned to American to gather more material, and made expeditions to Florida, Texas and Labrador. In Florida and South Carolina he was accompanied by a young Swiss artist, John Lehman, who contributed the evocative landscape backgrounds for Audubon's more elaborate prints of the snowy egret, spoonbill and brown pelican.

Audubon regarded himself as a 'true son of nature', collecting his own specimens and observing creatures in the wild. In order to capture the living likeness of a bird he used a unique method: he pierced his recently killed birds with wires through their wings, head and body, and secured them on boards positioned against squared paper the same size as the squared paper on which he was working. He then painted them as rapidly as possible before their colours faded, using a combination of pencil, pastel, watercolour, ink, oil and egg-white. Many of these studies are preserved in the collection of the New York Historical Society.

Critics of Audubon's work feel that some of his birds, such as the flamingo and bald eagle, are over-theatrical, with exaggerated and even contorted movements. But it should be appreciated that he was a pioneer in showing birds in movement and recording their actions with an animation seen in no other illustrator's work. His pictures show the characteristic activities of the birds: the mallard ducks shuffle through the undergrowth; the swan glides through the water near some waterlilies; the egret struts in the marsh, the humming-birds dart among the trumpet-flowers, and the abundant flock of Carolina parakeets (now extinct) tear at the seeds of the cocklebur.

The text is equally vivid, a good example being the description of the brown pelicans at Florida Keys: 'The Brown Pelicans are well aware of the time of each return of the tide, as the most watchful pilots. Though but a short time before they have been sound asleep, yet without bell or other warning, they suddenly open their eyelids, and all leave their roosts, the instant when the waters … resume their motion … they can judge with certainty the changes of weather … Indeed, most sea-birds possess the same kind of knowledge … and the best of all prognosticators of the weather, are the Wild Goose, the Gannet, the Lestris, and the Pelican.'

Audubon's achievement was to give bird illustration a new vision and excitement far removed from the stereotyped imagery of the past. Despite the many vicissitudes of his life, he fulfilled his dream of illustrating all the known birds of American in large-size plates. He died a famous man in 1851, at his family home, 'Minnie's Land', overlooking the Hudson River near New York.

CAROLINA PARAKEET
..................................................

*Conuropsis carolinensis*. Aquatint from *The Birds of America*. These parrots, which Audubon painted in Louisiana in 1825, showing them eating cockebur seeds, were considered pests. They were hunted and finally exterminated – the last one died at Cincinnati Zoo in 1918.

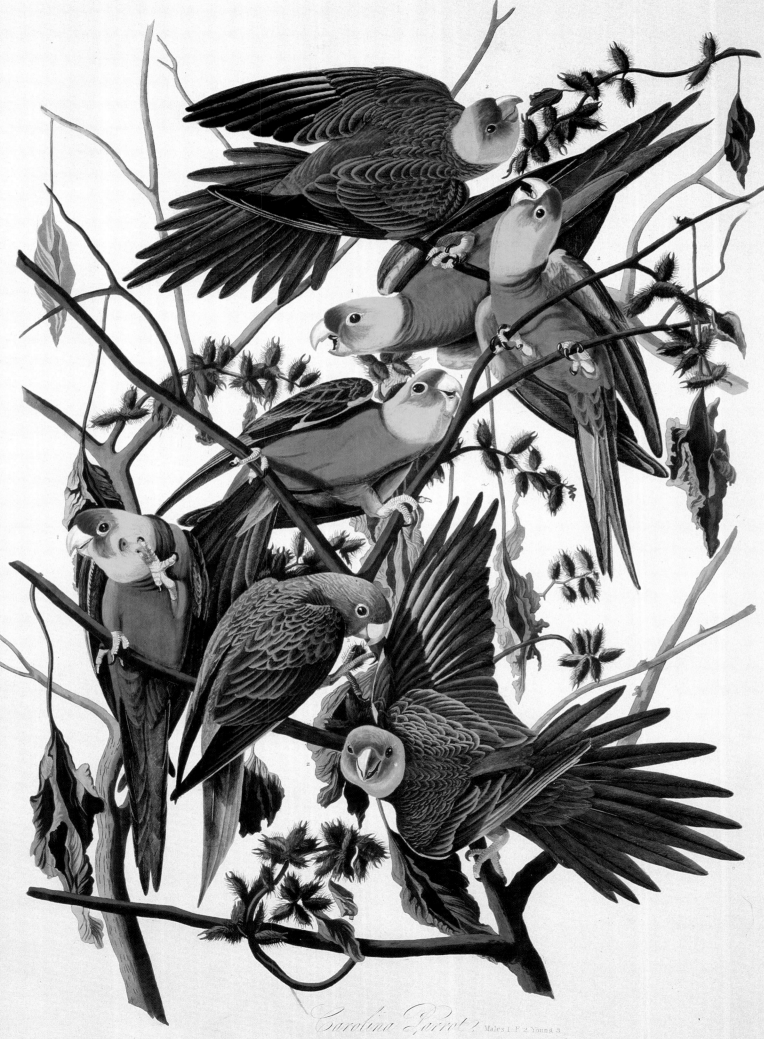

*Carolina Parrot* Males 1. 2. Young 3

PSITACUS CAROLINENSIS.

*Plant Vulgo. Cuckle Burr.*

Drawn from Nature & Published by John J. Audubon, F.R.S.E. M.W.S.

Engraved, Printed, & Coloured by R. Havell & Son, London.

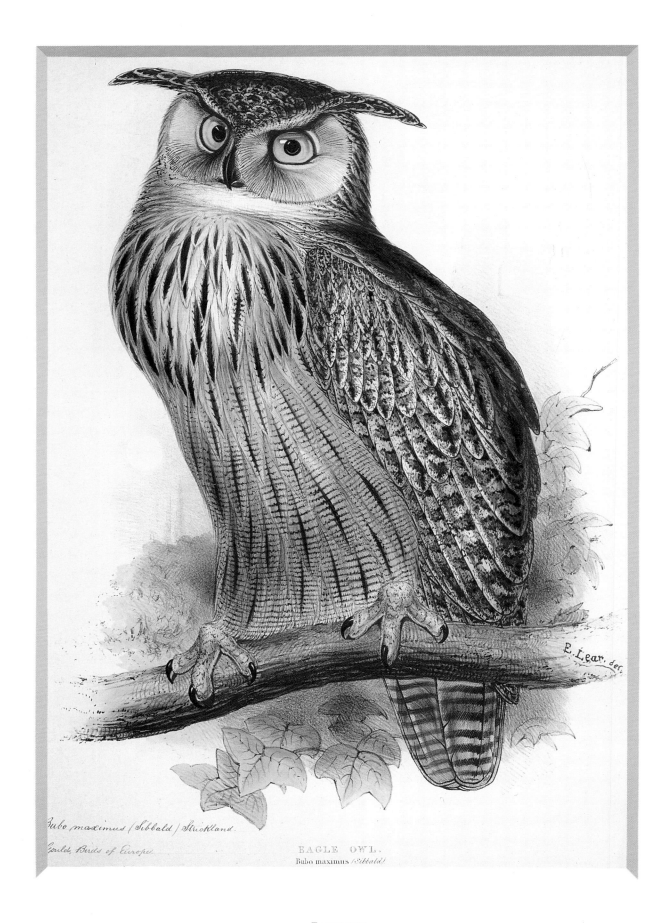

*Bubo maximus (Sibbald) Strickland.*

*Gould, Birds of Europe.*

EAGLE OWL.
Bubo maximus (Sibbald)

E. Lear, del.

### EAGLE OWL
...................................................
*Bubo bubo.* The largest European owl, drawn three-
quarters life size and lithographed by Lear for Gould's
*Birds of Europe.* In his comic drawings Lear sometimes
caricatured himself, with his large round spectacles, as a
great owl.

# The Great Illustrators:
## from Thomas Bewick to Edward Lear

In the late eighteenth century, as the Romantic movement gathered strength, a new interest in nature grew up, both in the wilder aspects of landscape and the familiar flowers and birds of the countryside. Commonplace things seen on everyday walks were no longer taken for granted, and poems were dedicated to daisies, daffodils, mice or a sparrow's nest full of eggs. Writers and naturalists felt that many of the riches of the natural world were unappreciated by country people, who not unnaturally regarded wild animals and plants as vermin or weeds only fit to be killed or controlled.

### GILBERT WHITE AND THOMAS BEWICK

Foremost amongst the natural history writings of this period is Gilbert White's *The Natural History and Antiquities of Selborne*, published in 1789. This account of rural life in an obscure village in Hampshire, England, has passed through some hundred editions, and its delightful informal style of writing is still fresh and easy to read today.

The Reverend Gilbert White (1720–93) was a curate at Selborne, where he was born, and lived for more than sixty years in a house called The Wakes built by his clerical grandfather. He left the area to go to school in Basingstoke and then to university, at Oriel College Oxford, and later sometimes went away on travels by horseback through the south of England, but he always regarded Selborne as his home. For most of his life he worked in a parish either there or in the neighbourhood, and refused all offers of preferment as this would have meant leaving his beloved countryside.

As a young man White had the usual country gentleman's interest in shooting and fishing, but in 1751 he began to keep a garden and natural history diary. Through his brother, Benjamin White, a London publisher and bookseller, he came to know the leading zoologist of the day, Thomas Pennant (1726–1798), author of *The British Zoology* (1761–66), who invited him to write letters concerning his discoveries about local birds and animals. White was forty-seven when he first wrote to Thomas Pennant and thus laid the foundations for his own book, a compilation of natural history notes sent not only to Pennant, but also to another member of the Royal Society, the Hon. Daines Barrington, a Welsh barrister.

Although he frequently referred to the scholarly writings of Ray, Willughby and Linnaeus, he was an out-of-door naturalist, with a remarkable gift of conveying the enjoyment of walking through the countryside making observations and discoveries along the way. As he strolled through the grounds near Selborne, which were 'very abrupt, uneven country, full of hills and woods, and therefore full of birds', he listened to birdsong, and was able to differentiate between three very similar birds by their notes. The chiff-chaff had a 'harsh loud chirp', the willow-warbler a 'a sweet plaintive note', and the wood-warbler 'a sibilous shivering noise on the tops of tall woods.' In view of his accurate observations on the absence of swallows and martins in winter, it seems strange he never fully accepted the facts of migration, and was preoccupied with theories of hibernation.

'A good ornithologist should be able to distinguish birds by their air as well as their colours and shape; on the ground as well as the wing, and in the bush as well as in the hand' wrote White to Barrington in 1778. These requirements were met by the artist-naturalist Thomas Bewick (1752–1828), whose wood-engravings in *A History of British Birds* (1797–1804) depicted the birds of the Northumbrian countryside. Bewick's first major work, *A General History of Quadrupeds*, was published in 1790, the year after White's *Selborne*.

Bewick was the son of a farmer and tenant collier, born at Cherryburn, some twelve miles west of Newcastle, a village on a high bank above the Tyne. In his memoirs, he described himself as a high-spirited country boy 'almost constantly engaged in some mischievous prank or other' and sent to school to be 'out of harm's way'. At school he filled up the margins of his books with drawings, and elsewhere used gravestone slabs or the flags of the floor and hearth to do chalk pictures of birds and beasts.

At the age of fourteen, Bewick sadly left the countryside for industrial Newcastle, where he was apprenticed to the engraver Ralph Beilby, and learnt the hard discipline of metal engraving. The Beilby family were industrious and

MUTE SWAN, WREN, ROBIN, ROOK

*Cygnus olor, Troglodytes troglodytes, Erithacus rubecula, Corvus frugilegus*. Wood engravings by Thomas Bewick from *A History of British Birds*, 1797–1804. Bewick's name is associated with a swan, as in 1830 he was commemorated by a newly identified species called *Cygnus bewickii*. The 'Jenny wren' and 'Robin redbreast' were often paired together in English folklore and poetry.

highly gifted in many crafts, William Senior was a jeweller and goldsmith, while William Junior and his sister Mary were enamellers on glass specializing in heraldic cartouches – today their work is very highly prized. The young Bewick was trained in a wide range of engraving activities, he etched sword-blades and engraved clock-faces, coffin-plates, mourning rings, banknotes, letter headings and heraldic crests on silver. As Ralph Beilby was at his best in engraving on metal he gradually passed on wood engraving work to his apprentice, and Bewick used this technical knowledge to make illustrations for children's books and ballads. Some prints for *Gay's Fables*, which he sent to the Society for the Encouragement of the Arts, won him a seven-guinea prize.

Once his apprenticeship was completed, Bewick worked at his home in Cherryburn, then undertook a three-hundred-mile tour to Scotland, and finally visited London. After the kindness shown him by the Scots, his impressions of London were unfavourable. 'It appeared to me a World of itself where everything in extreme, might at once be seen – extreme riches – extreme poverty – extreme Grandeur & extreme wretchedness – all of which were such as I had not contemplated upon before' he wrote in his memoirs. He was pleased to return to his native village and enjoy the scenery of the Tyne, which seemed to him a paradise after city life.

Later, when he returned to Newcastle to work as Beilby's partner, he walked every week to his parent's home, observing the landscape in all weathers and seasons, undaunted by dark nights, floods or snowstorms. During his spare time he made book illustrations using the wood-engraving technique, and his *History of Quadrupeds* sold so well that he decided to embark on a similar book of birds. To gain more knowledge he consulted some borrowed copies of 'Albin's History of Birds, Belon's very old book, & Willughby & Ray &c . . . and Gesner's Natural History'. He also used Pennant's *British Zoology* and White's *Selborne*, but soon made up his mind to 'copy

EAGLE OWL

..............................................

*Bubo bubo*. An uncoloured etching from Thomas
Pennant's *The British Zoology*, 1761–66. This book was the
inspiration for the letters between Gilbert White and
Pennant which were later printed in *The Natural History
of Selborne*.

GREATER FRIGATE BIRD

*Fregata minor*. Etching by F.-N. Martinet from the Comte de Buffon's *Histoire naturelle: Oiseaux* 1784. This 'agile pirate' of the tropical ocean has an enormous wing span in proportion to its small body. It soars, glides and harasses other birds in the air, but is a poor swimmer and finds difficulty in rising from the water.

nothing from the Works of others but to stick to nature as closely as I could'. After making a series of watercolours from the stuffed models collected by Marmaduke Tunstall in the Wycliffe Museum, he began his engravings, but found 'a very great difference between preserved Specimens & those from nature, no regard having been paid at that time to place the former in their proper attitudes, nor place the different series of feathers, so as to fall properly upon each other'.

Accordingly, whenever possible he drew from live birds or used newly killed specimens supplied by sporting friends. While waiting for specimens he designed small vignettes or tailpieces placed at the conclusion of each text. These tiny wood engravings were closely observed country scenes which marvellously convey a feeling of atmosphere and weather – the howling wind, a continuous drizzle, a gale at sea or a crisp, cold day. All sorts of rural episodes are described with humour and pathos: a large snowman being built; a horseman entangled in a kite; children sailing toy boats; a woman confronting a bull at a stile; a carriage accident, or a body hanging from a gibbet. The backgrounds accompanying the bird portraits also contain small landscapes, for instance a view behind the rook shows a scarecrow in a ploughed field and a noisy rookery in the distance.

Bewick was a master of the wood-engraving technique, which differs from the woodcut in that vertically cut end-grain is used instead of plank wood cut horizontally along the grain. He obtained very fine detail by using sharp tools or burins to incise precisely into a small block of boxwood, and his cutting was so delicate that he could suggest the texture of grass or feathers and the lines of falling rain against the close-grained background of the wood. Although his birds are simple silhouettes, they never appear stiff or awkward because the markings of their plumage relate so perfectly to the surrounding sparkle of foliage, plants, tree bark or water.

*A History of British Birds* has always been immensely popular, and was praised by such diverse writers as William Wordsworth, Charlotte Brontë (in the opening pages of *Jane Eyre*), John Ruskin and Beatrix Potter. John James Audubon was also a great admirer, and in 1827, during his stay in England, took tea at Bewick's house in Gateshead, and also visited his Newcastle workshop. He found him 'a perfect old Englishman, full of life, although seventy-four years of age, active and prompt in his labours'. Bewick showed Audubon a small vignette cut in boxwood, of a dog frightened at night, on which he was working, and Audubon added, 'The old gentleman and I stuck to each other, he talking of my drawings, I of his woodcuts. Now and then he would take off his cap, and draw up his grey worsted stockings to his nether clothes; but whenever our conversation became animated, the replaced cap was left sticking as if by magic to the hind part of his head, the neglected hose resumed their downward journey, his

fine eyes sparkled, and he delivered his sentiments with a freedom and vivacity which afforded me great pleasure . . .' This friendly meeting of two very different personalities was summed up in Audubon's eulogy on Bewick's work: 'Thomas Bewick of Newcastle-on-Tyne [must] be considered in the art of engraving on wood what Linnaeus will ever be in natural history, though not the founder, yet the enlightened improver and illustrious promoter.'

## THE COMTE DE BUFFON

The works of White and Bewick are delightful examples of the empirical spirit of investigation into nature which also prompted such French writings as those of Diderot and the Encyclopedists. Among these, George Louis Leclerc, the Comte de Buffon (1708–88) was supreme in the field of natural history.

Zoological illustration in eighteenth-century France was dominated by his *Histoire naturelle, générale et particulière* (1749–1804), an encyclopedic series of forty-four volumes, including ten of birds.

A naturalist, philosopher and theorist, Buffon was appointed Keeper of the Jardin du Roi, the French zoological gardens, which for fifty years under his direction became the leading scientific centre in Europe. An indefatigable worker, he commenced a catalogue of Louis XV's 'cabinet of curiosities', which expanded to become an enterprise describing the whole world of nature. The task was so immense that he had several collaborators, and it was not completed until after his death.

Buffon's natural history volumes, illustrated by hand-coloured etchings, were presented in a clear and attractive style, and became so popular that numerous editions, translations and adaptations were published in the nineteenth century. Many of the plates were drawn and etched by François-Nicolas Martinet, and two good examples of his simple and striking pictures are the great frigate bird and the avocet. The belligerent frigate bird swoops down to force other seabirds to drop or disgorge their food for its benefit, while the avocet, a more timid bird, is shown in silhouette, with its characteristic bill portrayed in profile.

## THE CLASSIFICATION OF SPECIES

Ornithologists through the centuries had been faced with the knotty problem of birds' names. As far back as 348 BC Aristotle had started to list them, and Pliny added further names, but the discovery of more and more species led to a chaos of nomenclature, and the use of colloquial names, which differed from country to country, caused more confusion. A clear example is the robin, which in America is a thrush, but called a robin because its red breast reminded the settlers of the familiar European bird. Some old English names given to birds were very descriptive, for instance

AVOCET

*Recurvirostra avosetta.* Etching from the Comte de
Buffon's *Histoire naturelle.* (ABOVE)

AZURE KINGFISHER

*Ceyx azureus.* From William Swainson's *Zoological
Illustrations,* 1st series, 1820-23. This was the first bird
book printed in Britain illustrated by hand-coloured
lithographs. (RIGHT)

26

82.

the 'green-legged horseman' for today's greenshank, or the 'great ash-coloured butcher bird' for the great grey shrike. Names could be chosen for a variety of reasons, colour, shape, song or habits, as signified by the yellow-hammer, pintail, cuckoo and the woodpecker.

The immense problem of devising an overall name system was solved by one man, the Swedish naturalist Carolus Linnaeus (1707–78), who in 1758 introduced his classification. Every plant and animal was given two names (the binominal system), one denoting genera and the other the species, based on the Latin or Greek languages which were universally understood by scholars of the time. Linnaeus said that 'The first step of science is to know one thing from another. This knowledge consists in their specific distinctions; but in order that it may be fixed and permanent distinct names must be given to different things, and those names must be recorded and remembered.' Linnaeus himself named many birds, and it became recognized that when new species were named priority was given to the first person to describe the unrecorded specimen in print. The Linnaean system is still used today, although many of the old Latin and English names are changed and adapted to accord with the latest scientific research.

The Linnean Society of London was founded in 1788, ten years after Linnaeus's death, to promote his system and to house his collection of plants, animals, books and manuscripts (purchased by Sir James Edward Smith after a dramatic visit to Sweden in 1784). Among the new birds recorded was Bewick's swan, *Cygnus bewickii*, which was recognized as a different species from the similar whooper swan. It was named by the naturalist author William Yarrell in memory of Thomas Bewick, as a tribute to the engraver's 'beautiful and animated delineations of subjects in natural history'.

Linnaeus' list of bird species increased dramatically during the early nineteenth century which was a period of great interest in the natural history of the expanding colonies of Britain and other nations. Vast numbers of newly discovered plants and skins reached Europe from remote parts of Australia, India, Africa and South America, collected by travellers, traders and colonial officials, and the classification of new species became an obsession. Linnaeus had listed 444 bird species; in 1801 Latham increased this to about 3000, and in 1862 Sir Richard Owen (later the first director of London's Natural History Museum) mentioned a total of over 8000.

## WILLIAM SWAINSON

Many of these new scientific findings were described and illustrated in large series of volumes with lavish plates using the latest printing techniques and expertise in hand colouring.

The magnificent works of Selby, Lear, Audubon and Gould were to dominate the period, but a precursor of these great illustrators was William Swainson (1789–1855). A versatile zoologist, Swainson was the first natural history artist to use the process of 'drawing on stone' (lithography) for the small plates of his *Zoological Illustrations of new, rare or interesting Animals* (1820–23). The process had been invented in 1796 by the Bavarian, Aloys Senefelder (1771–1830), initially as a cheap method of reproducing musical scores.

Born in Liverpool, the son of a customs officer, Swainson spent his early manhood with the British Mediterranean Army stationed in Sicily. Here he amassed shells, insects and bird specimens, and his collections were enlarged during explorations in Brazil from 1816 to 1818. On his return to England his zoological writings and illustrations earned him great respect from fellow members of the Linnean Society, but unfortunately, in the 1830s, his interest in an unaccepted form of classification proposed by William MacLeay and called the 'quinary system' brought him some discredit. He also quarrelled with Audubon about assistance with a text, *Ornithological Biography*, to be written to complement *The Birds of America* – Audubon, whose native language was French, needed help with his written English. The two could not agree over financial terms and acknowledgments, and the situation was exacerbated by Audubon's request for board and lodgings for himself and wife in the Swainson's home. The *Ornithological Biography* was eventually edited by a Scottish naturalist, William MacGillivray. All these difficulties and disappointments caused Swainson gave up his work in England, and in 1840 he emigrated with his family to a farm in New Zealand.

Swainson used the lithography process because it was less expensive than the elaborate and time-consuming etching and engraving techniques, but the full potential of the process had not yet been recognized, and his birds have fine, neat outlines as if they were engravings. The beauty of these early lithographs lies mainly in their superb hand colouring, done by a Mr Bayfield, whose address in Walworth is on the underside of a print used as a 'pattern',

MEXICAN TROGON

*Trogon mexicanus Swainson*. Lithograph by Swainson from *Zoological Illustrations*, 2nd series, 1829-33. The secretive sedentary trogons live in the tropical forests, their bright colours concealed by the broken sunlight and shadow of their leafy jungle habitat.

with colour instructions written by Swainson. The same colourist, with his assistants, later became responsible for the expert work in most of Gould's early volumes as well as Lear's Knowsley menagerie lithographs. The colourists of the nineteenth century played a vital role in bird illustrations, and it is unfortunate that much of their work is unacknowledged and only a few of their names or workshops have been recorded.

Swainson depicted single birds in simple backgrounds, and even though his pictures were painted from skins, the birds seem colourful and realistic. The kingfisher from Australia is a glowing azure colour, and the sedentary trogon from the tropical American forests has a soft red chest contrasting with the dark leafy greens of its wings and body. On the Brazilian lakes Swainson saw a jacana which had 'long toes spreading over a wide surface enabling it to walk on floating leaves of acquatic plants'. These birds are sometimes called lily-trotters and his text explains why. 'In such situations their appearance is really delusive; for their pressure being sufficient to sink the supporting leaf just below the surface, the birds actually appear to walk upon the water.'

## EDWARD LEAR AND JOHN SELBY

In April 1828, two years after its foundation, the Zoological Society of London opened its gardens at Regent's Park to a public fascinated by the prospect of seeing the unusual birds, reptiles and mammals of other lands. Among the visitors in its first years was the young Edward Lear (1812–88), a bird and animal artist, who had obtained permission to draw live parrots in the Zoological Gardens and at a temporary aviary housed in the Society's museum. Lear later became famous for his limericks and comic verse, but ironically, he only wrote these as a relaxation from his serious work: by profession he was a natural history illustrator, landscape painter and travel-book journalist.

Lear's childhood was often sad. He was born in 1812, at Upper Holloway, a rural suburb of north London, and came from a large family of twenty-one children, many of whom died in infancy. As the last but one child, he was neglected by his hard-pressed mother and looked after by older sisters. His father, a stockbroker, suffered frequent fluctuations in fortune, and at one period in Lear's childhood, due to financial losses, the house was let and the family divided. Lear was a delicate child, frequently ill with asthma, bronchitis, epilepsy and bouts of depression

called 'the morbids', and had always to wear spectacles because he was shortsighted.

Illness prevented him from having much formal school education, and he was encouraged by his sisters to draw and write. He enjoyed painting and later recalled that some of his happiest moments were spent copying animals from the encyclopedia volumes of the Comte de Buffon's *Histoire Naturelle*. In the 1820s Lear stayed with a married sister near Arundel, Sussex, and from there visited Petworth, the home of the Earl of Egremont, patron of the great landscape painter J. M. W. Turner, and collector of fine works of art. This aroused Lear's interest in art, which was further fostered by Mrs Godfrey Wentworth, daughter of Walter Ramsden Fawkes of Farnley, another of Turner's patrons. About 1828–31 he met Prideaux John Selby, an eminent naturalist, Fellow of the Linnean Society, and publisher of *Illustrations of British Ornithology* (1821–34).

Selby (1788–1867) was born in Alnwick, Northumberland, and was a highly respected country gentleman and landowner, becoming a deputy lieutenant and high sheriff of his native county. When a young man, he inherited a large estate situated a few miles inland from Bamburgh and the Farne Island, called Twizell House, which later became a friendly meeting place for natural historians.

Selby had a large collection of skins of both English and foreign species, and made records of birds he had seen in the field. The majority of the pictures for *British Ornithology* were the result of a close collaboration with two naturalist friends, his brother-in-law Captain (later Admiral) Robert Mitford and Sir William Jardine. The three men made careful bird studies in pencil, ink, watercolour and gouache, which provided the reference for etchings on large copper plates made by Selby and sometimes Mitford. These were taken to Edinburgh, and after further finishing touches – burnishing and further etching – were expertly printed in the professional workshop of William Home Lizars, producer of Audubon's first magnificent plates.

In Selby's prints, on a scale almost as large as Audubon's great volumes, the birds were nearly all shown life-size. It has been claimed that these magnificent hand-coloured prints were the finest etchings of British birds ever made; Selby's work has an accuracy and majesty that surpassed any previous ornithological volumes. He used to perfection the traditional format of a silhouetted bird grandly posed on a branch or placed on the ground against the indications of an appropriate background. Unfortunately his prints were issued at the same period as Audubon's

AFRICAN JACANA

*Actophilornis africanus.* Lithograph by Swainson from
*Zoological Illustrations,* 2nd series. Swainson saw these
'lily-trotters', with their enormously long toes and nails,
walking on floating vegetation in Brazil, but the species he
illustrated here is one that came from Western Africa.

massive aquatints, and their classical beauty has been rather overshadowed by the American's more busy, flamboyant and dramatic style. Selby so much admired Audubon's work that in 1826, after seeing Audubon's exhibition in Edinburgh, he arranged for his friend Jardine and himself to take art lessons from the American. Audubon's comments on their progress were very tactful: he remarked that neither naturalist was superior, for while Selby was the more enthusiastic and therefore faster, Jardine worked with great exactitude but less speed.

The lavishly produced volumes published by the French ornithologist François Levaillant (1753–1824) in Paris are in the same grand tradition as the engraved works of Selby and Audubon. Levaillant employed the brilliant artist Jacques Barraband, the skilled etcher Jacques-Louis Pérée, and printers Langlois and Rousset for the sumptuously coloured prints in his *Histoire Naturelle des oiseaux de paradis et des rolliers* (1801–6).

Levaillant was born in Surinam, South America, travelled in South Africa from 1781–85, and was the first to describe and illustrate many African birds from the skins he collected. These, stuffed and mounted, were beautifully painted in exquisite watercolours by Barraband, with their trailing feathers fancifully arranged in artistic compositions. The prints based on these paintings were brilliantly successful due to their technical virtuosity; they were produced by an elaborate mixture of processes – engraving, etching, colour printing and hand-finishing. In one aspect, however, Levaillant's pictures were less advanced than the work of his contemporaries, for all his birds were shown as models on simple props without the hint of a landscape background.

When Edward Lear was nineteen he made a drawing and a watercolour of the great auk, which was used for Selby's etching in *British Ornithology*. Lear must have used a skin to draw from, as the greak auk was then rare – and is now extinct. Like the dodo, it was clumsy and flightless, and was slaughtered by sailors for its fat and feathers. The last recorded sight of the bird was in 1844 near Iceland, and in the late nineteenth century huge prices were paid for its skin and its very large eggs at auctions.

While living in London and sharing rooms with his older sister Ann, Lear initially earned small sums of money by colouring prints (at ninepence to four shillings each), painting fans and screens, and making 'morbid disease drawings, for hospitals and certain doctors of physic'. Through Mrs Wentworth, he obtained employment in drawing at the Zoological Society, and decided to embark on an ambitious project of compiling his own book depicting all the known species of parrots.

Like Swainson, Lear used the new method of lithography for his prints in *Illustrations of the Family of Psittacidae, or Parrots* (1830–32), but the process was now better understood. It was promoted in England by Charles Hullmandel (1789–1850), whose book *The Art of Drawing on Stone* (1824) described the soft tones and shading that could be achieved, particularly suitable for the fine details of landscape and natural history subjects. After making preparatory sketches and watercolour studies, Lear drew the outlines of the birds and the shading of their feathers onto the prepared slabs of limestone, which were then printed at Hullmandel's lithographic workshop and hand coloured by professionals, using Lear's pictures and colour notes as guides.

As he preferred to use live birds as his models, rather than stuffed specimens, his portraits of parrots have a marvellous liveliness and sense of immediacy. His skill as a watercolourist enabled him to describe the smooth downy plumage of the crested cockatoos or the ruffled spiky feathers of the exuberant macaws with sensitivity and accuracy. The colourists of the prints were thus able to capture the parrots' gaudy reds and blues and soft pinks and yellows to produce prints of breathtaking realism.

Lear's prints were a brilliant artistic achievement for a young man with little art training, and were compared favourably with Audubon's great work. Unfortunately Lear had little business flair, and did not make his proposition a financial success: although he found 175 subscribers, he was unable to obtain enough payments to cover the expenses of colourists and printing. As was then usual for luxury productions, the prints were issued in parts of four or five plates, and his room was cluttered with unsold sets of his lithographs. He wrote to a bookseller friend that his chairs were so overflowing with parrots prints that there was no space for visitors except to sit in the grate! After the twelfth part of his book and the forty-second plate was finished, he decided to give up his work on parrots, and produced no further text.

The president of the Zoological Society at the time was Lord Stanley, who invited Lear to visit his menagerie at Knowsley, near Liverpool, to make drawings of his collection of rare birds and animals. Lord Stanley, later 13th Earl of Derby, took an interest in breeding foreign zoological species and studying their adaptation to English climatic conditions, and in order to obtain examples of rare creatures he financed expeditions to West Africa, Honduras and the Hudson Bay territories. Lear worked at Knowsley at various times between 1832 and 1837, and some ten years after these visits his best watercolours were lithographed in *Gleanings from the Menagerie and Aviary at*

BRAZILIAN WOODPECKER

*Pica Braziliensis Swainson*. Lithograph by Swainson
from *Zoological Illustrations*, 1st series. Swainson saw
this bird during his travels through Brazil.

PLATE LXXIII.

GREAT CRESTED GREBE.

1. Adult. 2 Young after 2nd moult.

PLATE LXVI.

### SCAUP POCHARD, FEMALE
..........................................

*Aythya marila*. Etching by W. H. Lizars for Prideaux John
Selby's *Illustrations of British Ornithology*. A view which
is probably Lindisfarne (Holy Island) can be seen in the
background. In Selby's work care was taken to show the
vermicular markings of plumage which can be seen on the
duck's sides and back. *(ABOVE)*

### CORMORANT
..........................................

*Phalacrocorax carbo*. Etching by W. H. Lizars in Selby's
*Illustrations of British Ornithology,* showing the birds in
breeding plumage with white thigh patch. *(RIGHT)*

### GREAT CRESTED GREBE, ADULT AND YOUNG
..........................................

*Podiceps cristatus*. Etching by W. H. Lizars from Prideaux
John Selby's *Illustrations of British Ornithology*, 1821-34.
Hunted in England for their soft underpelts, and reduced
to less that a hundred birds in the late nineteenth century,
the grebes have since made a remarkable recovery in
numbers. *(PREVIOUS PAGE)*

PLATE LXXXIV.

COMMON CORMORANT.
Summer Plumage.

TAWNY OWL.

FIELDFARE, THRUSH, REDWING, BLACKBIRD
..........................................
*Turdus pilaris, Turdus philomelos, Turdus iliacus,*
*Turdus merula.* Etching by W. H. Lizars from Selby's
*Illustrations of British Ornithology.* (*ABOVE*)

TAWNY OWL
..........................................
*Strix aluco.* Etching by Prideaux John Selby for his
*Illustrations of British Ornithology.* This life-size owl is a
superb example of Selby's etching on a plate measuring
27in by 21½in. (68.6 × 54.6 cm.). (*LEFT*)

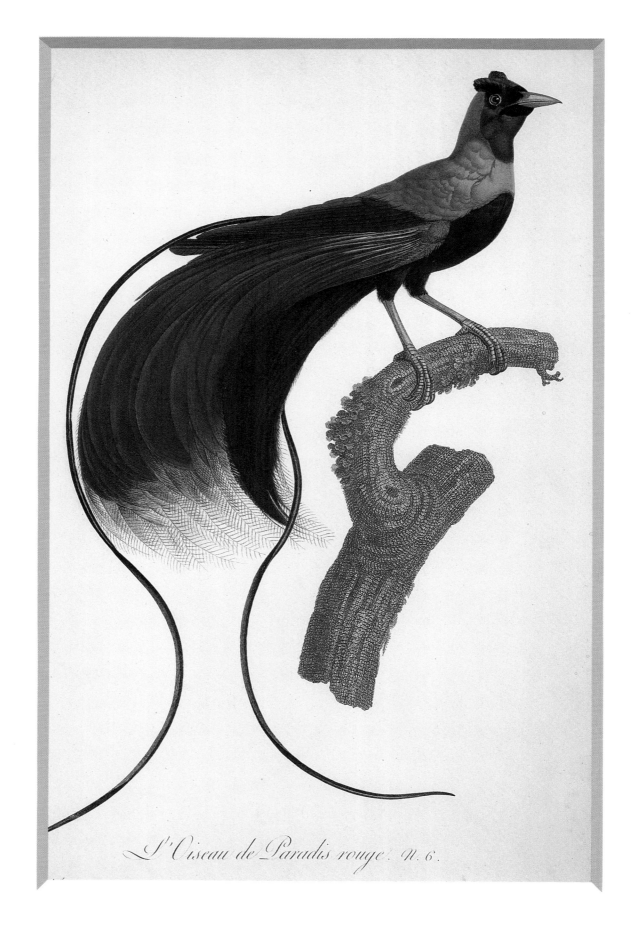

*L'Oiseau de Paradis rouge. n. 6.*

RED BIRD OF PARADISE

*Paradisaea rubra.* From François Levaillant's *Histoire
naturelle des oiseaux de paradis*, 1801–6. Colour-printed
engraving and etching by Perée with added hand
colouring, the drawing by Barraband.

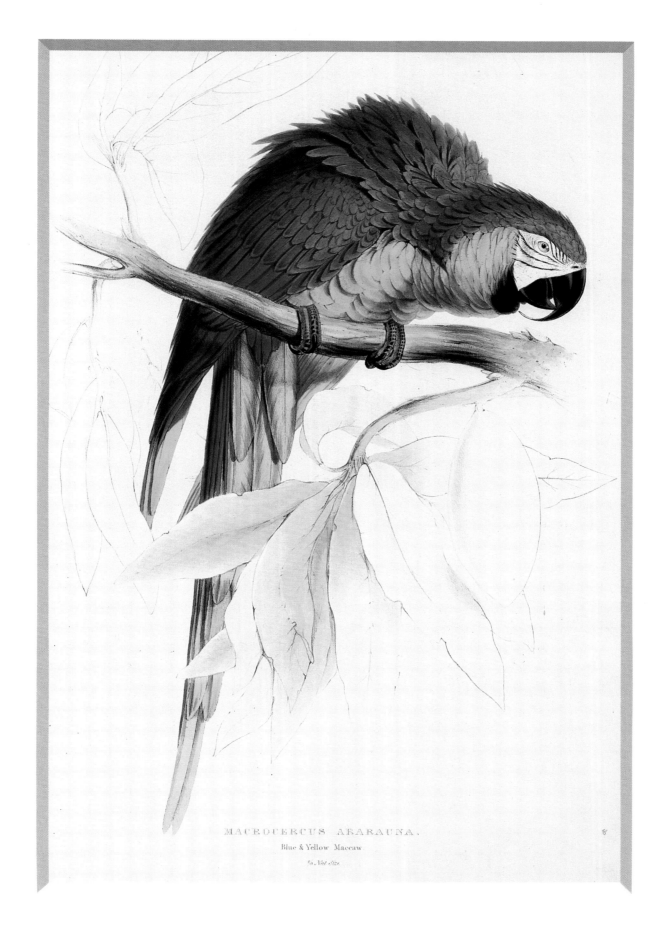

MACROCERCUS ARARAUNA.

Blue & Yellow Maccaw

### BLUE AND YELLOW MACAW

..................................

*Ara ararauna.* Hand-coloured lithograph from Edward
Lear's *Family of Psittacidae, or Parrots,* 1830-32. Lear
was only eighteen when he began drawing parrots from
life for this book, the first publication on a family of birds.

The Art of Bird Illustration

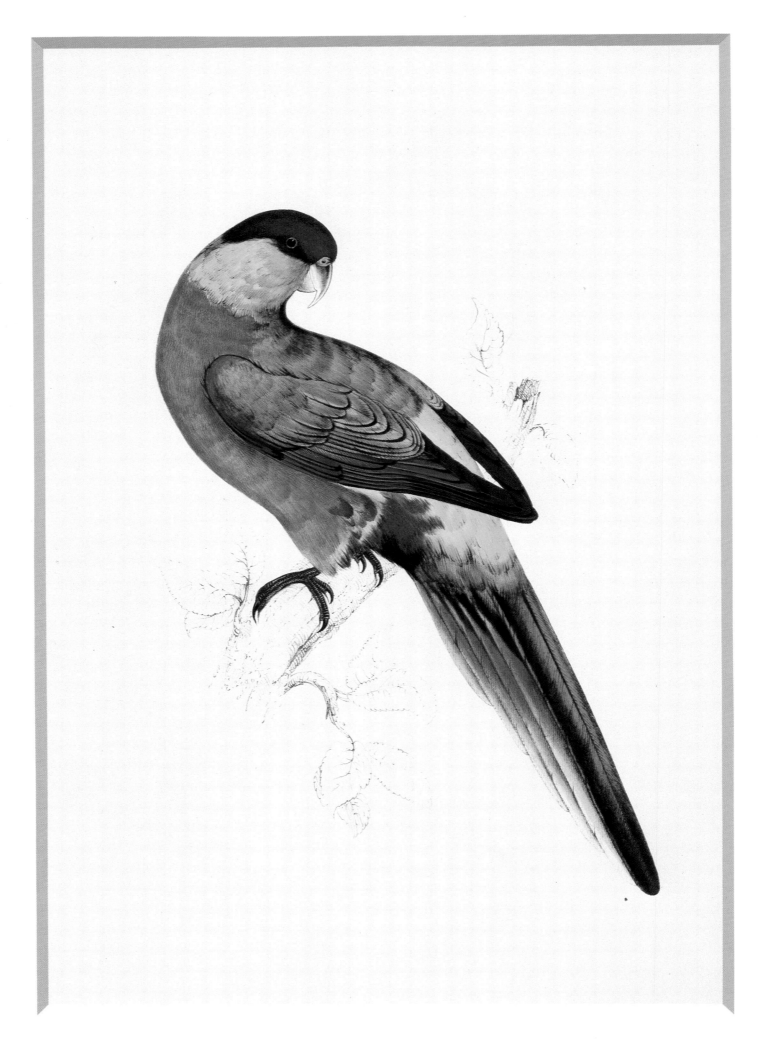

118

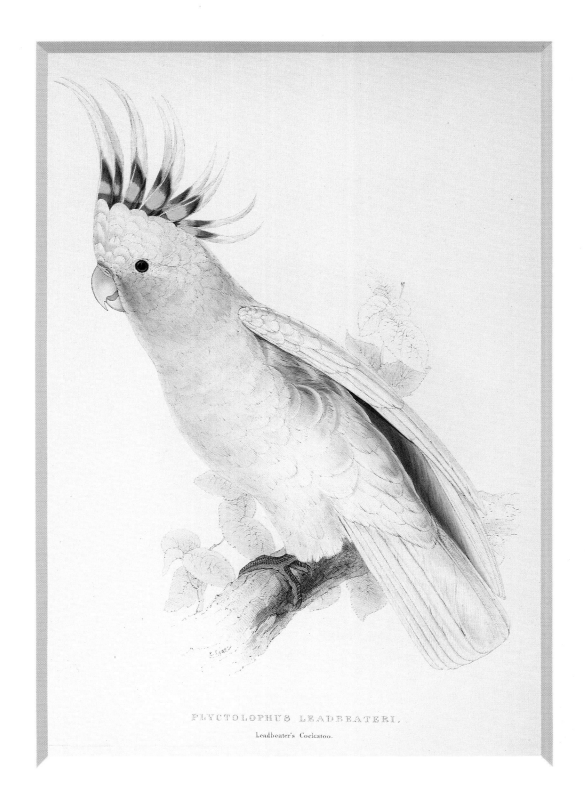

PLYCTOLOPHUS LEADBEATERI.

Leadbeater's Cockatoo.

### LEADBEATER'S, MAJOR MITCHELL'S, OR PINK COCKATOO

*Cacatua leadbeateri*. Lithograph by Edward Lear from *A Family of Parrots*. The bird was named in 1831 after Benjamin Leadbeater, founder of a well-known London firm of dealers in bird skins. *(ABOVE)*

### RED-CAPPED PARROT

*Purpureicephalus spurius*. Lithograph from Lear's *A Family of Parrots*. Drawn in 1831 from a bird living in the aviaries at Knowsley Menagerie. *(LEFT)*

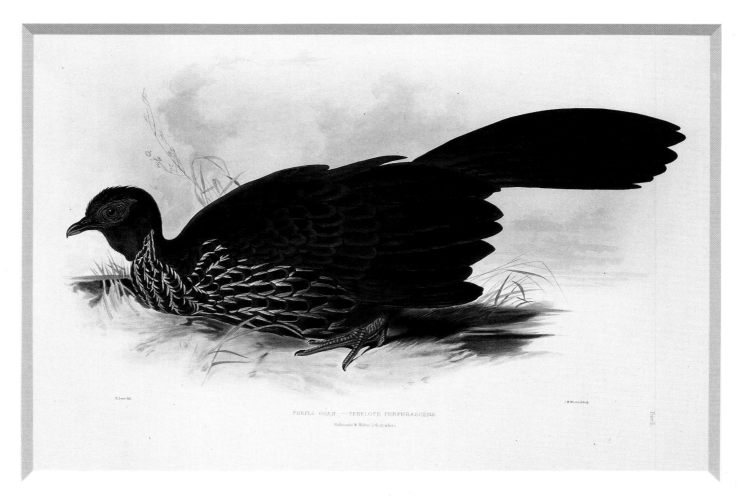

CRESTED GUAN

.......................................

*Penelope purpurascens.* Lithograph by J. W. Moore from
Lear's drawing in *Gleanings from the Menagerie and
Aviary at Knowsley Hall,* 1846.

*Knowsley Hall,* published in 1846. In the same year Lear's
first *Book of Nonsense* was issued, which also had its origins
in Knowsley Hall visits, as it was there that he developed
his comic talents by entertaining the younger members of
the large household.

## JOHN GOULD

.......................................

During September 1830 Lear drew the lesser sulphur
crested cockatoo in the Zoological Society's museum and
temporary aviary at Bruton Street, and there met the
curator, John Gould. About two years later, after Lear had
abandoned his parrot prints, Gould, who was embarking
on his own publications, bought Lear's remaining stock.
His idea was to complete the edition, but these plans were
never fulfilled.

Gould (1804–81) was born at Lyme Regis, Dorset, but
brought up in the Surrey countryside at Stoke Hill, near
Guildford. In 1818 his father was appointed gardener at

Windsor Royal Park, and Gould, aged fourteen, began to
follow the same trade. In his spare time he learnt to pre-
serve and mount specimens, and traded stuffed birds and
blown eggs with the scholars of nearby Eton College. After
a short time as gardener at Ripley Castle, Yorkshire, he
settled in London as a taxidermist, and in 1827 obtained
the position of 'curator and preserver' of the museum
collection of the Zoological Society. He also received
commissions from the royal family, and in 1829 helped to
stuff the first giraffe to come to England. This had been a
present to George IV from Mehemet Ali of Egypt, and had
died at Windsor Great Park less than two years after its
much celebrated arrival.

During the years 1830–32, when Lear was producing
his prints of parrots, Gould started his own first publish-
ing venture, *A Century of Birds from the Himalaya Moun-
tains* (1830–33), based on a collection of rare skins which
he had stuffed and mounted. As Gould himself was not an

ROSE-RINGED PARAKEET (YELLOW VARIETY)

.......................................

*Psittacula krameri.* Lithograph from Lear's *A Family of
Parrots. (RIGHT)*

WHISTLING SWAN.
Cygnus ferus; *(Ray)*

WHOOPER SWAN
..............................

*Cygnus cygnus.* Drawn and lithographed by Lear for
Gould's *Birds of Europe*, 1832–7. Gould called it a
whistling swan. (ABOVE)

TOCO TOUCAN
..............................

*Ramphastos toco.* Drawn and lithographed by Lear from
Gould's *A Monograph of the Ramphastidae, or Family of
Toucans*, 1st ed. 1833-5. Signed 'E. Lear del 1833'. Lear
later painted a live toco toucan at Knowsley Menagerie in
July 1836. *(LEFT)*

GANNET
..............................

*Sula bassana.* Drawn and lithographed by Lear for
Gould's *Birds of Europe*. When fledged, the juvenile bird
is black, which prevents it from being taken for a
trespassing adult. *(NEXT PAGE)*

123

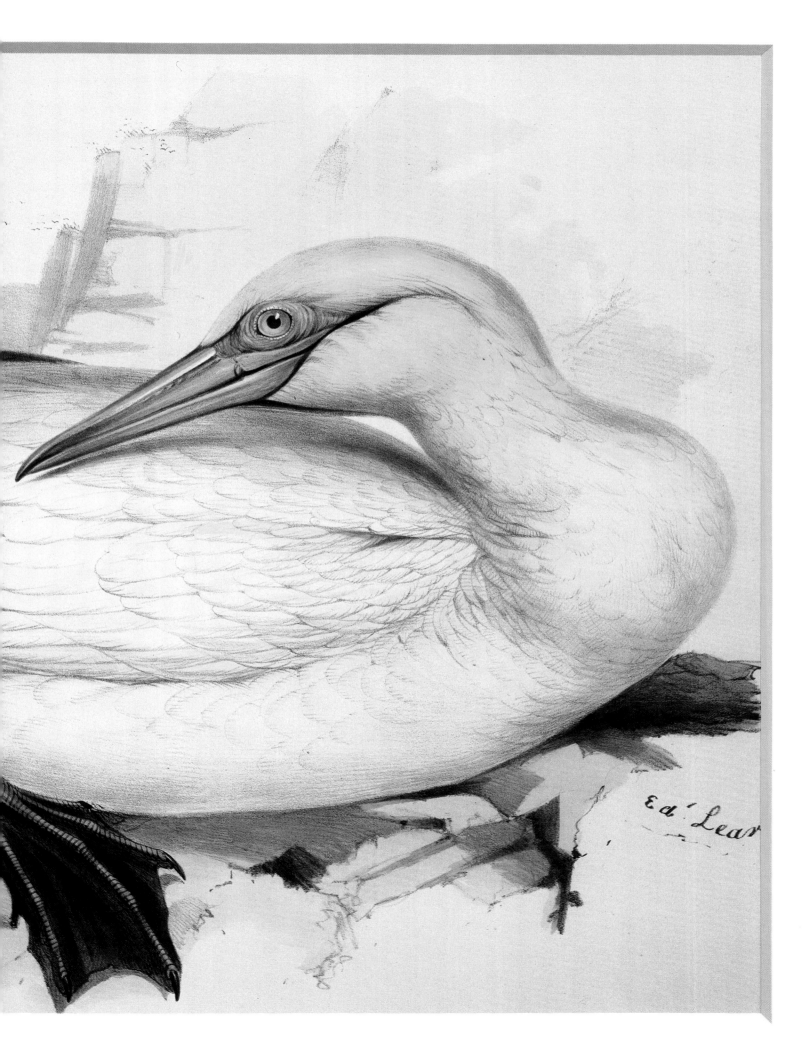

Ed.<sup>d</sup> Lear

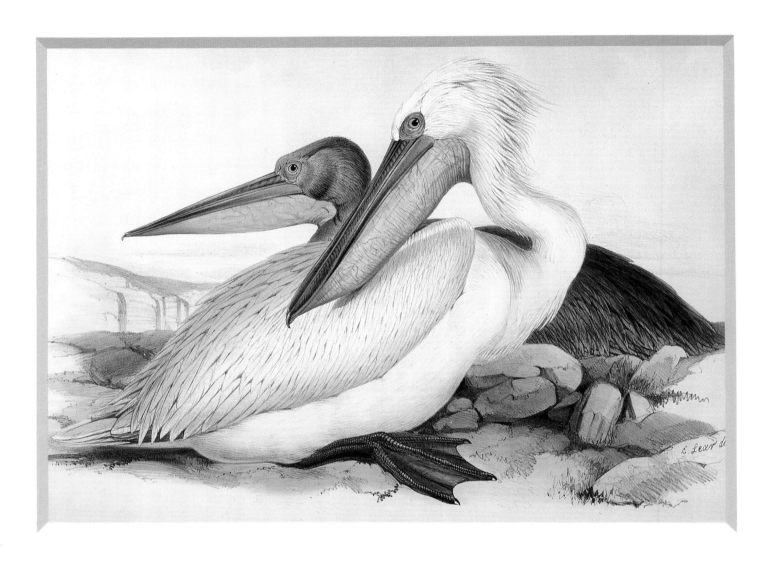

DALMATIAN PELICAN
...............................

*Pelecanus crispus.* Drawn and lithographed by Lear for
Gould's *Birds of Europe.* In 1849 Lear was amused to see
'many thousand of Pelicans all together' at Avlona, on the
west coast of Albania. The pelicans of the Nile inspired
'The Pelican Chorus', a nonsense poem set to music in
*Laughable Lyrics,* 1877. (*ABOVE*)

RAVEN
...............................

*Corvus corax.* The largest of the European crows, drawn
and lithographed by Lear for Gould's *Birds of Europe.*
(*RIGHT*)

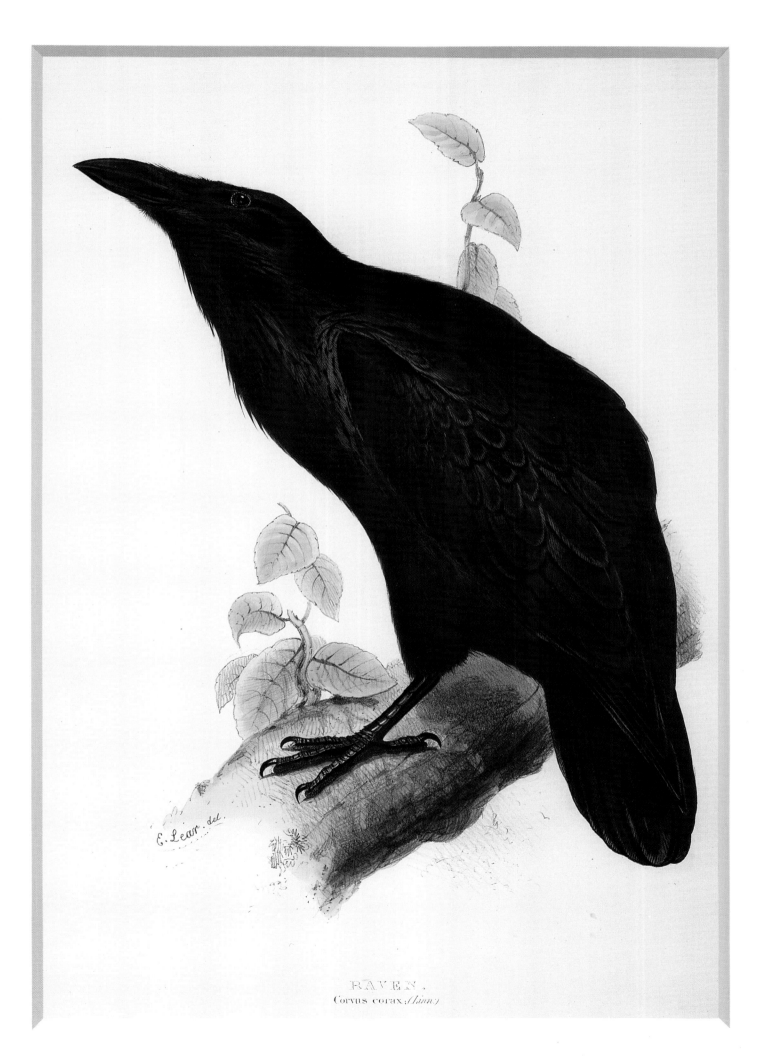

RAVEN.
Corvus corax, (Linn.)

expert draughtsman, he sought the assistance of his wife Elizabeth (1804–41), a former governess, who was talented in drawing. She carried out her husband's instructions, using his rough sketches as a basis for her watercolours and outline drawings on the lithographic stones. Like Lear's, these illustrations were printed by Hullmandel, produced in the same size and format, and coloured by hand. Unlike Lear, however, Gould was a shrewd businessman, and made his project a financial success, acquiring over 200 subscribers through his contacts at the Zoological Society and with royalty.

*The Birds of the Himalayas* was followed by further productions, *The Birds of Europe* (1832–37), *A Monograph of the Ramphastidae, or Family of Toucans* (1833–35) and *A Monograph of the Trogonidae, or Trogons* (1833–35). For these Gould employed Edward Lear to assist his wife with the drawings on stone; *The Birds of Europe* has about sixty-eight of Lear's plates, although his signature is not always present. The Lear prints are usually of the larger, more ungainly species, and the owls, stork, pelicans and vulture seem almost too large to be contained on the page. Lear accompanied Gould on visits to zoos and collections in Berlin, Rotterdam, Amsterdam and Berne, journeys which he recalled later as unhappy occasions. Gould, the self-made man, had brisk and demanding manners, which may have conflicted with Lear's more sensitive temperament.

Lear received much praise for his work, and through his connections with Gould and Lord Stanley was greatly in demand by other naturalists. But he found this excess of zoological work both exacting and restrictive, and often complained about poor health and eye strain. In 1836, in a letter to Gould written from Knowsley, he said that his eyes had become 'so sadly worse that no bird under an ostrich shall I soon be able to see to do'. The cold and damp of northern England did not suit him either. He longed to live in a warmer climate, and in 1837, inspired by an enjoyable sketching tour the previous autumn, he decided to give up zoological work and paint landscape, eagerly accepting an offer from the Derby family towards the cost of a journey through Europe to Rome. For the rest of his life he painted abroad, returning to England at intervals to complete work and arrange exhibitions. In later years, long after he had given up ornithological illustration, memories of his birds recurred in his nonsense verse, animating his fantasy world with strange owls, parrots, storks and pelicans.

### RESPLENDENT QUETZAL

*Pharomachrus mocino.* A double-folded page was needed for this lithograph by Elizabeth Gould for her husband's *Monograph of the Trogonidae, or Family of Trogons,* 1st ed. 1835–38. The quetzal is the national bird of Guatemala, where a coin, the quetzal, is the unit of currency. The name is derived from *quetzalli,* an Aztec word for the bird's long tail feathers.

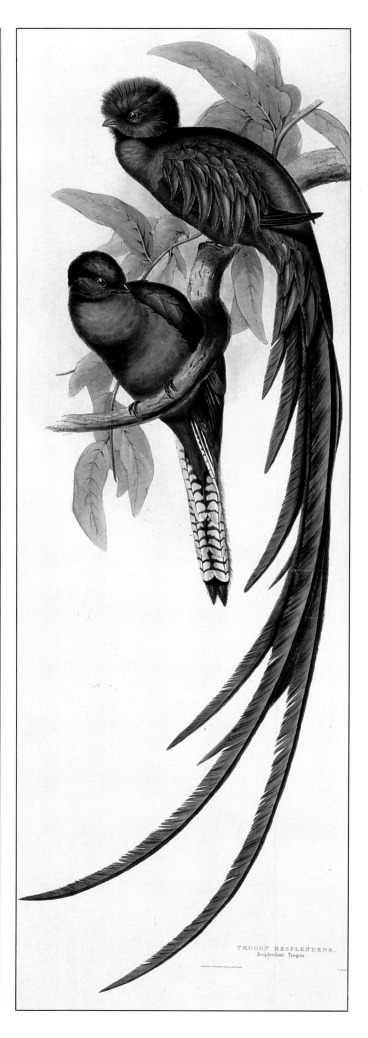

TROGON RESPLENDENS.
Resplendent Trogon.

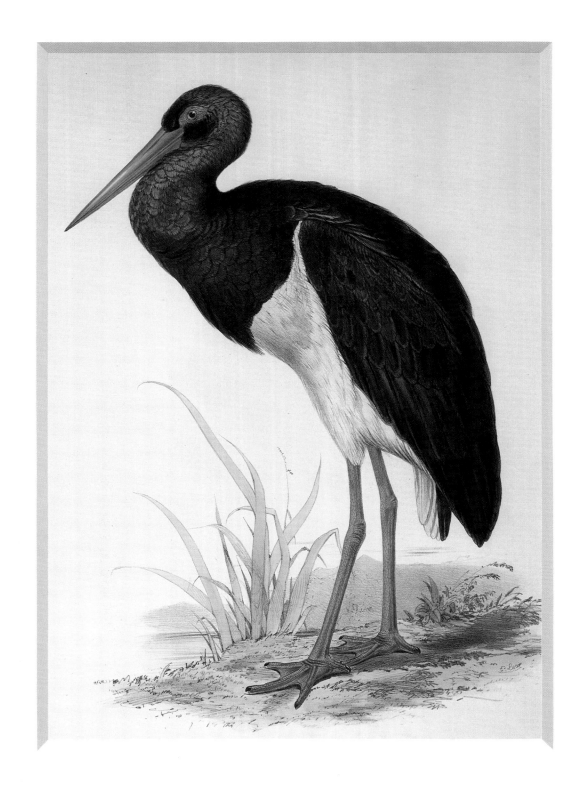

BLACK STORK

*Ciconia nigra*. Drawn and lithographed by Lear for
Gould's *Birds of Europe*. This stork nests on tall rocks or
trees and is seldom seen near buildings. It is rarer than
the white stork, since it has not been traditionally
protected as a good luck emblem.

**LAUGHING KOOKABURRA**

*Dacelo gigas.* Watercolour dated 1789 by George Raper,
midshipsman on HMS Sirius, a ship of the First Fleet.

# The Birds of Australia

'WHY WILL YOU CONTINUE to walk topsy-turvy so long? – for everyone knows, that the people in the Antipodes, being on the other side of the world, – must necessarily have their heads where their heels should be: when you come back you will all be puzzled to walk properly.' wrote Edward Lear to John Gould from Rome in 1839. He was referring to Gould's two-year expedition to Australia with his wife Elizabeth. By this time Lear had given up natural history work for landscape painting, but told Gould he had not altogether forgotten zoology, for he still knew 'an Opossum from a Trogon' and wanted to hear about the 'novelties' Gould was discovering abroad.

Unfortunately, Gould, always busy, was a practical rather than a newsy correspondent, and did not reply to Lear's chatty letters except by a scrawl, which Lear said was so illegible that he would keep it to sell as an ancient hieroglyphic. Lear's curiosity was based on reports from Australia of weird-looking creatures, for accounts had come in from New Holland – as Australia was originally called – of 'large hopping animals, quadrupeds with duck's bills, black swans, huge birds that only walked, and foxes that flew, and many birds and animals that seemed hardly credible.'

## COOK'S VOYAGES

The first expedition to Australia linked with natural history was Captain Cook's epic voyage in *HMS Endeavour*, which circumnavigated the world in 1768–71. James Cook (1728–79), who was born in Marton, Yorkshire, sailed as a lad in a collier from Whitby, then rose through the ranks in the British navy, and distinguished himself as a navigator and cartographer around the coasts of Canada. He was appointed by the Admiralty to set sail for Tahiti to observe the transit across the face of the sun of the planet Venus, and also received 'secret' orders to sail south in search for the supposed fifth continent, Terra Australis Incognita. To assist as scientists, making observations and collecting samples from the unknown land, the Royal Society appointed an astronomer, Charles Green, and a naturalist, Joseph Banks, recently made a Fellow.

Joseph Banks (1743–1820), born in London but the son of a rich Lincolnshire landowner, was educated at Eton and Oxford, where he took private lessons in botany. Having made an expedition to Labrador and Newfoundland, he was eager to join Cook on his journey, and agreed to put up a large sum of money from his personal fortune.

This, estimated at £10,000, paid for himself, two naturalists (Daniel Carl Solander and Herman Sporing), two illustrators (Alexander Buchan and Sydney Parkinson), as well as lavish equipment for drawing and preserving specimens, a fine natural history library, four servants and two dogs. John Ellis, a fellow naturalist, remarked in a letter to Linnaeus that 'No people ever went to sea better fitted out for the purpose of natural history, nor more elegantly.'

The *Endeavour* sailed out from Plymouth in August 1768, and had reached Tahiti via Cape Horn by April the following year. Shortly after arrival there, the topographical painter Alexander Buchan died, and additional work fell to the accomplished natural history artist Sydney Parkinson (1745–71). On shore he had to work in a mosquito net to prevent flies from eating the paint, while at sea in the captain's cabin he diligently drew the fresh specimens the naturalists had collected. Since both Banks and Solander were primarily botanists, plant studies predominate in Parkinson's work, and only a handful of the 1,300 or so drawings were of birds and animals. Two of his most finished bird sketches were painted during this period, one of a little green parrot now believed extinct, and one of an airborne tropic bird with red streamers, perhaps seen from the ship when leaving Tahiti for New Zealand.

Finally, in April 1770, the shores of Australis Incognita were sighted, and some days later the *Endeavour* sheltered in a cove so abundantly full of plants that it was given the name Botany Bay. Parkinson was still kept busy with botanical drawing, and only one sketch showing an Australian land bird is known; an outline of a red-tailed cockatoo with added colour notes in writing. Cook, however, later reported their impressions of the bird life: 'The Land Fowles are Bustards, Eagles, Hawks, Crows such as we have in England, Cocatoes of two sorts white and black, very beautiful Birds of the Parrot kind such as Lorryquets, Pidgeons, Doves, Quales and several sorts of smaller birds.' Near the Endeavour river in Queensland, Parkinson made some lively kangaroo sketches, and these, together with a skull and a skin reconstructed in London, were used for George Stubbs' famous painting exhibited at the Royal Academy in 1773. Sadly Parkinson did not live to receive a hero's homecoming when the *Endeavour* finally returned to England as he died, aged only twenty-six, on the journey, shortly after contracting dysentry at Batavia. His name, unlike Banks' was very much forgotten, and he received no acknowledgement for his paintings.

*The Art of Bird Illustration*

### Black-fronted Parakeet

*Cyanoramphus zealandicus.* Watercolour (unfinished)
by Sydney Parkinson, of a bird collected in Tahiti, painted
during Cook's first world voyage (1768-71). A specimen,
believed to have belonged to Banks, still exists in
Liverpool Museum. The species is now extinct.

*Phaëton erubescens.*

Sydney Parkinson pinx. 1769.

### RED-TAILED TROPICBIRD

*Phaethon rubricauda*. Watercolour by Sydney Parkinson,
dated 1769. Called a 'Bos'n-bird', this white seabird with
red streamer-like tail plumes circles around ships, gliding
high in the air and occasionally plummeting for fish.

The Forsters, Johann Reinhold and his son George, sailed rather unexpectedly on the second of Cook's voyages around the world (1772–75). At the last moment, when *HMS Resolution* was being made ready, Banks had a disagreement with the Admiralty and refused to sail, and they were recruited instead for the positions of scientists. They made some valuable studies of Oceanic and Antarctic birds, and George Forster (1754–94) painted a bearded penguin on an ice flow. Unlike the compliant Parkinson, both father and son had quarrelsome natures, continually complaining to Cook about conditions on board, and on their return they had a prolonged argument about the publication of their material.

## FERDINAND BAUER AND MATTHEW FLINDERS

Ferdinand Bauer (1760–1826), like Sydney Parkinson, was primarily a botanical artist, but his few paintings of Australian birds and animals are of unsurpassed beauty. Born in Feldsberg, Austria, he was the son of a court painter to the Prince of Liechtenstein, and had an equally gifted older brother, Franz, who became the official botanical draughtsman at Kew Gardens, London. In 1801, when a natural history artist was needed to accompany Captain Matthew Flinders in *HMS Investigator* during a survey of the Australian coastline, Banks arranged for Bauer to work in close co-operation with the botanist Robert Brown.

The journey during which Australia was circumnavigated lasted three years (1801–3), and was fraught with adventure and misfortune. Throughout the voyage the crew had problems with their poorly refitted ship, which finally proved too unseaworthy for the return trip to England. Flinders decided to pay off his sailors, leave Bauer and Brown behind in Sydney, and take a passage back to England to obtain another ship. Unfortunately for him, a stop was made at Mauritius where, due to hostilities between the French and English, he was put in prison for over six years by the French governor. Poor and weak in health, he finally reached home in 1810, spent four years preparing his great work *A Voyage to Terra Australis*, and died aged forty on the day after its publication.

Bauer, left behind in Australia, was unaware of Flinders' predicament, and continued his botanical work on expeditions through New South Wales and to Norfolk Island in the Pacific Ocean. Eventually, when the *Investigator* was satisfactorily reconditioned, Bauer and Brown travelled home, arriving five years before Flinders. Bauer did not remain for long in England, however, and returned to his homeland in 1814.

During his travels he was indefatigable, and made over 1000 plant drawings and some hundred zoological studies. These are painted with amazing, delicate precision, for both he and his brother Franz made expert use of the microscope. Two paintings of parrots depict a Port Lincoln ringneck, seen in South Australia, and rainbow lorikeets

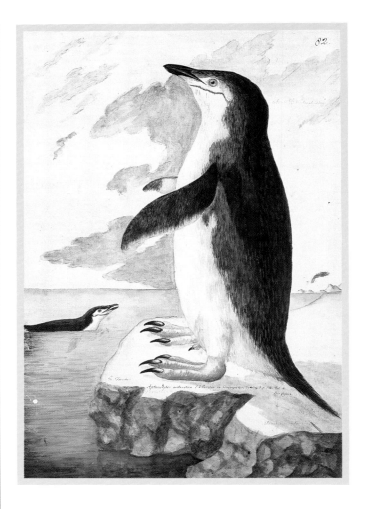

CHINSTRAP OR BEARDED PENGUIN
................................
*Pygoscelis antarctica.* Watercolour by George Forster, painted during the winter of 1772-73 on Cook's second world voyage. (*ABOVE*)

PORT LINCOLN PARROT
................................
*Barnardius zonarius.* Watercolour by Ferdinand Bauer painted near Port Lincoln during Flinders' circumnavigation of Australia, 1801-03. (*RIGHT*)

sketched at Port Phillip, Victoria. His superb watercolours are now preserved in the Natural History Museum, London, while his preliminary pencil sketches, many annotated with a numbering code, are in the Natural History Museum at Vienna. A biography, with a description of his work tracing the links between Vienna and London, has recently been written by Marlene J. Norst, published by the British Museum (Natural History) in 1989.

## THE AUSTRALIAN COLONISTS

In the late eighteenth century the idea of a penal settlement was being discussed in England, and on Banks' advice it was decided to locate this on the eastern coast of Australia. In 1787 the First Fleet under the command of Captain Arthur Phillip sailed for Botany Bay with 736 convicts and

a large number of sailors, marines and officers. Finding Botany Bay itself unsuitable, they travelled a few miles north to Sydney Cove (then called Port Jackson), where they saw the magnificent harbour and put ashore to carry out the arrangements made back in England for the founding of the new colony.

There was no official artist with the First Fleet, but there were some officers versed in cartography who had artistic ability, one of whom was George Raper (1768?–1799) a seaman on *HMS Sirius*, later promoted to midshipman. From 1789 to 1791 he painted views of the harbour and birds and flowers in the vicinity, which were among the first made of the natural history of the settlement. Two examples of his watercolours, with neat notes of size and measurements, are the kookaburra and a blue-faced honeyeater. These, although rather formal and stilted, were careful and attractive portraits.

Thomas Watling (b.1762) of Dumfries, Scotland, was a professional painter who was transported to Australia for forging banknotes. As a landscape artist in the Romantic style he had a poor opinion of Australian scenery, which he regarded as arid and monotonous. In a letter to an aunt in Scotland he wrote, 'The landscape painter may in vain seek here for that beauty that arises from the happy-opposed offscapes,' meaning that he missed the idealized imagery of the woods and glades of his home country. However, he painted the first large oil landscape of Sydney, and also made drawings of the Aborigines and zoological studies for John White, surgeon of the First Fleet, and an ardent naturalist. The Watling Collection in the library of the Natural History Museum, London, in fact comprises drawings by several early colonial artists, but among the signed Watling paintings is a handsome black cockatoo. It is accurately depicted, and its measurements noted – 'From the tip of the beak to the tip of the tail two feet eight inches.'

In England scientists anxious to classify and describe Australian species relied on skins and drawings sent by colonial settlers, officers and officials. Two early Australian governors, Captain John Hunter and Captain William Bligh, of *Mutiny on the Bounty* notoriety, were both able amateur draughtsmen. The first professional natural history artist and colonist was John William Lewin (1770–1819), who arrived in New South Wales in 1800, settling first at Parramatta and later in Sydney. He found zoological illustration a precarious occupation, but succeeded in publishing two small ornithological volumes, *Birds of New Holland with their Natural History*, with eighteen hand-coloured etchings (1804–8, issued in London), and *Birds of New South Wales with their Natural History* (1813), which was the first illustrated natural history book to be published in Australia.

## GOULD'S BIRDS OF AUSTRALIA

'Would not a work on the Birds of Australia be interesting? I have a great number of new and interesting species to make known and have the idea of making it my next illustrative work. I have even some serious intention of visiting the colony for two years for the purpose of making observation ...' So wrote John Gould to his friend Sir William Jardine in November 1836. He had been excited by specimens sent to him from New South Wales by Elizabeth Gould's two emigrant brothers. After he had published two parts (twenty plates) of his proposed *Birds of Australia*, now called the 'cancelled parts', he decided to carry out his project of an expedition to gather material to illustrate and describe all the birds.

Due to the success of his previous publications, Gould had many commitments in London, and elaborate preparations had to be made for the journey. He resigned from his post at the Zoological Society and left his invaluable secretary, Edwin Prince, in charge of his publishing and taxidermy businesses. He was unable to finish his work for Charles Darwin, who had just returned from an epic five-year voyage round the world in *HMS Beagle*; Darwin had collected birds and had asked the Goulds to classify and illustrate them for his projected book, the *Zoology of the Voyage of HMS Beagle*. The specimens of Darwin's that most intrigued Gould were the little brown finches of the Galapagos islands. Although of the same species, they showed different modifications according to which island they inhabited: some had thick beaks as large as a hawfinch while others were as small as a warbler. It was from an investigation of their differences and other scientific data that Darwin many years later formulated his theories on evolution.

'I am so busy that my brain is in a complete jumble' Gould wrote to Jardine in a letter which gave details of his travel plans. A cabin on the barque *Parsee* was available for Gould's equipment and his wife Elizabeth's work – for she was not to be allowed a complete rest. Their party included a skilled taxidermist, John Gilbert, two servants, a nephew, and their eldest child Henry, aged seven. Three younger children were left behind with Elizabeth's mother and a married niece. On the voyage Gould was never idle, and in calm weather he was lowered in a small boat to observe petrels and ocean birds.

RAINBOW LORIKEET
...........................
*Trichoglossus haematodus.* Watercolour by Ferdinand
Bauer painted at Port Phillip, Victoria, in April 1802,
during Flinders' expedition.

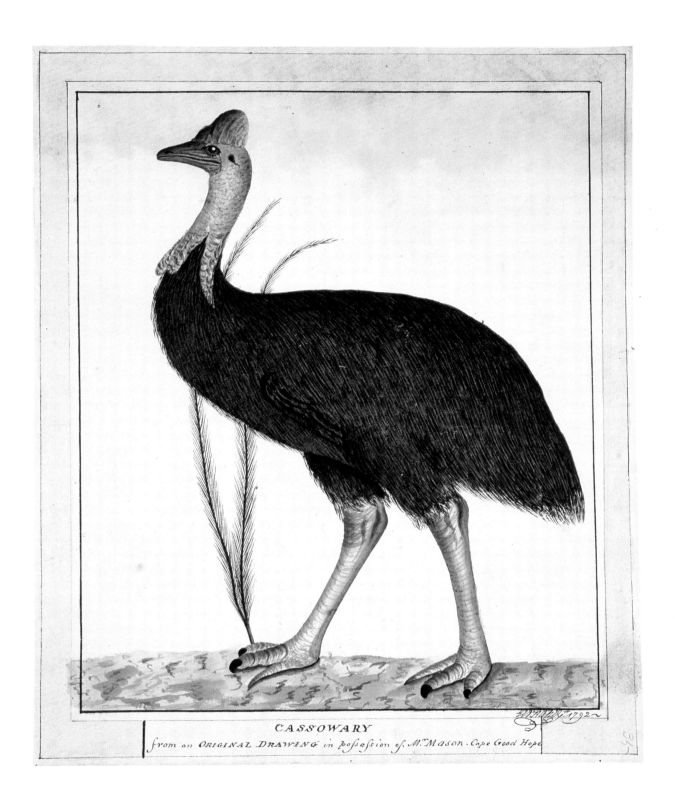

CASSOWARY

from an ORIGINAL DRAWING in possession of M.ʳ Mason. Cape Good Hope

AUSTRALIAN CASSOWARY
..............................................

*Casuarius casuarius.* Watercolour dated 1792 by George
Raper, inscribed 'from an original drawing in the
possession of Mr Mason, Cape of Good Hope'. Raper
himself may not have seen living cassowaries, which
inhabit North-East Queensland and New Guinea. *(ABOVE)*

BLUE-FACED HONEYEATER
..............................................

*Entomyzon cyanotis.* Watercolour dated 1789 by George
Raper, one of a series showing the birds and flowers
found near the early colonial settlement at Sydney. *(RIGHT)*

Banksian Cockatoo Latham Syn Supp ij p 92 – first

From the tip of the beak to the tip of the tail
Two feet eight inches –    Native name Kur vatt.

All the varieties of the black Cockatoos are so called, this is the most uncommon Bird.

### LARGE GROUND FINCH

*Geospiza magnirostris.* Lithograph from Darwin's
*Zoology of the Voyage of HMS Beagle* illustrated by John
and Elizabeth Gould. These finches with big strong beaks
are confined to the Galapagos Islands. Darwin based
his theory of evolution by natural selection on a study of
various Galapagos finches. *(ABOVE)*

### YELLOW-TAILED BLACK COCKATOO

*Calyptorhynchus funereus.* Watercolour by Thomas
Watling, a Scottish artist deported for forgery. From the
Watling Collection of natural history drawings made
between about 1788 and 1794. *(LEFT)*

### EMU AND CHICKS

*Dromaius novaehollandiae.* Australia's largest bird,
drawn and lithographed by Waterhouse Hawkins for
Gould's *The Birds of Australia* 1840-48. *(NEXT PAGE)*

WHITE-THROATED TREECREEPER
...............................................
*Climacteris leucophaea.* Lithograph by Elizabeth Gould
for *The Birds of Australia.* These birds creep up tree
trunks in a spiral climb as they search for insects.

After four months they arrived in Tasmania, where they
were looked after by the Governor, Sir John Franklin, who
had travelled with Flinders, and later died in the search
for the North-West passage in the Arctic. Lady Jane Frank-
lin, a patron of natural history and the arts, accompanied
Gould and Gilbert in an expedition to the south coast of
the island, as well as arranging Gould's other journeys to
northern Tasmania (then Van Dieman's Land) and Flinders
Island. From Hobart, Gould also travelled to Adelaide and
explored 'the Murray Scrubs' in South Australia. Meanwhile
Elizabeth, pregnant with her fifth child, stayed at Govern-
ment House, Hobart, and made preparatory paintings of
plants and birds for their future publication.

In August 1839 the Goulds travelled to New South Wales
to visit Elizabeth's brothers, and Gould carried out field
work in the Hunter river – Liverpool Ranges area. He con-
stantly exclaimed on the beauty and radiant colours of
Australian birds, and was fascinated by the strange
mannerisms of lyre and bower birds and amazed by the
immense flocks of green grass parakeets which gathered
at the waterholes. Charles Coxen, his brother-in-law,
reared some of these parakeets (called by the Aborigines
betcherrygah, and corrupted to budgerigar) and the
Goulds took a pair of live birds back to England – the
ancestors of the now universally popular 'budgies'.

On their return to London the Goulds went into action
to prepare the 600 or so plates for *The Birds of Australia*
(1840–48). Gould's earlier publication, *The Birds of
Europe*, had included several plates by Edward Lear, but
the only one signed by Lear in this case was of a spotted
cormorant, though a pair of cockatiels from Lear's *Illustra-*

MELOPSITTACUS UNDULATUS.

*tions of the Family of Parrots* was adapted by Elizabeth.

In August 1841, to give them a change of air, Gould rented a country cottage at Egham, on the Thames in Surrey, and there Elizabeth died suddenly of puerperal fever following the birth of her sixth child at the age of thirty-seven. Her death was a severe shock to her husband, and throughout the rest of his life he paid tribute to the memory of an affectionate wife and valuable assistant in his natural history pursuits. Although modest about her talents, Elizabeth had been highly regarded by Audubon, Charles-Lucien Bonaparte and Lear, who asked Gould for 'a little sketch . . . as a memorial of a person I esteemed and respected so greatly'.

It was now necessary for Gould to find another lithographer for the remaining plates of *The Birds of Australia*, and one plate of the emu and chicka was contributed by Benjamin Waterhouse Hawkins (1807–89). Trained as a sculptor, Hawkins later made gigantic cement models of

BUDGERIGAR

*Melopsittacus undulatus*. Lithograph by Elizabeth Gould for *The Birds of Australia*. Perhaps the world's best-known parrot and cage-bird, the wild grass parakeets are mostly yellow and green. Gould introduced the first pair of live 'budgies' into England from Australia in 1840.

prehistoric animals for the grounds of the Crystal Palace. But the person who finally filled Elizabeth Gould's place as lithographer and illustrator was Henry Constantine Richter (1821–1902), an accomplished and conscientious artist who proved to be the perfect interpreter of Elizabeth's finished drawings and her husband's rough sketches. Another tragedy for Gould was the loss of his assistant, the explorer John Gilbert, who was killed by Aborigines in an expedition through Australia's Northern Territory. However, in spite of all these misfortunes, *The Birds of Australia* was published on schedule, a monumental achievement in Australian ornithology.

### NOISY SCRUB-BIRD
......................................

*Atrichornis clamosus.* Lithograph by H. C. Richter for
Gould's *The Birds of Australia.* This is a very rare,
unobtrusive bird once thought to be extinct but now
inhabiting one small area in Western Australia. The male
mimics and gives penetrating calls which are almost
ear-splitting. *(ABOVE)*

### SUPERB LYRE BIRD
......................................

*Menura novaehollandiae.* Lithograph by Elizabeth
Gould for *The Birds of Australia.* The male's elaborate
lyre-shaped tail is shown erect in courtship display.
*(RIGHT)*

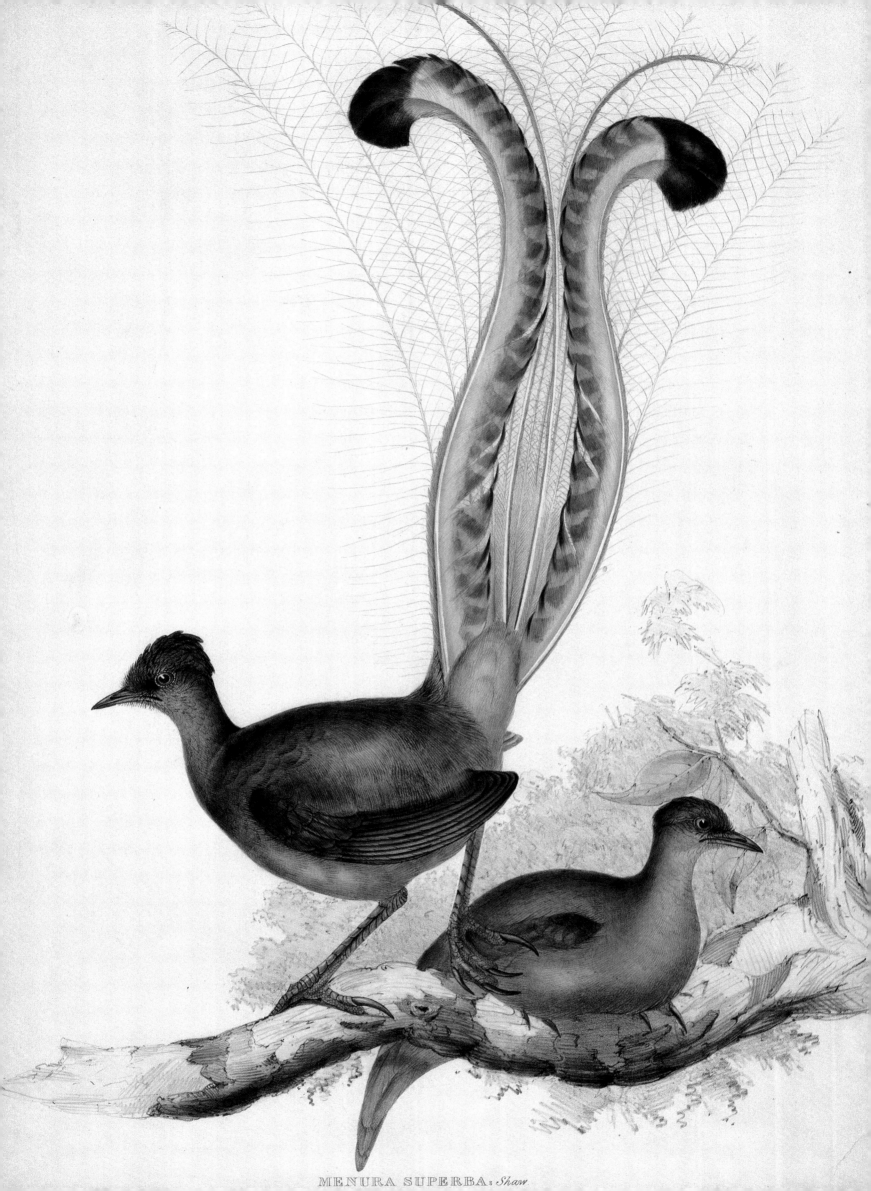

MENURA SUPERBA: *Shaw*

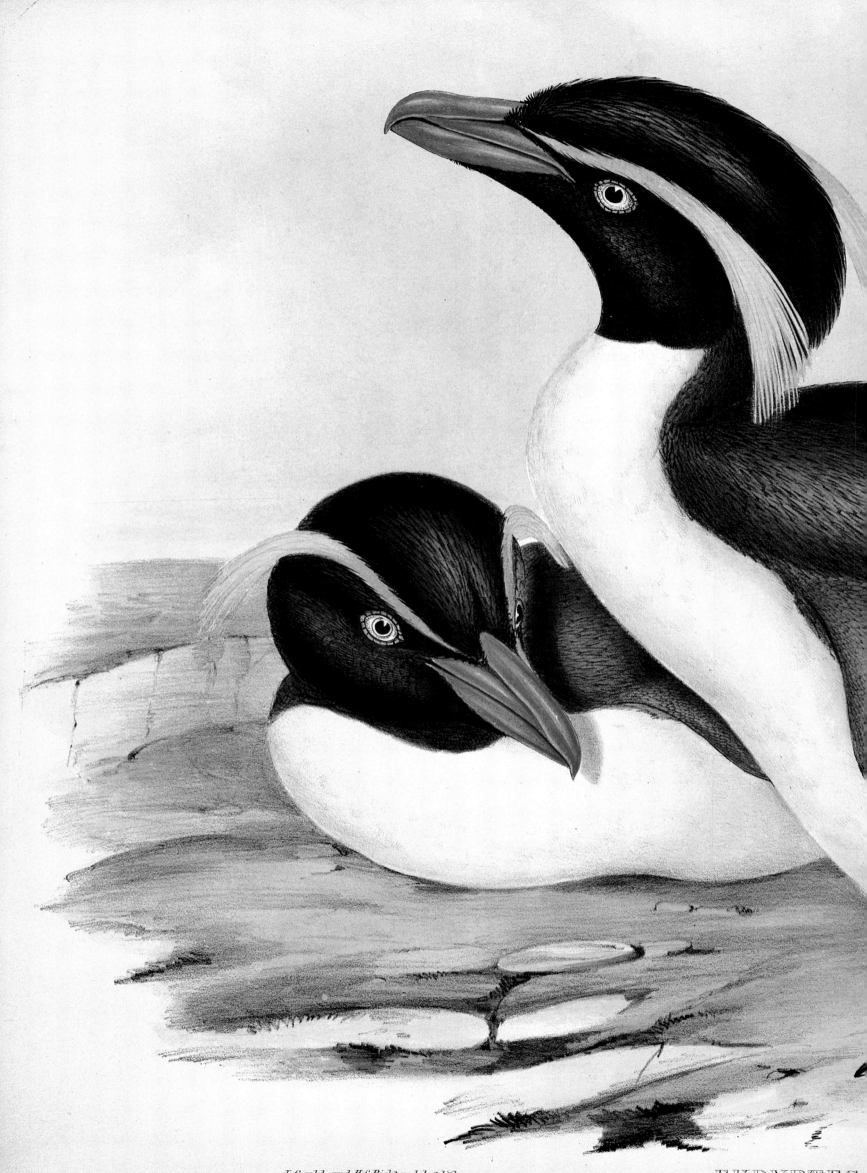

EUDYPTES

RYSOCOME.

Hullmandel & Walton Imp.

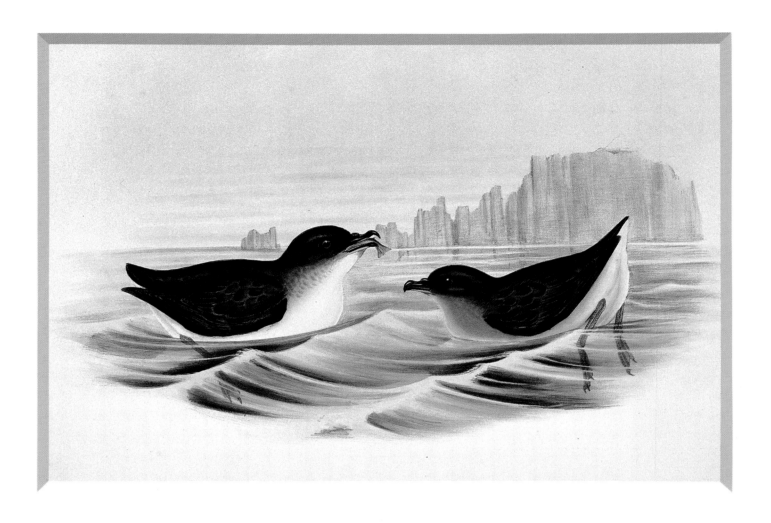

COMMON DIVING-PETREL

*Pelecanoides urinatrix.* Lithograph by H. C. Richter for
*The Birds of Australia.* These petrels swim underwater
using their wings as flippers. Gould made a special study
of petrels during the voyage from Australia. *(ABOVE)*

CRESTED PENGUIN OR ROCKHOPPER

*Eudyptes chrysocome.* Lithograph by H. C. Richter from a
drawing by Gould for *The Birds of Australia.* *(PREVIOUS
PAGE)*

WOMPOO PIGEON OR MAGNIFICENT FRUIT PIGEON

*Ptilinopus magnificus.* Lithograph by H. C. Richter for
Gould's *The Birds of Australia.* Living among the trees of
North Australia and New Guinea, the bird's beautiful
colours blend with the foliage.

*151*

**EASTERN ROSELLA**

*Platycercus eximius.* Lithograph by H. C. Richter for
*The Birds of Australia.* The bird is also called the Rose-
hill parakeet from Rose-hill, a district near Sydney.

**CRIMSON ROSELLA**

·······································

*Platycercus elegans.* Lithograph by H. C. Richter for
Gould's *The Birds of Australia.* This bird, perhaps the
most glamorous of Australian parrots, was formerly
named after the English zoologist, Thomas Pennant.

RUBY-THROATED HUMMING-BIRD

*Archilochus colubris.* Lithograph by H.C. Richter for John
Gould's *Monograph of the Trochiltdae, or Family of
Humming-Birds.* This tiny bird, no more than 3½ in.
(8.9 cm) long, flies up to 2000 miles from eastern
America and southern Canada to Central America. In
1857 Gould saw the birds at Bartram's Gardens in
Philadelphia and the Capitol Gardens in Washington DC.

# Bird Artists of
## the Later Nineteenth Century

THE LUXURIOUS AND BEAUTIFUL natural history volumes published in large series in the nineteenth century were appropriate for wealthy libraries, country houses and learned institutions, but some naturalists felt that zoological books were being priced beyond the means of the middle-class public. To remedy this situation Sir William Jardine (1800–1874), the Scottish naturalist and great friend of Selby, brought out a series of little books called *The Naturalist's Library* (1833–43).

These modestly priced, pocket-sized volumes covered many natural history subjects, including humming-birds, pigeons, parrots and sunbirds. The illustrations were engraved and etched by Jardine's brother-in-law William Lizars of Edinburgh from drawings by well-known artists such as Selby, Lear and Swainson. For the first volume Lizars copied humming-birds from other authoritative books by Temminck and Lesson, and the ruby-chested humming-bird is a typical example of a small, beautifully hand-coloured engraving. As a preface each volume had an informative biography of an eminent naturalist and the series commenced with a memoir of Linnaeus.

## GOULD'S HUMMING-BIRDS

As the century advanced, elaborate taxidermic displays became fashionable, few homes were complete without a glass 'shade' with stuffed birds. The art of taxidermy became a much prized skill, and the introduction of arsenic pastes, or soaps, at the beginning of the century made the preservation of specimens more effective. In 1851, the year of the Great Exhibition, Gould's display of 1,500 mounted humming-birds exhibited in a pavilion at the Zoological Gardens attracted large crowds. The birds were shown in specially designed hexagonal glass cases with overhead canopies so that their iridescent colours could be viewed from several angles. Among the 75,000 or so visitors who saw the display was Charles Dickens, who described the birds in *Household Notes* as 'feathered jewels glittering in our vision'.

One of the ideas behind the humming-bird pavilion was to attract subscribers for Gould's current publication *A Monograph of the Trochilidae, or family of humming-birds* (1849–61). His colourists made many experiments in an attempt to capture the iridescent colours of the birds

with a special formula of oil and varnished colours painted over gold leaf. The illustrations were all made from Gould's stuffed specimens; the tiny birds were suspended by wires among dried plants and fernery so that they looked as if they were flying. No live models were then available, as at the time it had proved impossible to keep the birds alive in captivity. Gould saw his first live 'hummer', a ruby-throated humming-bird, at Bartram's Gardens in Philadelphia during his first visit to America in 1856. He attempted to keep one as a pet, travelling with it 'in a little thin gauzy bag' suspended from a button in his coat, and feeding it with saccharine fluid pumped from a small bottle. Sadly, two humming-birds which he transported to England soon died, although one survived (probably in a state of torpor) for just two days in London.

Gould's artist for his humming-bird pictures was Henry Constantine Richter, who had made the plates for *The Birds of Australia*, and used Gould's quick sketches and compositional studies for his own finished watercolours and lithographs. He was invaluable to Gould, and remained his artist for nearly forty years, contributing some 1,600 pictures. Gould's monograph contained an amazing variety of delightfully balletic humming-birds, and Richter's 360 prints aptly demonstrated their scintillating colouring and aerobatic dexterity, showing them darting among the exotic plants which they fed on and pollinated.

In June, Queen Victoria noted in her diary that she and Prince Albert drove with 'our three girls, Alexandrina and the 2 Ernests, to the Zoo', to inspect 'a collection, (in a room specially designed for the purpose) of Gould's stuffed Humming Birds. It was the most beautiful and complete collection ever seen, and it is impossible to imagine anything so lovely as these little Humming Birds, their variety, and the extraordinary brilliance of their colours'. Some years earlier, the Queen may have seen Gould's pet live budgerigars, for in 1840 when Gould took them to the Duke of Northumberland's evening soirée, Prince Albert indicated that the Queen might like to see them also. Queen Victoria was devoted to several of her own pet parrots, especially one called Lory, painted by Edwin Landseer in 1838, whom she described as 'so tame that it remains on your hand, and you may put your finger in its beak, or do anything with it, without its ever attempting to bite'.

RUBY AND TOPAZ (OR RUBY-CHESTED) HUMMING-BIRD

*Chrysolampis mosquitis.* Engraved by W.H. Lizars and
coloured by hand, for Sir William Jardine's *Naturalist's
Library,* Vol 1, 1833. Over 7,000 copies were sold of the
first volume in this series of forty inexpensive pocket
books. (ABOVE)

WHITE-NECKED JACOBIN

*Florisuga mellivora.* Lithograph by H.C. Richter for
Gould's *Monograph of the Family of Humming-Birds.*
During courtship the male flaunts its white plumage and
spreads out its tail to resemble a blue-edged flower.
(*RIGHT*)

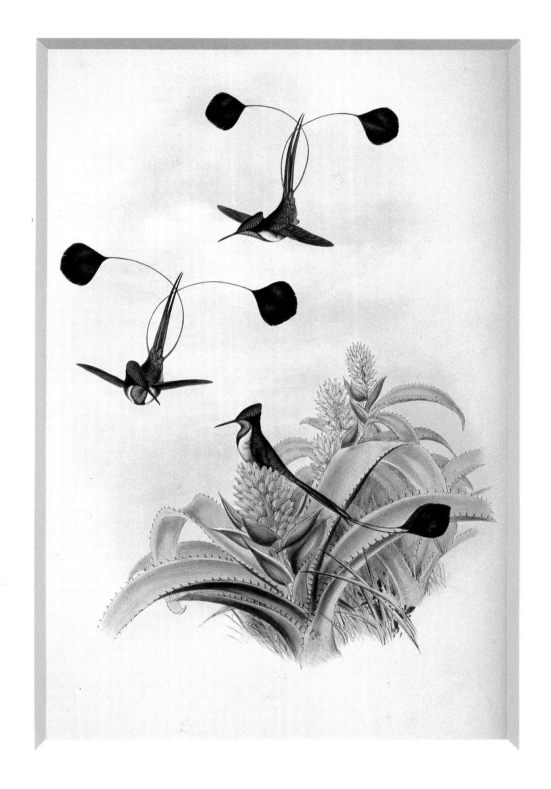

LODDIGES' RACQUET-TAILED (OR MARVELLOUS)
HUMMING-BIRD
·······································
*Loddigesia mirabilis.* Lithograph by H.C. Richter for
Gould's *Monograph of the Family of Humming-Birds.*
This is a very rare bird, found only in one valley in the
heights of the Peruvian Andes. George Loddiges (1784-
1846) was a famous collector of humming-birds. *(ABOVE)*

VERVAIN OR LITTLE HUMMING-BIRD
·······································
*Mellisuga minima.* Hand-coloured lithograph by H.C.
Richter for Gould's *Monograph of the Family of
Humming-Birds.* From Jamaica, this bird weighs only
about .08 oz (2.2 g) and has a nest half the size of a walnut
cup, made of silk, cotton and lichen. *(LEFT)*

## SIR EDWIN LANDSEER

Landseer (1803–1872), born in London and the son of an engraver, drew animals from early childhood, and exhibited animal pictures at the Royal Academy at the age of sixteen. As an attractive social personality he was at ease in fashionable and aristocratic circles, and his paintings were so successful that in 1839 he was commissioned to paint a group of the Queen's pets, *Islay and Tilco with a red Macaw and two Love-Birds*. The scarlet macaw (unnamed) is shown perched on a T-shaped pedestal looking down on the begging Skye terrier, Islay, and the reclining black and tan toy spaniel Tilco. *Punch* and *Blackwood's Magazine* interpreted the animals as actors in a story, the macaw as the dominant 'jack in office' tantalizing the others with its biscuit and lecturing like a schoolmaster, while the dunce Tilco reclined at the foot of the stand chewing a pen in its mouth. But whatever the picture's meaning, the birds and mammals in this picture were painted in a lively vivacious manner without the added human sentimental expressions that featured in some of Landseer's other paintings.

This portrait of the royal pets, exhibited at the Royal Academy, became an immensely popular image, reproduced as a print and even a pattern for Berlin woolwork embroidery. Amongst the juvenilia of Beatrix Potter is a tracing from such a reproduction. But although Potter's animals are charming, and she made delightful illustrations of a bird with human characteristics in *The Tale of Jemima Puddleduck*, on the whole she found birds difficult to costume. She once complained about a potential commission: 'I have never been good at birds; and whatever you say – I cannot see them in clothes. I could not possibly dress up the pigeons – No birds look well in clothes!'

## JOHN RUSKIN AND J. M. W. TURNER

'The Relation of Wise Art to Wise Science' was a theme close to the heart of Ruskin when Slade Professor of Fine Art at Oxford in the 1870s. Ruskin (1819–1900), born in London and the son of a prosperous merchant family, was a writer whose art theories had immense influence in the late nineteenth century. He lectured extensively on art, architecture and natural history subjects, and presented his ideas with illustrations that had been carefully devised, prepared and selected. Among his 'visual aids' were his own drawings from birds' skulls and watercolours of plumage, and he had models of wing feathers made to demonstrate the flight of birds.

Ruskin's material was presented – both to university audiences and working men's night classes – in a new and exciting manner, with pictures placed on walls or tables, or brought in by attendants at relevant moments. He formed study collections for his students, consisting of geological specimens, shells, illuminated manuscripts, bird illustrations, plaster casts and Old Master engravings, at a museum in Wakely, near Sheffield, and at his drawing school in Oxford. He believed that children also should have pleasure from art and natural history, and suggested that in the village school 'Slates – & sums – and grammar' should be abolished, and the room filled 'all round of coloured pictures, & bird's feathers and boat models & pretty stones and moss.'

In contrast to his writings, which are an exasperating mixture of complicated thoughts and perceptions, Ruskin's watercolours are delightfully fresh and spontaneous. The picture of a kingfisher, now in the Ashmolean Museum, Oxford, was painted as an exercise in 'dominant colour', and is a brilliant study of turquoise, violet and emerald hues. It was probably done in 1870 to 1871 in connection with his Oxford lectures, and was filed in a cabinet devoted to 'Exercises in Colour with Shade on Patterns of Plumage and Scale'. Several other studies of birds' plumage made for teaching purposes show the structure, markings and scale of individual feathers in microscopic detail. In the Ruskin Gallery, Sheffield, there is a watercolour of a single peacock's plume which is quite breathtaking in its accuracy.

Ruskin's interest in painting plumage may have been spurred by his admiration for Turner's watercolours of dead game and other birds painted about 1815–20 at Farnley Hall, Yorkshire. Joseph Mallord William Turner (1775–1851), probably England's greatest artist, was the son of a barber, born at Covent Garden, London. Ruskin was Turner's loyal supporter throughout his career, even when his style of painting became controversial, and was mocked by many critics.

Ruskin saw the bird sketches during a visit to Farnley Hall in 1851, the year of Turner's death, when he found in the library a five-volume album called the *Ornithological Collection*. This natural history project contained a brief description of individual bird species and a compilation of feathers, Bewick's wood-engravings and watercolours by Turner and other artists. The album had been assembled by Walter Ramsden Fawkes, a patron and friend of Turner, but after his death in 1825 the project was abandoned. Ruskin, excited to find the album intact twenty-four years later, advised that as the feathers were rubbing against the watercolours, Turner's pictures should be

ISLAY AND TILCO WITH A RED MACAW
AND TWO LOVE-BIRDS

Oil painting of the royal pets by Sir Edwin Landseer, commissioned by Queen Victoria and painted in 1839. It was placed in the drawing-room at Osborne House on the Isle of Wight, the Queen's favourite residence.

STUDY OF A KINGFISHER

Watercolour by John Ruskin, who described it as a study
with dominant reference to colour. It was painted in 1870
or 1871 in connection with his Oxford lectures.

HEAD OF A PEACOCK

Watercolour by J.M.W. Turner from an album of bird
studies made at Farnley Hall, Yorkshire *c.* 1815-20.

PEACOCK'S FEATHER

Watercolour by John Ruskin, who wrote on 22 October
1875 that 'I have to draw a peacock's breast feather
without having heaven to dip my brush in.'

PYRRHULA VULGARIS.

J.Gould & H.C.Richter, del et lith.

Walter, Imp.

WHITETHROAT

*Sylvia communis.* Lithograph by H.C. Richter for Gould's
*Birds of Great Britain.* It is a restless bird which warbles
during its jerky flight or while creeping among
hedgerows. *(ABOVE)*

BULLFINCH

*Pyrrhula pyrrhula.* Lithograph by H.C. Richter for
Gould's *Birds of Great Britain,* 1862-73. In 1872, at
Gould's house, Ruskin admired a bullfinch's nest set in a
foundation of wild clematis twigs. *(LEFT)*

GYRFALCON
..................................

*Falco rusticolus.* Drawn and lithographed by Joseph Wolf
for Schlegel and Wulverhorst's *Traité de Fauconnerie*,
1844-53, a history of falconry. This is the largest of the
falcons. *(ABOVE)*

PEREGRINES
..................................

*Falco peregrinus.* Oil painting by Joseph Wolf, dated
1866. Birds of prey seen in the solitude of moorlands and
mountains were Wolf's favourite subjects. *(RIGHT)*

LE GROËNLANDAIS, FAUCON BLANC MUÉ.

GREAT HORNBILL
...........................................

*Buceros bicornis.* Drawn and lithographed by J.G.
Keulemans for D.G. Elliott's *Monograph of the
Bucerotidae, or Family of Hornbills,* 1876-82.

mounted in a separate volume. The twenty watercolours of *The Farnley Book of Birds* were recently bought by Leeds City Art Gallery. Most of the pictures are of dead game and specimens, but there is one sketch of a peacock's head, which was perhaps painted from a live bird in Farnley Hall gardens.

Ruskin's own collection of bird illustrations included the work of Audubon, Levaillant, Bewick, Lear and Gould. He regarded Gould's work as pleasing and of practical use for students, rather than 'exemplary as art', and in an essay called 'The Dabchicks' suggested that British children would particularly enjoy the plates of Gould's *Birds of Great Britain*, as its 'practical and natural arrangement'

could be easily understood. He enthused especially about the amazing construction of a nest of withered wild clematis twigs illustrated in the plate of the bullfinches, waxing lyrical over its architectural complexity. '... The branched heads all on the outside, producing an intricate Gothic boss of extreme grace and quaintness, apparently arranged both with the triumphant pleasure in the art of basket-making, and the definite purpose of obtaining ornamental form.'

*The Birds of Great Britain* (1862–73) was the fruit of Gould's late middle age, produced after many years of describing foreign birds, and in it many family groups of birds, nests, eggs, chicks and fledglings were illustrated for the first time. The majority of the plates were drawn and lithographed by Richter, a brilliant pictorial designer, who arranged the birds in delightfully composed settings among British common wild plants – honeysuckle, dogrose, gorse, flowering may and ivy. The dullish whitethroats, for instance, are placed amongst a carefully drawn

CERIORNIS BLYTHII.

### BLYTH'S TRAGOPAN

*Tragopan blythii.* Drawn and lithographed by Joseph Wolf for D.G. Elliott's *A Monograph of the Phasianeidae, or Family of the Pheasants,* New York, 1872. This rare pheasant of north-west Burma was named after E. Blyth (1810-73) a curator of the Natural History Museum in Calcutta.

disarray of hedgerow bramble, and a resting red admiral butterfly adds a bright splash of colour.

## JOSEPH WOLF

Drawings of several birds of prey, game birds and water-birds were contributed by Joseph Wolf (1820–99) to be lithographed by Richter. Born near Koblenz, Germany, the son of a farmer, Wolf spent his boyhood sketching and learning about the wildlife of the surrounding country-side. At sixteen he was apprenticed to a firm of commercial lithographers, but his interest was not held by routine work, and at home he painted a series of small bird water-colours which were remarkable for their detail and accuracy. He showed them to an eminent naturalist in Frankfurt, and eventually received a commission to make life-size illustrations for Schlegel and Wulverhorst's *Traité de Fauconnerie* (1844–53), published in Leyden. This magnificent book of plates on the history of falconry was inspired by the formation of a falconry club at the royal castle of Loo in Holland, which had returned falconry to its medieval status as a sport of kings and princes. Among Wolf's illustrations is one of a hooded gyrfalcon resting on the gloved hand of a falconer. Although the bird appears calm and immobile, its strength and ferocity are brilliantly conveyed through its aristocratic pose.

Wolf's career as a natural history artist was interrupted by the political upheavals in 1848, the 'year of revolutions'. After studying oil painting at Darmstadt and Antwerp, he decided to accept an invitation to complete the last illustrations for G. R. Gray's *Genera of Birds* (1837–49) at the British Museum. His gifts as an animal artist were quickly recognized; a small oil painting, *Woodcocks seeking Shelter*, commissioned by Gould, was exhibited at the Royal Academy, and at the suggestion of Sir Edwin Landseer had the honour of being placed 'on the line', a position at eye-level much coveted by artists.

'We only see distinctly what we know thoroughly', Wolf remarked, and as an avid bird watcher he felt he 'knew' birds better than many indoor naturalists. He made a particular study of feather formation, the effects of light and shade on plumage, and the relationship of birds' colours to their surroundings. Wolf, like Landseer, was a lover of the Scottish Highlands, and during different seasonal conditions studied the peregrine falcon, golden eagle, osprey and ptarmigan in the solitude of the mountains.

Although he preferred to make wild life and landscape the subject of paintings rather than book illustration, he made many valuable contributions to the elaborate natural history monographs published towards the end of the century. One of the most sumptuous bird books ever produced was D. G. Elliot's *A Monograph of the Phasianeidae, or family of the Pheasants*, published in New York in 1872. The author, Daniel Giraud Elliot (1835–1915), was a wealthy American naturalist, Curator of Zoology at the Field Museum of Chicago. The first volume of his work on pheasants was dedicated to his illustrator in the following words: 'To Joseph Wolf, Esq. F.Z.S. etc. whose unrivalled talent has graced this work with its chief attraction and whose marvellous power of delineating animal life renders him unequalled in our time.'

## JOHN GERRARD KEULEMANS

Wolf's illustration of Blyth's tragopan, an ornate pheasant now rare in the forests of north-western Burma, was lithographed by John Gerrard Keulemans (1842–1912), a Dutch natural history artist who came to England twenty-one years after Wolf in 1869. Born in Rotterdam, he was also for a time employed by Dr Schlegel of Leyden. An interest in travel took him to West Africa, where he bought a coffee plantation, but he became too ill with fever to continue working there, and came to England with the encouragement of Dr Richard Bowdler Sharpe, a librarian at the Zoological Society. Sharpe, although only in his twenties, was working on his *Monograph of the Alcedinidae or family of Kingfishers* (1868–71), and employed Keulemans to illustrate it. A diligent and conscientious worker whose draughtsmanship was accurate and reliable, Keulemans produced many hundreds of zoological illustrations for books, scientific articles and periodicals during the next thirty years.

At times he felt oppressed by routine illustrative work; as a draughtsman he was poorly paid, and some of his lithographs, though competent, appear rather dull and uninspiring. During his lifetime his other artistic work received little attention, but his watercolours reveal that he knew how to paint birds with understanding and realism. A watercolour of pied hornbills which was painted as a study for D. G. Elliot's *A Monograph of the Bucerotidae, or Family of the Hornbills* (1876–82) is an attractive pictorial composition suitable for adaptation as an illustration. In contrast, his watercolour *The Gannetry*, painted in 1885, is a variation in style from his illustrative work, for instead of depicting a single bird or a pair of birds it evokes the crowded atmosphere of a gregarious colony of nesting gannets.

Gould's series of bird illustrations, *The Birds of New Guinea* (1875–88), was left unfinished at his death in 1881, and Sharpe, his friend and biographer, completed his work. Among the New Guinea birds were the flamboyant birds of paradise illustrated by William Matthew Hart (1830–1908) in the rich gaudy colours and elaborate detail so much loved by the late Victorians. Hart, born in Ireland, is a little known artist, but he drew and lithographed many splendid exotic birds towards the end of the nineteenth century, and contributed to Sharpe's *Monograph of the Paradiseidae* (1891–8). A Londoner, always poor as he had to support a large family, he probably never saw the birds alive in the romantic settings he so diligently illustrated.

SPOTTED BOWER-BIRD

*Chlamydera maculata.* Lithograph by William Hart for
Gould's *Birds of New Guinea 1875-88.* This Australian
bird decorates its bower with light-coloured or shiny
objects, such as bones, shells, spoons, coins or even car
keys. *(ABOVE)*

THE GANNETRY

Watercolour by J.G. Keulemans, dated 1885. Keulemans is
best known for his book illustrations, but this painting
shows he was also a powerful natural history artist.
*(NEXT PAGE)*

EPIMACHUS SPECIOSUS, (Bodd.)

W. Hart del. et lith.

Mintern Bros. imp.

**BLACK SICKLE-BILLED BIRD OF PARADISE**

*Epimachus fastuosus.* Lithograph by William Hart for
Richard Bowdler Sharpe's *Monograph of the
Paradiseidae,* 1891-8. The unspectacular female is shown
between the two flamboyant male birds.

PARADISEA RAGGIANA, *Sclater.*

W. Hart del. et lith.

Mintern Bros. imp.

### COUNT RAGGI'S BIRD OF PARADISE
.......................................

*Paradisea raggiana*. Lithograph by William Hart for
Sharpe's *Monograph of the Paradiseidae*. Although a
target for plumage hunters, this is still one of the more
plentiful birds of paradise.

## ARCHIBALD THORBURN

The last great series of bird prints of the century was the seven volumes of Lord Lilford's *Coloured figures of the birds of the British Islands* (1885–98). Keulemans had begun the work, but in 1887 illness caused him to abandon it, and as Wolf was too elderly, the young Archibald Thorburn completed the drawings for the remaining plates. Archibald Thorburn (1860–1935), born near Edinburgh, was the son of a well-known Scottish miniature painter. He attended art school in London, but said he learnt more from his father than any other art teacher. He greatly admired Wolf's paintings, and shared the latter's enthusiasm for the field study of birds on the Scottish moors and mountains. Like Wolf, Thorburn was interested in studying the camouflage of birds' colours and the muted browns and greys of game birds that blend so harmoniously into their natural surroundings.

Thorburn's watercolours have been reproduced by both nineteenth- and twentieth-century printing techniques; Lord Lilford's volumes were originally printed by the nineteenth century process of chromolithography, but many Thorburn prints have been issued in this century using modern photographic methods. His picture of Temminck's tragopan, illustrated in Charles William

### A SHELDUCK
*Tadorna tadorna*. Watercolour by Archibald Thorburn.

Beebe's *A Monograph of the Pheasants* (1912–22) is an excellent example of the rich colours that could be achieved by an early form of process printing.

Today photography can capture the movement of birds' flight and intimate details of their behaviour, and ornithologists now learn about birds by using binoculars and cameras as well as hides. Artists no longer feel obliged to paint with the exacting detail that Ruskin recommended to his students, and today many painters prefer to portray birds in their natural settings. Thorburn's work is a blend of the old and modern styles of painting, and thus bridges the gap between the two centuries. A comprehensive collection of every aspect of this much-admired chronicler of bird life can be seen at the Thorburn Museum and Art Gallery in Dobwells, Liskeard, Cornwall. In this book, a lovely watercolour of a peacock butterfly sunning itself in front of a magnificent peacock displaying its train provides a splendid tail-piece to end this selection of bird pictures through the ages.

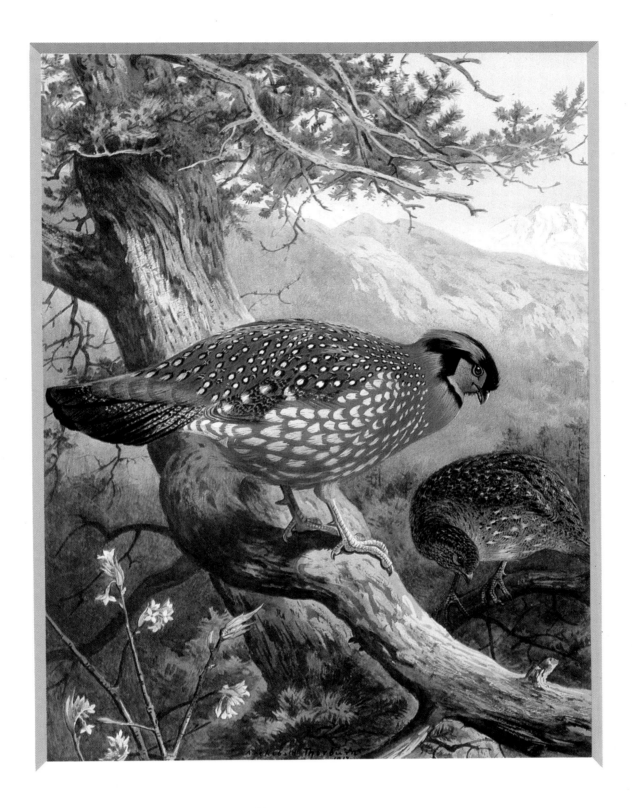

**TEMMINCK'S TRAGOPAN**

*Tragopan temminckii.* A process print by Frisch, Berlin
from a drawing by Thorburn, from C.W. Beebe's
*A Monograph of the Pheasants,* 1918-22. The bird lives in
the eastern Himalayas, but its habitat is threatened by
timber felling and agriculture. It was named after Prof. C.J.
Temminck (1778-1858) Director of the Natural History
Museum, Leyden.

**PEACOCK AND PEACOCK**

Watercolour by Archibald Thorburn, dated 1917. From the
Museum and Gallery of Thorburn's work at Dobwalls,
Liskeard, Cornwall. *(NEXT PAGE)*

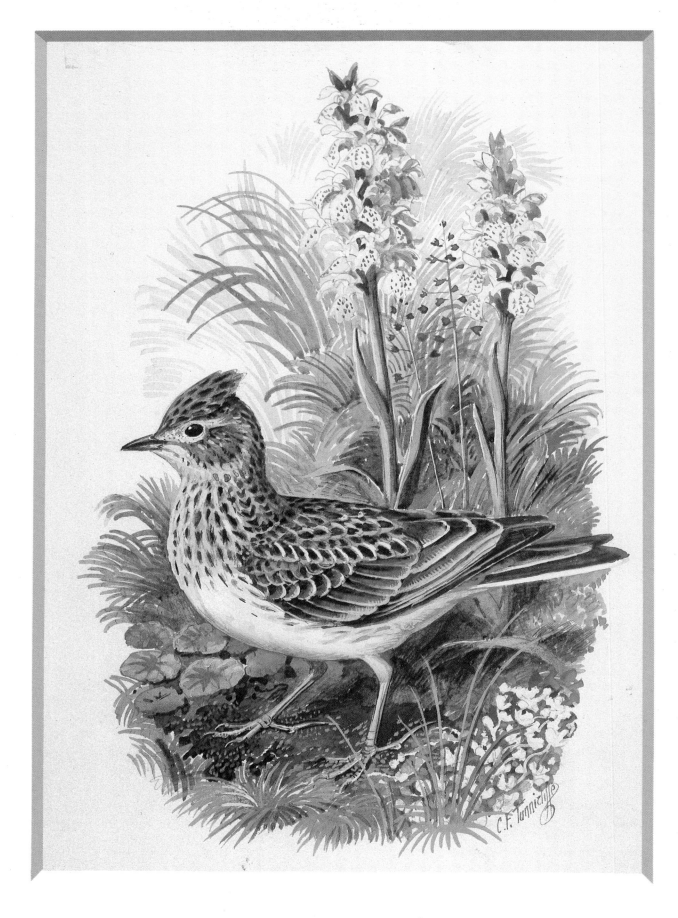

SKYLARK
....................................
*Alauda arvensis.* Watercolour by Charles Frederick
Tunnicliffe. A powerful songster, the small skylark is hard
to see on the ground, particularly in a wheatfield.

# Conclusion:
## the Twentieth Century

In THE PAST it was the role of the illustrators to capture the beauty of birds, while today's bird watcher has the benefit of cameras, binoculars and telescopes to watch and record their appearance and behaviour. However, bird illustration and painting continues to be prized both for its scientific and its artistic value. Artists are still needed to make studies for manuals and pocket field guides, as good drawings can often be more clear and explicit than photographs and thus serve a valuable purpose in identification. Modern printing processes enable bird pictures and prints to be more widely distributed than ever before, and birds are increasingly popular as images on greetings cards and calendars.

Most bird artists today make field studies, as did many of the best illustrators of the eighteenth and nineteenth centuries, but instead of the gun, they carry a camera. Photographs of living birds began to take over from shot specimens as early as 1882, when the Frenchman Professor E. J. Marey invented what he described as a photographic rifle, which enabled him to take 'shots' of seagulls in flight.

Today high-speed film and telescopic and zoom lens enable the photographer to achieve spectacular results – although both photographer and artist share similar problems, as birds are notoriously fidgety models. Observation 'hides' in conservation areas are helpful for viewing birds without disturbing them, and many unusual devices are now used to conceal both camera and photographer. The veteran photographer Richard Kearton (1862–1928), who can be seen as the father of natural history photography, hid himself within the confines of a generously proportioned hollow cow! His brother Cherry, who once held on to the rungs of a ladder with his teeth while using both hands to photograph a carrion crow, took the first pictures of birds from the air in the Spencer Brothers airship during the first decade of the twentieth century.

Richard Kearton's *With Nature and a Camera* was published in 1897 and since these early pioneer days more and more methods of recording and filming birds on the wing and at rest have been developed. Great bird photographers of the old school like Eric Hosking (born 1909) have seen their magnificent still photographs rivalled by television films, which can today bring the most intimate details of the daily life of the rarest species into our homes at the touch of a button.

Yet the work of the artist co-exists quite happily with that of the photographer, and there are still many paintings and illustrations which convey the beauty and grace of birds in their environments, giving pleasure to countless bird lovers. To make such studies, the artist still uses museum skins, or birds recently killed through accidents, as reference for measurements and details of feathering.

### C. F. TUNNICLIFFE AND THE RSPB

For the purposes of this book one twentieth-century artist must stand for many, and none can be more representative than Charles Frederick Tunnicliffe (1901–79). His powerful but sensitive works created a furore when first exhibited shortly after the artist's death, prior to a proposed auction and the public enthusiasm was so great that they were purchased by the Isle of Anglesey Borough Council for permanent exhibition.

Anglesey was the area of Wales which Tunnicliffe loved, and where he lived for the latter part of his life. There in the marshes, or on the shore at Cob Lake, Malltraeth, he filled countless sketchbooks with crowded field studies and drawings of birds' habitats. Many of these show aspects of bird behaviour, recording their daily activities, but he also made meticulous colour studies of dead birds measured to the last millimetre, which he called 'feather maps'. These valuable documents were prepared as reference material for his large watercolours exhibited each year at the Royal Academy, which were the culmination of all his patient work. He said that all his field and studio work was of little avail unless he could use them to grasp the real essence of the character of a bird. The ability to capture the characteristics – or in bird-watchers' language the 'jizz' of a living bird – is the challenge that has been faced by all ornithological artists.

Tunnicliffe was born in the village of Langley, Cheshire, the son of a smallholder farmer. He attended Macclesfield Art School, and later the Royal College of Art, London, where he specialized in etching. One of his first artistic successes was the series of lively and powerful wood engravings of animal life done for Henry Williamson's remarkably observed, unsentimental novel *Tarka the Otter*. For many years Tunnicliffe was the major artist for the designs of the RSPB (Royal Society for the Protection of Birds) products, and painted the artwork for the attractive colour covers of their magazine *Birds*.

BLACKBIRD

*Turdus merula.* Watercolour by Charles Frederick
Tunnicliffe, used by the Royal Society for the Protection of
Birds as a card and journal cover.

*Recurvirostra avosetta*. Watercolour by Charles Frederick Tunnicliffe. In 1947 the avocets nested in England after many years absence, and Tunnicliffe studied them breeding at Havergate Island, East Anglia in 1950.

The RSPB was founded in 1889 after a small group of ladies in Didsbury, Manchester, co-ordinated opposition to the trade in bird plumes for millinery. In Victorian fashionable circles, capes, collars and fans were decorated with trimmings from humming-birds, jays or kingfishers, while hats were adorned with birds' heads and even whole birds. The silky feathers of the great crested grebe were used for muffs, tippets or collars, and the grebe population, slaughtered unmercifully for this purpose, was reduced to very small numbers. Such carnage prompted the famous Victorian artist George Frederick Watts to paint a pile of ladies' feathered millinery, giving the picture a title referring to the Massacre of the Innocents.

After many years of campaigning, the Importation of Plumage (Prohibition) Act came into force in 1921, and gradually the fashion of wearing feathers ended. The RSPB in Britain now maintains some 120 nature reserves, promoting the protection of birds in their natural environ- ment, and similar activities are conducted by the National Audubon Society in the United States of America and the Gould League in Australia.

The bird adopted by the RSPB as an official symbol is the avocet. The return of this stately wading bird to breed in East Anglia in 1947, after an absence of 150 years, and its subsequent protection by the RSPB, is one of the success stories of conservation. At the bird reserves at Minsmere and Havergate Island, Suffolk, Tunnicliffe made many drawings of this rare species, and these were used for the Society's Christmas cards and journal covers.

184

Álcatralsa. This fowle is of the greatnes of a Swanne.
and of the same forme sauing the heade, w^ch is in length .16. ynches.

Tanboril.

**HEAD OF A BROWN PELICAN**
Watercolour by John White, 1555.

# *Print Collecting*

T HERE IS AN IMMENSE VARIETY of bird art available to today's collector, with prices ranging from a few pounds or dollars to several millions. At the top of the market is the complete first edition of Audubon's *The Birds of America* (4 vols. 435 plates). This is the most expensive set of books in the world, and reached a record $3.96 million (£2.5 million) at Sotheby's, New York, in June 1989. When it was first published between 1827 and 1838 subscribers were asked to pay two guineas, then a large price, for each of the eighty-seven parts (about five plates), and the total expenditure for the purchase of the whole work was about £183, then $1000.

At the lower end of the scale are the single bird prints, which can be purchased for modest prices at secondhand bookshops and print stalls in antique markets. Individual hand-coloured etchings by Wilson and Buffon, for example, can be found for under £100, and a variety of small hand-coloured plates from such series as Jardine's *The Naturalists Library* or Swainson's *Zoological Illustrations* can be purchased for no more than £40 ($60) or less.

## PRINTS AS DECORATION

Sadly, in recent years many beautiful natural history volumes have been dismantled due to an increasing demand for coloured prints for interior decoration, their scholarly texts and superb bindings discarded for the sake of sales of individual prints. Even reputable auction houses have sold all the plates from Gould's and Audubon's complete works separately. There is now an urgent need for examples of these fine books to be kept in their entirety, and for libraries and collectors to preserve their valuable collections of books for future generations to appreciate. For study purposes some libraries now have facsimile copies available to prevent damage to the fragile pages of old volumes.

However, one excuse for breaking up books is that a print on a wall can be easily seen and appreciated, while many beautiful prints remain shut away from view in large and unwieldy volumes. The individual print can also be more easily cleaned and cured of 'foxing', the rust-brown spotting that is the scourge of all works on paper. Experts can treat this persistent mould on single sheets of paper, while pages bound within a volume are less accessible.

On the other hand, the original bright colours of hand-coloured plates remain fresh when protected in closed

books away from the light, whereas mounted prints and watercolours are immediately subject to fading when exposed to the harmful ultra-violet rays of sunlight. For this reason framed prints and watercolours should always be displayed away from the sun or the damp as in a very short time colours fade and paper deteriorates.

Although most bird prints were intended as an aid to science and were originally made to be bound in volumes, they were occasionally used in the past for the purposes of interior decoration. Dixon's embossed prints based on George Edwards' etchings were planned specifically for the apartments of fashionable ladies, and framed in a way that fitted with the chinoiserie style popular at the time. At Temple Newsam, near Leeds, the owner cut out the birds from Audubon's prints and pasted them on the Rococo wallpaper as picturesque details, while in the rooms of Whiteslea Lodge, a shooting lodge in Norfolk, Gould's prints were pasted on walls to help to identify birds seen from the window. During this century Stephen Tennant, the owner of Wilsford Manor, Wiltshire, recorded how in 1942, when designing a scheme of decoration for his home, he bought some exquisite prints of birds 'all in the same divine blue plumage', for his bedroom.

Interior decoration shops today sell framed reproduction and antique bird prints as part of fashionable 'traditional' décor, but the buyer should remember that lavish framing and mounting can add substantially to the price of a picture. It is also important to check that new mounts and backings for prints and watercolours are made from acid-free preservation boards, as these are essential to help prevent the spread of foxing on old paper.

## PRINTS AND REPRODUCTIONS

The word 'print' as used today is very misleading, as it encompasses a bewildering variety of reproduction processes. Works of art which involve the hand of the artist or craftsman are known as 'original' prints; these include woodcuts, engravings, etchings and lithographs. In the past most natural history subjects were printed in outline and coloured by hand with watercolours, but some original prints were sold 'plain' without any colouring, and these can sometimes be found today with modern hand colouring. 'Recent' or 'later' hand colouring on old prints (and reproduction prints with hand colouring) should be correctly labelled by the printseller.

Many examples of Gould's original prints have modern colouring, for when he died in 1881 about thirty tons of his unused material including uncoloured prints were acquired by the booksellers, Henry Sotheran of Piccadilly, London. They remained forgotten until 1937 when some of the stock was dispersed in sales. Sotheran's still sell Gould's prints, some with their original hand colouring and others with 'later' colouring but done in the traditional manner using Gould's own pattern plates.

To add to the confusion, the term 'print' is also widely used for photographic reproductions. Some of these are of very high quality, and when framed and glazed even the discerning collector can find it difficult to identify which reproductive method has been used. Close inspection and a magnifying glass are needed to identify the brushwork of a watercolour or the incised line of an engraving, as facsimile prints now reproduce carefully even the creases, blemishes and rust spots of the originals. Colourful photographic reproductions and posters have been made of Lear's large prints of macaws, cockatoos and owls, which cost a fraction of the price of the genuine lithographs. At the remarkable sale of H. Bradley Martin's ornithological library at Sotheby's, New York, in 1989, a record price of $231,000 (£146,203) was reached for Lear's book of forty-two plates, *Illustrations of the Family of Psittacidae, or Parrots*.

## PRICE VARIATIONS

Prices of bird books and prints vary greatly according to their availability and subject matter. The popular volumes of Bewick were published in large editions, and as their text blends so perfectly with the small-size illustrations many volumes fortunately remain unbroken. The works of the prolific naturalists Buffon and Gould, who published long series, are less rare and thus less expensive than the specialized productions of Catesby, Lear, Levaillant or Audubon.

Prints of colourful exotic birds such as parrots, birds of paradise or humming-birds, also birds of prey, game birds and ducks, are more sought after and expensive than the nondescript finches or seabirds. This preference for showy birds was highlighted in a recent sale of the prints from Gould's *The Birds of Australia:* the flamboyant cockatoos fetched over ten times as much as the little brown waders. Unfamiliar birds depicted by such artists as Martinet, Swainson or Keulemans are available for very little, and often have been discarded from dismantled books where the brighter birds have brought higher prices. Who, after all, would want a Swainson lithograph of a drab mournful grahlinule *(Graninula lugubris)* which has lost its context and therefore its meaning?

Recently, bright colour prints of farmyard and cage birds from popular Victorian natural history books have been in demand for home decoration. The inexpensive Cassell's series of books were illustrated by chromolithographs printed in rich tones by a process using oil-based colours.

Audubon's and Thorburn's much valued original work has been reproduced by a confusing variety of printing processes. Between 1840 and 1844 Audubon himself published *The Birds of America* in a 'miniature' or octavo edition of a hundred parts at $1 each to be bound in seven volumes. Later publications of the full-size Audubon plates include 150 chromolithographs by Julius Bien produced

in 1860, and lately a new edition of five prints has been produced with great expertise from some of Audubon's recently rediscovered and resurfaced metal plates. Even facsimile editions of Audubon's plates are sold at antiquarian book and print auctions.

### PAINTINGS AND DRAWINGS

Paintings by Thorburn, particularly those of game subjects, are among the most expensive examples of British bird art, but prints reproduced from his pictures vary greatly in value and quality. Thorburn's prints have been issued in many editions – signed, limited and unlimited – and prices are set between £900 and £50 according to whether the prints are numbered and signed, numbered but unsigned, or published in an unnumbered quantity.

The most expensive bird paintings are by Melchior d'Hondecoeter, whose *Menagerie* of pelican, flamingo, heron, cockatoo and ducks in a parkland setting reached $290,000 (£147,959) at Christies, New York, in 1981. In a similar style but less costly are the oil paintings of Jacob Bogdani, Tobias Stanover and Peter Casteels, decorative large-scale Baroque assemblies of birds made for grand country houses. In 1984 Turner's album of twenty watercolours fetched the price of £200,000 at Sotheby's, London, but this large sum perhaps reflects the fame of the artist rather than the quality of the paintings. Many beautiful preliminary watercolours by Barraband for Levaillant's *Histoire Naturelle des Oiseaux de Paradis* were sold at Sotheby's, Monaco, for high sums in 1988. Saleroom prices, however, although interesting, are often misleading for collectors because only the top figures are usually quoted, and amounts for lesser-known works are not reported.

Drawings and paintings by the wild-life artists Wolf and Landseer have always been highly regarded and have increased in value with the renewed interest in the late nineteenth century. Yet paintings by Keulemans or Hart are relatively little known, for these artists never exhibited, and their pictures are gradually coming on the market at steadily increasing prices.

From this brief account it can be seen that purchases of bird art can be made to suit all pockets. In conclusion, I would like also to recommend strongly the pictures by contemporary bird painters and printers, as it can be immensely stimulating and rewarding to buy from living artists. Today there is a wealth of exciting contemporary work exhibited by commercial art galleries, wild-life artists' and printmakers' societies.

In this study of a volatile and changeable market the aim has been to provide suggestions rather than a shopping list with exact values, for prices are always subject to chance variations. Yet given the luck and judgment which gives zest to the formation of any collection, acquiring bird pictures by past or present artists can provide an enthralling hobby ideal both for future investment and present enjoyment.

MAUREEN LAMBOURNE, APRIL 1990

# Select Bibliography

ANKER, Jean — *Bird Books and Bird Art.* Copenhagen, 1938.

ARMSTRONG, Edward A. — *The Folklore of Birds.* Collins, 1958.

AUSTIN, Oliver L. Jr. — *Birds of the World.* Golden Press, New York, 1983.

BAIN, Iain (ed.) — *Thomas Bewick: A Memoir.* Oxford Univ. Press, 1979.

BARBER, Lynn — *The Heyday of Natural History, 1820–70.* Cape, 1980.

BLUNT, Wilfred — *The Ark in the Park.* The Zoo in the Nineteenth Century. Hamish Hamilton, 1976.

CARR, D. J. (ed.) — *Sydney Parkinson.* Artist of Cook's *Endeavour* Voyage. Croom Helm, 1983.

CHANCELLOR, John — *Audubon: A Biography.* Weidenfeld and Nicolson, 1978.

DANCE, S. Peter — *The Art of Natural History.* Country Life, 1978.

FORSHAW, Joseph M. — *Parrots of the World.* Blandford Press, 1989.

HAMMOND, Nicholas — *Twentieth Century Wildlife Artists.* Croom Helm, 1986.

HYMAN, Susan — *Edward Lear's Birds.* Trefoil, 1989.

JACKSON, Christine E. — *Bird Illustrators: Some Artists in Early Lithography.* Witherby, 1975
*Wood Engravings of Birds.* Witherby, 1978.
*Bird Etchings.* Cornell Univ. Press, 1989.

JAMES, T. G. H. — *Egyptian Painting and Drawing.* British Museum Publication, 1985.

JENKINS, Alan C. — *The Naturalists.* Hamish Hamilton, 1978.

KASTNER, Joseph — *The Bird Illustrated. From the Collections of The New York Public Library.* Abrams, New York, 1988.
*A Species of Eternity.* Dutton, New York, 1978.

LAMBOURNE, Maureen — *John Gould: Bird Man.* Osberton Productions, 1987.

LYSAGHT, A. M. — *The Book of Birds.* Phaidon, 1975.

LYLES, Anne — *Turner and Natural History: The Farnley Project.* Tate Gallery, 1988.

MOOREHEAD, Alan — *Darwin and the Beagle.* Penguin Books, 1971.

MOYAL, Ann — *'A bright & savage land'. Scientists in Colonial Australia.* Collins, Sydney, 1986.

NOAKES, Vivien — *Edward Lear: The Life of a Wanderer.* Collins, 1968.
*Edward Lear 1812–1888.* Royal Academy of Arts Exhibition catalogue, London, 1985.

NORST, Marlene — *Ferdinand Bauer: Australian Natural History Drawings.* British Museum (Natural History), 1989.

ORMOND, Richard — *Sir Edwin Landseer.* Catalogue of exhibition at the Philadelphia Museum of Art and the Tate Gallery, London, 1981.

PALMER, A. H. — *The Life of Joseph Wolf.* Longmans, 1895.

RAJNAI, Miklos — *Jacob Bogdani.* Catalogue of exhibition at the Richard Green Gallery, London, 1989.

RAVEN, C. E. — *John Ray, Naturalist.* Cambridge University Press, 1942.

SAUER, Gordon — *John Gould: The Bird Man. A Chronology and Bibliography.* Landsdowne Editions, Melbourne and Sotheran, London, 1982.

SITWELL, Sacheverell — *Fine Bird Books 1700–1900.* Collins, 1953.

SKIPWITH, Peyton — *The Great Bird Illustrators and their Art 1730–1930.* Hamlyn, 1979.

TOYNBEE, J. M. C. — *Animals in Roman Life and Art.* Thames and Hudson, 1973.

TUNNICLIFFE, C. F. — *Sketches of Bird Life.* Ed. Robert Gillmor. Gollancz, 1981.

WHITE, T. H. — *The Book of Beasts.* Jonathan Cape, 1954.

# Index

# Acknowledgements

My special thanks are due to Christine Jackson for sharing her knowledge and for the scholarship of her books which are invaluable for reference and as an insight into the world of bird illustrations. I am grateful also to Peyton Skipwith for his pioneer research in bird books and for encouraging my interest over many years.

To Gina Douglas (Linnean Society), Ann Datta and Carol Gokce (Zoology Library, Natural History Museum), Anne Stevenson Hobbs (National Art Library), Sarah Minchin (Nature in Art, Wallsworth Hall, Gloucester), Dorothy Lothian (Henry Southeran Ltd) and Don Bailey (Greek and Roman Dept., British Museum) my grateful thanks for showing me many beautiful examples of bird art in galleries, libraries and museum collections.

Quarto would like to thank the following for their help with this publication and for permission to reproduce copyright material. Whilst every effort has been made to trace and acknowledge all copyright holders, Quarto would like to apologise if any omissions have been made.

KEY: a = above, b = below, r = right, l = left, c = centre

Ashmolean Museum, Oxford : pp44, 69, 162, 176.

The Bodleian Library, Oxford : pp20, 22, 23, 24b, 26.

The British Library: p24a.

By Courtesy of the Trustees of the British Museum: pp8, 10, 11, 12, 13, 14, 15, 16, 17, 18b, 70.

E T Archive: Frontispiece, pp6, 184.

Courtesy Richard Green Gallery: p52/53.

Hull City Museums and Art Galleries: p18a.

Leeds City Art Galleries: p163a.

By permission of the Linnean Society of London : pp31, 33, 34, 35, 36, 37, 38, 39, 40, 42, 43, 46, 47, 48, 49, 72, 73, 74, 75, 76, 77, 79, 98al, br, 99, 100, 102, 103, 104, 107, 108, 110/111, 113, 114, 115, 120.

Master and Fellows Magdalene College, Cambridge: p29.

Reproduced by Gracious Permission of Her Majesty the Queen: p160.

By courtesy of the Natural History Museum, London : pp58, 59, 60, 61, 62r, 63, 64, 66, 67, 80/81, 82, 83, 84, 85, 86, 88/89, 90/91, 92, 93, 95, 120, 128, 130, 132, 133, 134, 135, 136, 138, 139, 140, 141, 142/143, 144, 145, 146, 148/149, 150, 151, 152, 153, 154, 156, 157, 158, 159, 164, 165, 166, 168, 169, 171, 174, 175, 177.

Nottingham City Museum: p54.

The Royal Society for the Protection of Birds: pp180, 182, 183.

Ruskin Gallery, Collection of the Guild of St. George: pp96, 116, 119, 121, 122, 123, 124/125, 126, 127, 129, 163b.

The Society for Wildlife Art of the Nations, Gloucester, England: pp19, 112, 167, 172/173.

The Thorburn Museum and Gallery: p178/179.

Courtesy of the Board of Trustees of the V&A : pp27, 30, 57, 62, 117, 118, 147.

Reproduced by permission of the Trustees of the Wallace Collection, London : p50/51.